T0274265

FOREVER BELLE

Forever Belle

SALLIE WARD OF KENTUCKY

THE UNIVERSITY
OF TENNESSEE PRESS
Knoxville

Randolph Paul Runyon

Copyright © 2024 by The University of Tennessee Press / Knoxville.
All Rights Reserved. Manufactured in the United States of America.
FIRST EDITION.

Library of Congress Cataloging-in-Publication Data
Names: Runyon, Randolph, 1947- author.
Title: Forever belle : Sallie Ward of Kentucky / Randolph Paul Runyon.
Other titles: Sallie Ward of Kentucky
Description: First edition. | Knoxville : The University of Tennessee Press,
 [2024] | Includes bibliographical references and index. |
Summary: "Born into a politically connected Kentucky family, Sallie Ward
 (1827–1896) began her public career as a southern belle who captivated
 the popular press in Kentucky and throughout the nation. Known for her
 somewhat scandalous behavior, including obtaining a divorce and smoking
 cigars, she cut a swathe across the nineteenth century that seems out of
 proportion to her real circumstances. While Sallie and her frequent travels
 and adventures are the focus, there is also valuable material on her family,
 and especially on the murder trial of her brother Matt Ward, in which he
 was rather scandalously let off due largely to his connections to the rich and
 powerful. This study is both an analysis of a unique character in nineteenth-
 century America and an examination of how celebrity was created and
 perpetuated before the rise of mass culture" —Provided by publisher.
Identifiers: LCCN 2023042338 (print) | LCCN 2023042339 (ebook) |
 ISBN 9781621908517 (paperback) | ISBN 9781621908524 (kindle
 edition) | ISBN 9781621908531 (pdf)
Subjects: LCSH: Ward, Sallie, 1827–1896. | Women—Kentucky—
 Biography. | Women—Southern States—History—19th century. |
 Fame—History—19th century. | Southern States—Social life and customs—
 19th century. | LCGFT: Biographies.
Classification: LCC F455.W37 R86 2024 (print) | LCC F455.W37 (ebook) |
 DDC 976.9/03092 [B]—dc23/eng/20231002
LC record available at https://lccn.loc.gov/2023042338
LC ebook record available at https://lccn.loc.gov/2023042339

For Elizabeth

Contents

Illustrations

Acknowledgments

I AM GRATEFUL for the assistance of Jennie Cole, director of Collections Access, Filson Historical Society; Scot Danforth, director of the University of Tennessee Press, whose unflagging encouragement drew me on; Lindsey Apple and Patrick A. Lewis, who gave invaluable counsel; copyeditor Katie Hannah for her sharp eye; Timothy Pack for his artistry; and Kim Spence, senior director of Collections and curator of Works on Paper, the Speed Art Museum, who made it possible for G. P. A. Healy's paintings of the Wards to adorn these pages, and to the Speed Art Museum for its generosity. Above all, thanks to Elizabeth Runyon for her insightful comments as this work progressed. Despite all the excellent advice I have received, there may well be mistakes that remain, and for them I alone am responsible.

Introduction

SALLIE WARD WAS a charmer. Her beauty inspired poems and duels. Born to wealth in 1827, she used it to advantage, ordering expensive clothes from abroad, setting new standards in fashion and, to the outrage of some, wearing rouge. She knew how to dominate the news and did so for decades on a national scale, from early triumphs and a scandalous divorce to renewed social prestige and profitable marriages. Newspaper readers and acquaintances alike found her endlessly fascinating, not least because she was strangely able to retain her beauty, or the illusion of it, to the end, which came in 1896.

Her first national press exposure was due to her ravishing appearance at a costume ball in Newport, Rhode Island, in 1846, leading to articles in the *New York Evening Express* and Milwaukee's *Weekly Wisconsin*. The extravagant festivities surrounding her first marriage, to T. Bigelow Lawrence of Boston, were covered in Boston, New Orleans, Baltimore, Buffalo. South Carolina, Vermont, and Detroit. Her divorce was news in New York, Virginia, Alabama, Mississippi, Pennsylvania, Michigan, Vermont, Missouri, and South Carolina. Her scandalous return to society at a costume ball in Louisville three months after the divorce generated even more stories in even more papers. Editors typically sent their newspapers to one another, since all benefitted from finding copy to fill their columns. It was almost a nineteenth-century internet, increasingly facilitated in the 1840s by the spread of telegraphic communication.

In her childhood and adolescence, she was adored by the populace of her native Louisville, as if she were "a French princess in her hereditary province." Mothers named their daughters after her, turfmen their racehorses, shipbuilders their boats, farmers their prize cows. She was admired from street corners as she passed by in her carriage, and along the banks of the

Mississippi as she made her way to and from New Orleans, often on board the steamboat her father had built and that bore his name.[1]

Her story acquires even greater interest when considered in the context of her once-powerful family. The parents were rich, the children indulged. Their immense wealth, as was the norm in that place and time, was ill gotten, built on the suffering of countless enslaved persons in the cotton fields of Mississippi and Arkansas. The land on which the latter toiled was itself stolen from the Choctaw through the machinations of Sallie's paternal grandfather. She, like her three younger sisters, was pampered, yet she was kind to others, especially the poor, and for that was beloved. But her brother Matt, intelligent and somewhat literary, was capable of evil, and the story of how that evil manifested itself is instructive for what it reveals of the power of money and the shortcomings of Kentucky jurisprudence. He and one of his brothers were indicted for murder; a another brother shot a man in an argument in a riverboat bar. Like herself, Sallie's three sisters were charming and beautiful; unlike her, they sensibly preferred private domesticity, though Malvina created a scandal when she eloped at fourteen. Malvina lived the longest, had the most children, and suffered the most tragedy. Sallie's only surviving child, John Wesley Hunt, died mysteriously, as did his father, but he left behind a daughter whose Hollywood career merits a book of its own; I have tried to do it justice within a smaller compass.

Sallie Ward's life has drawn parallels with that of the tempestuous heroine of *Gone with the Wind*. The novel's opening words—"Scarlett O'Hara was not beautiful, but men seldom realized it when caught by her charm"—are reminiscent of remarks made about Sallie Ward. The *Boston Post* reporter who covered her first wedding wrote that she "can scarcely be called a beauty . . . but nevertheless possesses a certain indescribable air and manner which to the great majority of fashionable people render her eminently attractive." According to an unnamed "intimate friend" who wrote about her after her death, "It has been said that Sally Ward's beauty was not as great as that of many other women of her time." Margaret Mitchell notes the "French descent" of Scarlett's mother; Sallie's mother was a Flournoy, third-generation French, and prided herself on her Gallic origins. Like Scarlett, Sallie was born rich, lost her wealth in the Civil War, and married a man, Vene Armstrong (her third husband), to whom she would never in normal circumstances have given a second look. Like Frank Kennedy in Mitchell's novel, he may have been a sexually unappealing merchant, but he was her ticket out of poverty. Sallie would never go hungry again.[2]

Yet as far as character goes, the two women were polar opposites. Sallie may have shed few tears when a lover or two perished on the dueling field,

but she was at heart a generous soul, repeatedly raising money for the poor of Louisville, and furthering the ambitions of ordinary folk in whom she came to take an interest. As a contemporary wrote in 1885, she was "a woman of the world, but a woman of heart, ever ready with kind words and actions kinder still." Scarlett was only ever out for herself, and almost comically selfish. The fictional belle was a deeply racist Confederate, but Sallie proved so strong a Unionist that Lincoln was willing to accede to her request to expedite the shipment of her piano and satin-covered chairs from New Orleans to Louisville, even though her husband at the time was fighting for the South.[3]

Sallie was such a charismatic figure that myths about her sprang up like weeds, both during her lifetime and after. I have tried to separate fact from fiction, and some of the facts I have uncovered are more engrossing than the fiction. An often-cited but error-ridden source is Ella Hutchison Ellwanger's 1918 article "Sallie Ward: The Celebrated Kentucky Beauty." According to Ellwanger, Sallie was the eldest child of the family, but in fact Matt was. Ellwanger claims that Sallie's first husband was older than she by many years though it was by only months; she asserts that Sallie was eighteen at the time of the marriage but she was actually twenty-one.[4]

Apart from the occasional article in the *Louisville Courier-Journal* retelling old tales, nothing of any consequence has been published about her since Thomas D. Clark's colorful account in "Born to Be a Princess," a chapter in his 1942 book *The Kentucky* written with obvious delight: when Sallie appeared at a ball arrayed in jewels and lace "she glittered like a drunken conquistador's dream of El Dorado"; when she presented a banner to volunteers on their way to the Mexican-American War, "the contours of her body [were] clearly showing through the drapes of the silken flag, a living embodiment of the goddess of liberty"; as her gallop on horseback through the Market House indicated, Sallie "was so full of spirit and daring that it was hard to tell what she would do next."[5]

Eighty years is long enough to wait for a reconsideration of a Kentucky legend still remembered. Now it is easier to get precise information on long-past events than it used to be, with digitized newspapers, books, articles, pamphlets, and letters available in abundance. Letters of immeasurable value, while not publicly digitized, were located for me by the gracious staff of the Filson Society. Through them we can see Sallie through the eyes of her friends, sometimes approving, often not.

The desire to take a lingering look at such a fascinating woman motivated this undertaking. I have felt, and hope to make the reader feel, like the man in the following anecdote:

Some years since, a friend who was of a very inquisitive nature and had a great admiration for handsome women was passing along the shopping street of Louisville when his attention was drawn to an elegant turnout standing at the curb-stone. In the carriage was a very showy lady. So much was gained at a glance, and an inquiry disclosed the fact the lady was the famous Sallie Ward, as she was called, not only before her marriage but after, even when the wife of Dr. Hunt. Our friend took a turn back and made a square inspection of the famous and fast beauty, who stood the stare like a soldier, looking the gazer in the eye as much as to say, "How do you like it as far as you have gone?" Our friend touched his beaver, as a sort of "Thank'ee for the favor," and Sallie graciously returned the courtesy, as if to say "You are welcome."[6]

THE MOST PERFECT BEAUTY I EVER SAW

No account of Sallie Ward is complete without the tale of her riding a horse through Louisville's Market House, upsetting fruits and vegetables and sending sellers and buyers fleeing for safety. Someone could have been seriously hurt by those galloping hoofs. The building had been erected in the middle of a street and had openings at both ends, a tempting target for a spirited young woman approaching it on horseback.[1]

The story, as historian Thomas D. Clark remarked, is one that "Kentuckians have not yet ceased telling." Jacob Lewis Smyser (1834–1934), interviewed in 1927, though not an eyewitness was living in Louisville at the time and remembered hearing about the event, which he called "the talk of Kentucky." The earliest mention in print I can find dates from 1850, when the *New York Daily Herald*, explicitly referring to Sallie Ward, used the story to show the difference between a young woman from Kentucky and one from New England: "One would dash through the market place, in a feminine way, and only stop to pay a fine of twenty dollars, and be off again—the other would walk as demurely as a quaker, compared with the other earth-quaker, and never attract extraordinary attentions."[2]

In 1879, humorist Eli Perkins invented a fictional witness who claimed to have seen Sallie "gallop her horse through the Louisville market house when she was a dashing school girl." In 1889, a Lexington, Kentucky, newspaper columnist told the story about as well as any, and with a valuable clue that allows us to determine the year it might have taken place: "when only about eighteen years old, she galloped at full speed through a crowded market-house, putting her thoroughbred over stalls like a steeplechaser. She was accompanied by several escorts and friends, one of whom had thoughtlessly bantered her to the performance. She was promptly served with a summons to appear before the court, and next day the thoughtless admirer had the privilege of paying a heavy fine for his pains. As for Miss Ward, she laughed at him and told him never to dare Sallie Ward." This is the only account that gives Sallie's age, which allows us to place the event circa 1845, since she was born in 1827. Versions differ as to whether the idea was hers or her admirer's, whether it was she who paid the fine or he, and whether she was accompanied by only one or several devotees.[3]

Another Sallie story has her riding up the front steps of the prominent Louisville hotel known as the Galt House and into the lobby, whirling her horse about and making him bow to the startled guests. Eugene Field, author of "Wynken, Blynken, and Nod," told it as fact in a Chicago newspaper, but it may be as fantastical as his poem. A Louisville correspondent for the *New York World* in 1885 termed it "a legend" but identified every member of the accompanying quartet of friends, leaving some ambiguity as to whether it had no basis in fact whatsoever or if it really did happen but as time passed turned into a legend.[4]

In another instance of her ability to make mischief, Sallie and a friend disguised themselves as beggars and "so played upon the credulity of her parents that she prevailed on them to give her a goodly sum of money." While attending a private girls' school in Philadelphia, one day she put on a man's clothes and showed up among her fellow students in a place where only females were allowed. The girls screamed and fled, she laughed, told them to come back, and they did, noting how handsome she looked in male attire. Sallie spent two years at the school, graduating in 1844. She did not make a habit of cross-dressing, though in 1845 an observer noted that "our fashionable ladies are all using canes and learning to smoke cigars" in emulation of Sallie Ward—adding that it was "the latest touch in Paris." Amantine Lucile Aurore Dupin, writing under the name George Sand, set the style in France and Sallie may have introduced it to Kentucky.[5]

She was interviewed in 1867 by Elizabeth Fries Ellet, who described her in flattering terms in her *Queens of American Society*. Many, most, or pos-

sibly all of the details in those ten pages came from what Sallie told her, and thus show us how she saw herself:

> Every class in Louisville, Kentucky, where she lived, seemed to take pride in the loveliness of this young girl. It was a curious kind of popularity, more like that of a French princess in her hereditary province, to which her people claimed a sort of ownership, than the simple admiration of republicans for a fair being highly favored of fortune. If a child had a pet kitten or bird of remarkable beauty, it was fondly named "Sallie Ward." If a farmer rejoiced in the possession of a young lamb or heifer which he wanted to praise to the utmost degree of comparison, he would recommend it as a perfect "Sallie Ward." She was the ideal of all that was pure, beautiful and sacred to young people who saw her only at a distance in her father's carriage, or walking, attended, or at church. Once, when a mother was teaching her bright little girl, six years of age, to say her prayers, and to meditate on the grandeur and power of the Almighty Creator, she told her how God made the glorious sun, the stars, and all the beautiful flowers, the child interrupted her with "And, mamma, He made Sallie Ward!"

Whatever Sallie may have invented, the part about farmers naming their prize livestock after her is true. An historian of Scott County in 1882 recorded that a certain successful cattleman "started his herd in 1865, with the three cows, Sallie Ward, 2d and 3d." Sallie Ward the Second was evidently the offspring of yet another bovine Sallie Ward.[6]

There was no denying she was good-looking. At the age of sixteen she "attracted attention by the mature development and rounded beauty of figure that afterward became famous," a reporter recalled after her death. A youthful suitor wrote to a friend, "By George, when Sallie Ward's face is in repose, she is the most perfect beauty I ever saw. Lord, Lord what would I have given to have kissed her for about an hour, all over—the face of course. I went with her one night to a concert, and don't think I took my eyes off her ten minutes during its continuance."[7]

Sallie's beauty flourished in a privileged setting, for her father was one of the wealthiest men in the state. The yellow-brick mansion that housed Mr. and Mrs. Robert Johnson Ward and their eight offspring, together with its stables, slave quarters, and park-like grounds, occupied the northeast corner of the intersection of Walnut and Second Streets. A Hebe—cup-bearer to the gods—sculpted by Antonio Canova welcomed visitors; Ward had purchased it in New Orleans. The building was made for entertaining, and Ward had supervised its design. Hundreds of guests could mill about and not feel crowded. It had three parlors in a row, twenty by twenty-two feet in size, connected by folding doors. From the third, glass doors opened

onto a greenhouse, and beyond that a conservatory with palms, camellias, and, in the center, a pyramid of rare flowers reaching to the ceiling. Nearby was an aviary with a hundred caged birds, set loose at intervals to drink from the pool and the fountain constantly flowing through a miniature tin castle. For luncheons, tables of massive mahogany were brought in, with silver plate and cut glass, together with rounds of mutton, whole turkeys, sirloins of beef, and saddles of venison, pyramids of oranges, grapes, and macaroons, all beneath a spun candy web. Wine flowed like water. Every morning, two towering enslaved men set out with wheelbarrows that would return from the Market House laden with delicacies for the Wards' fabled feasts; neighbors would rush to their windows to see.[8]

To maintain this lifestyle cost Ward $50,000 a year, equivalent to one and a half million today. Born in 1798 in Scott County, he was descended through his mother, Sally Johnson Ward, from a wealthy and powerful family. His maternal grandparents were Robert and Jemima Suggett Johnson. According to legend, Jemima had led the women and girls out of a frontier fort called Bryan's Station to fetch water in the face of imminent attack from British soldiers and their Native American allies. When the enemy subsequently shot blazing arrows into the fort, the water saved the day.[9]

Sally Johnson Ward's brother, Richard Mentor Johnson, was said to have killed Tecumseh at the Battle of the Thames in 1813 and rode that notoriety to the US House of Representatives (1807–19, 1829–37), the US Senate (1819–29), and ultimately the office of vice president under Martin Van Buren (1837–41). But after that his political career languished when he refused to give up his relationship with Julia Chinn, an enslaved woman of mixed race whom he considered his common-law wife. She bore him two daughters whom he educated and married into White families. Johnson later turned over the management of his plantation and of his school for Choctaw children to Chinn.[10]

The future vice president began the school in 1825, having learned from his brother-in-law William Ward, a federal Indian agent and the father of Robert Johnson Ward, that the Choctaw Tribe of Mississippi wanted to establish an academy to educate their children. They would support it to the tune of $70,000 a year, the equivalent of over a million today. In debt from a failed expedition to North Dakota in 1818 and an abortive mining venture in Illinois, then Senator Johnson saw this as an opportunity to reestablish his finances. As a Washington insider, he was able to acquire a federal contract with its promised tribal money for the school, which he built on his Scott County farm at Great Crossings, five miles west of Georgetown. The school educated some six hundred Choctaw youths over the twenty-three years of

its existence. It started with idealism and good professors, but declined in later years, its students increasingly malnourished and ill clothed.[11]

When Andrew Jackson became President in 1829, he set to work to force Choctaw people out of Mississippi and into what would become Oklahoma. Tribal leader Greenwood LeFlore, son of a Choctaw woman and a French fur trader, was able to persuade his people to sign the Treaty of Dancing Rabbit Creek in 1830, which included the provision that those willing to become American citizens could stay in Mississippi and each receive 640 acres. Johnson's brother-in-law was in charge of administering the distribution, and, according to Deborah Boykin, tribal archivist for the Mississippi Band of Choctaw Indians, while some Choctaws "managed to register and be allotted land by the illusive and antagonistic Indian agent, William Ward, many had to sell their property to survive." In many cases, writes James Taylor Carson, Ward simply "refused to enroll the Choctaw claimants' reserves." His "malfeasance" made the treaty, in LeFlore's view, an "utter failure." But, for the Wards and Johnsons, it was a success because Ward was well placed to get those lands at bargain prices. As Ann Bevins points out, "possibly most" of the Johnsons' vast wealth came "from connections established in the location of Mississippi Delta lands when . . . William Ward was an Indian agent." A Frankfort, Kentucky, newspaper observed in 1832 that "Col. William Ward, the Choctaw agent, passed through this place on Friday last, accompanied by a number of Indian boys on their way to the Choctaw Academy in Scott county." Apparently giving Ward's version of events, the writer continued: "Col. Ward . . . has contributed much towards civilizing this unfortunate race. He has convinced them that they cannot exist as an independent nation within the limits of the State of Mississippi . . . and they have cheerfully [sic] consented to . . . settle upon the lands set apart for them . . . beyond the limits of Arkansas Territory."[12]

Robert J. Ward married Emily M. Flournoy in 1825. She was descended from French-speaking Huguenots. Jean-Jacques Flournoy (1684–1740) was born in Geneva, Switzerland, and came to Virginia by 1720. His son Matthews Flournoy (1732–1793) made many trips to Kentucky, on the last of which he was killed by Native Americans at Cumberland Gap. He had built a house on North Elkhorn Creek in Scott County.[13]

His son, Matthews Flournoy Jr. (1776–1842), was Emily Flournoy Ward's father. He represented Scott County in the Kentucky Senate 1821–25 and House of Representatives in 1826. Robert J. Ward was also in the legislature at that time, representing Scott County in the House of Representatives from 1822 to 1827 and again in 1831, and served as Speaker of the House in the 1824 term. Emily's father ran for governor in 1836, having secured

the Democratic nomination, the *Louisville Journal* complained, because of the "underhand manoeuvres of the Johnson and Flournoy families." He lost, however, capturing only 44% of the vote. He came in for some harsh comments from the *Louisville Journal* that cannot be entirely discounted just because it was a Whig paper. He and his running mate, Elijah Hise, were characterized as "a couple of noisy, narrow-minded, and vindictive demagogues . . . The shameful violence and infamous recklessness of their bearing" during the campaign was "everywhere marked by broils, battles, and other occurrences disgraceful to a civilized community." A case in point is what happened in Georgetown when Flournoy punched an opposing speaker who complained he was monopolizing the platform, which led to a general mêlée in which he bit off half the complainant's finger. Flournoy "is a contemptible fellow," said the *Journal*, "and deserves to be booted out of the society of gentlemen."[14]

Not sharing the *Louisville Journal*'s low opinion of her father, Emily Flournoy Ward was proud of her forebears, giving two of her sons, Matthews (usually abbreviated as Matt. or Matt) and Victor, the same middle name, Flournoy. Matt was born May 19, 1826; Sallie on September 29, 1827; Malvina on May 12, 1831; Robert in 1834; the twins Victor and William in 1839; Emily in 1841; Lillie in 1846. The Wards lived in a farmhouse near Great Crossings, four miles west of Georgetown, until 1828, when Robert bought an architecturally distinguished house on East Main Street in Georgetown that still stands. In 1833 he sold it and moved the family to Louisville, where in 1838 he would build the aforementioned mansion on the northeast corner of Second and Walnut Streets.[15]

From February 1834 to April 1835, Ward partnered with Robert A. Moffett in a wholesale grocery based in Frankfort that grew into a receiving and forwarding enterprise. They had sugar, coffee, rice, wines, cognac, rum, and other products from New Orleans, St. Louis, and Louisville arriving on the *Plough Boy*, a Kentucky River steamboat. In 1834, Ward and Moffett merged with Frankfort merchant Philip Swigert to take advantage of the arrival of the Lexington and Ohio Railroad in Frankfort. They incorporated the railroad into their operations and bought the steamboat, shipping commodities to Louisville and St. Louis and importing merchandise from New Orleans.[16]

Ward was at the same time a mail contractor, a political post probably awarded because of his activity on behalf of the Democratic Party; he was a delegate to the April 1835 state party convention. That year, he was appointed by the governor to be one of the directors of the State Bank of Kentucky and the Northern Bank of Kentucky. At that time, he teamed up

with Chapman Coleman to offer a diverse range of products and services: they sold wines, oranges, lemons, sugar, coffee, nails, bagging, rope, twine, jeans, and window glass and offered to buy wool and hemp. In 1836, they served as the Louisville representatives for a Natchez, Mississippi, plantation owner whose runaway slave was reported to have been seen in the city, and the following year did the same for a slave owner in Port Gibson, Mississippi.[17]

Ward was a member of the Louisville Colonization Society in 1836 and its president in 1839, a post in no way inconsistent with his taking part in the return of fugitive enslaved persons. For colonizationists, though claiming to denounce the evils of involuntary servitude and to be performing a humanitarian service by shipping Black persons to Liberia, were in fact seeking to protect slavery by ridding the South of freedmen. Slaveholders considered the latter dangerous, their very presence inciting enslaved men and women to flee, and suspected that these free people actively assisted escapes. Those suspicions were well founded. Ward was still active in this organization in 1839, inviting Rev. Ralph Randolph Gurley, one of its founders (who invented the name Liberia), to speak at the 4th street Methodist church.[18]

On March 6, 1837, a notice appeared in the *Louisville Journal* offering land for sale on the northeast corner of Walnut and Second Streets. It fronted 222 feet on Walnut, 145 on Second. Ward bought this property and built his mansion on it, completing the work in 1838. Coincidentally, advertisements for Coleman and Ward, which had appeared with considerable frequency since April 1835, ceased after June 27, 1837, and did not start up again until January 1839. It would seem that Ward was devoting all his time to overseeing the construction of his residence.[19]

With the new year came a resurgence of activity at Coleman and Ward. "We have a likely young negro man to hire for the ensuing year; he would make a valuable porter about a store." In subsequent months came ads for pork, New Orleans sugar, and Mississippi cotton. In March 1840, Coleman left the firm to strike out on his own; Ward partnered with William Moffett to keep the business going, though in 1841 he began an additional line of work as one of the eight directors of the Firemen's Insurance Company of Louisville, which specialized in covering warehouses and cargo.[20]

In October 1839, he branched out in a different way, setting up Ward and Moffett, commission merchants, in New Orleans. He brought in a third partner, his brother George W. Ward, who had recently been in the same line of work in Matagorda, on the Texas Gulf Coast. From then on, Robert J. Ward was a mercantile presence in both Louisville and New Orleans,

frequently traveling up and down the Mississippi. In 1843, Moffett in the Crescent City was replaced by George Jonas, who would remain in place until his retirement in 1854.

Meanwhile, Ward's children were growing up, his two oldest daughters in particular, each capturing her share of attention from admirers. On February 2, 1845, Joshua F. Bullitt described Sallie and Malvina to his brother John, away at Lexington attending law school: "The Wards are all the rage here among the élite. Of the two, Miss Mal is my favorite. She is not fully out yet—just budding—and the delicacy of her complexion is much more charming to me than the full bloom of her sister. [Malvina] is not quite so amiable [as Sallie], but far more spicy." He had prefaced this with an appreciation for the young ladies' sexuality: "None of the younger régime seem disposed to go farther than flirtation. *That* however they seem to understand in all its moods and tenses. If you want to get up anything of that kind, I would recommend particularly Miss Johnson, a little dark-eyed girl who was down here about a month ago. I do not know her at all, but she is consanguineously related to the Wards, and they are unrivalled in that line. . . . If she is anything like them [Sallie and Malvina] you will not find it like walking five miles to ride one. Not at all. She will meet you half way, and, if you are at all tardy, pull you the other half." The identity of the Miss Johnson he recommended is not known, but Sallie and Malvina's father had nine maternal uncles bearing that name and she is likely descended from one of them.[21]

On Sunday, April 12, 1846, one month shy of her fifteenth birthday, Malvina Ward conspired with Colin Throckmorton, to elope. At 28, Throckmorton was almost twice her age. He was a U. S. Navy veteran and the son of Aris Throckmorton, proprietor of the Galt House, but he had neither a profession nor a job—a highly unsuitable candidate for son-in-law. The two had agreed to meet at a certain place at three in the afternoon, but she arrived fifteen minutes early because their clocks were not in sync. She waited a while, then went to a friend's house; when Throckmorton arrived and she was gone, he searched about for some time, then went to the Ward house, assuming he'd find her there. In the meantime, someone had written a note to her father informing him of the intended elopement. When Throckmorton rang the bell, the servant told him he believed Miss Malvina was in the house and directed him to the parlor. Mrs. Ward came in, locked the door, and began to berate him. She was soon joined by her husband. For two hours they tried to force him to reveal the plan. Mrs. Ward was so furious that at last the young man told her husband he would tell him the whole story if he would just make his wife go away.[22]

An acquaintance, Dr. Cary H. Fry, of whom more later, wrote, "it was the most ludicrous affair I ever heard of, and has been the source of an immense deal of amusement to the whole community." Fry added that the Wards were planning to ship her off to Philadelphia "but it will do no good, for she says she will marry him at all hazard, and I believe she will do it, unless *he* should get out of the notion. The cross of the Johnson and Flournoy stocks is a very peculiar one, and I think obstinacy is their prominent characteristic." Another observer thought Throckmorton had not been all that serious, that he "was prevented probably as he desired as he told so many persons beforehand of his plan."[23]

But he was serious—even though his father told him he would disown him if he married her—and so was she. Malvina was kept under lock and key until her father could take her to Philadelphia, to Madame Segoine's School near Washington Square, most likely the same school Sallie had attended a few years before. He made Malvina a similar threat, saying she would never get a cent of his money if she married Throckmorton.[24]

Colin Throckmorton followed them to Philadelphia, keeping a watchful eye on the comings and goings of the students, awaiting his chance. He was not alone, having engaged several young men of the city to help and having made arrangements in advance with several cab drivers. On Tuesday afternoon, May 5, he saw her walking with one of her teachers and several of the students. Two of his coconspirators came up from behind and lifted her bodily into a waiting cab. Then he got in, but the cries of the students attracted enough attention that a gentleman came up, opened the door of the cab, and asked what was the matter. Colin said she was his sister, and he was taking her home. Malvina seemed unwilling to continue and was preparing to get out when Colin pushed her back into her seat. At the same time an accomplice pushed the inquiring gentleman out of the way, jumped into the vehicle and shouted at the driver to go ahead; the rest of the company entered another carriage and both vehicles took off at high speed. For the space of two blocks Miss Ward cried for help, though it would have been hard to hear her over the din of some fifty adults and children running after them and yelling at the top of their lungs "feller running away with a gal! Huzza, huzza!" The cessation of her cries after so short an interval led one reporter to conclude that Malvina had accepted the *fait accompli*.[25]

That evening they were united in marriage by the Rev. John Chambers of the Independent Presbyterian Church. As the *New York Herald* reported, because the bride "is not yet sixteen years of age, the marriage will not stand a legal test if the father is disposed to push matters to extremities." Robert J. Ward, so far as is known, did not contest the marriage.[26]

At two o'clock in the afternoon of May 9, Malvina and Colin returned
to Washington Square, she in new clothes, walking proudly past her former
school, tossing her head in defiance. They were soon noticed. Windows were
opened and girls screamed in delight to see their former classmate a married
woman. The *New York Herald* reporter remarked: "The hero is remark-
ably handsome, possessing a fine form, tall and symmetrical, an eye of fire,
a bronze face, and an air most martial. The heroine is also of magnificent
form—tall and elegantly proportioned, a beautiful fair complexion, deep
blue eyes, light bronzed hair, and most bewitching mouth, together with
a most wonderful expression of firmness mingled with tenderness. As she
passed along she looked a goddess, and she walked a Queen. Oh! may they
be happy forever."[27]

The next day they checked into the Astor Hotel in New York City, honey-
mooning until the fourteenth, when they took the train to Baltimore and
thence to Wheeling, where they boarded a steamboat, arriving home the
evening of the twentieth. An acquaintance wrote: "I travelled from Cincin-
nati to Louisville with Mr. and Mrs. Colin Throckmorton. The utter folly of
the affair and the parties struck me in an unusually forcible manner. I feel
deeply for Mr. Ward. So noble, so kind, so courteous a gentleman to have
such a contemptible numbskull for a son-in-law."[28]

News of the elopement had spread from Philadelphia to New York City,
Milwaukee, New Orleans, Vicksburg, Vermont, and Connecticut. Their ad-
venture even inspired a play: "Colin and Mal are being rendered immortal
by some Cincinnati Dramatist, and they are now being represented on the
boards there," a Louisville acquaintance wrote. But neither set of parents
would take them in. "The rupture between Mal and her family seems not
likely to soon be healed," a friend observed. She and Colin were lodging at
the home of a woman the letter-writer refers to as "old Mrs. Bates, who
says she will always give them a home; that Colin is a fool but she likes Mal,
and thinks the world and all of her." Mrs. Bates "is so much disgusted with
[Colin] that if it were not on his wife's account she would send him adrift.
Poor child!"—meaning Malvina—"I am told she is very unhappy but tries
to make the best of a bad bargain."[29]

In early February 1847, nine months after the elopement, Malvina had
a baby boy. She named it Robert Ward, doubtless hoping for a reconcilia-
tion with her father. The infant died at five months. Colin's father, Major
Aris Throckmorton, took over sole proprietorship of the Galt House in
January 1847 and "had Colin and his wife there," according to Mildred
Bullitt. She adds: "the story is that the old man thrashed Colin last week,
and that [Colin] took Mal out to old Mrs. Bates' one day, and returned to

his father the next. I think it a great pity the Major doesn't thrash him into doing something for an honest livelihood. I have heard that Mal is greatly subdued, and that much sympathy is felt for her by those who see her."[30]

During all the newspaper coverage in May 1846 of her sister's Philadelphia adventure Sallie Ward had not been idle. The Mexican-American War was underway, and she saw an opportunity to shine. On the morning of Saturday, May 23, two days after Malvina's return, a stirring ceremony was enacted in front of the Ward residence. Sallie presented on behalf of the women of the city an American flag to the Louisville Guards, a company of volunteers leaving for the war, who had been marched from their boat across town for the purpose. As Helen Deiss Irvin remarked, "she had a shrewd sense of stagecraft" and played her part to perfection. "There was scarcely a dry eye in the vast throng" of soldiers and friends who had come to bid farewell "as the youthful daughter of Mr. Ward appeared with a beautiful silken flag bearing the stars and stripes." Two days later, on the riverbank at Portland (in the western part of Louisville), she presented to the Louisville Legion—also headed for Mexico—a regimental banner, this one designed and made at her own expense. "As those brave fellows marched by the open carriage in which I sat," she recalled in later years, "each one lifting his hat to me, it was the proudest moment of my life. I esteemed the honor of being selected to present the flag to these noble sons of Kentucky far greater than all the homage of a ball-room."[31]

On June 11, a soldier wrote from Texas: "We have with us the beautiful flag presented to our company by Miss Ward, and will carry it with us wherever we go. It shall never be captured or disgraced as long as one man is left to fight in its defense under its glorious folds." A correspondent wrote from Monterey on February 27, 1847: "If we are attacked here and come off victorious, Miss Ward may well claim the credit of the victory," for under her banner "we cannot fail to conquer." The regimental banner she gave them, made of green silk with heavy gold embroidery, was a bit impractical, as it proved too heavy to carry in parades. As for the American flag she also presented, it had so faded from constant use that its red stripes became invisible. The paymaster's wife took the matter in hand, replacing them with strips cut from a red petticoat.[32]

When the soldiers returned to Louisville on May 27, 1847, they marched through the city to Robert J. Ward's house to return the honored emblems. She welcomed them atop her horse, as she had been just about to go for a ride. She shared in their glory and the gesture added to her fame, which had been growing from her appearances at places where the fashionable, the wealthy, and the influential liked to gather: Saratoga Springs, New York;

White Sulphur Springs, [now West] Virginia; and Newport, Rhode Island. At the Grand Fancy Ball on August 18, 1846, at Newport's Ocean House Hotel she dazzled as Zuleika, the heroine of Byron's 1813 poem "The Bride of Abydos":

> The dress of *lamé d'argent* exquisitely embroidered in silver, *double jupe* over white satin . . . The Turkish pantalets were of white satin, spangled, and confined around the ankle with pearl and silver lace, and the slippers of silver. Her girdle and necklace were of pearls and diamonds, and her hair braided with pearls; an Oriental turban of *lamé d'argent*, confined with diamonds, with a bird of Paradise feather, one side fastened in, with a diamond star, in the centre of which was a rare and burning opal from the East, of great value. This was one of the most magnificent, if not *the* most magnificent costume in the room. Byron's conception must have been fully realized in this beautiful personation of his Zuleika. Seldom has the mantle of "the child of greatness" fallen upon a better representation than the fair maiden "throned by the West."[33]

"For several years," a Wisconsin columnist noted in 1850, "her beauty has been the theme of themes in the Southern States, and in the fashionable circles of the North, the oft-told eulogies of her physical and mental charms found eager listeners." Concerning her mental charms, Thomas D. Clark records that at Harrodsburg's Graham Springs "Sally was the high light of the gay assemblies," and not just for her beauty: "No one dared interrupt when Sally and George" Prentice, editor of the Louisville *Journal*, "were exchanging thrusts with their flashing wits."[34]

Sallie was witty, or at least original, in her dress. She liked to shock people by walking down the sidewalk with mismatched footwear: a satin slipper competing with a buttoned boot. Equally shocking were her bejeweled bracelets on not just her wrists but her ankles, which she would lift her dress to reveal.[35]

> When she rode through the market 'twas the talk of the town,
> When she crossed the dusty street she raised her dainty gown,
> And from her tidy ankles the laddies plainly see
> Her leg deserved the diamond garter clasped above her knee.[36]

Many accounts confirm her controversial use of cosmetics. She darkened her brows, added eye shadow, and rouged her cheeks. The story goes that while walking in Louisville one day she passed a group of laborers who stopped work to gaze at her. One of them exclaimed, "By God, painted!" "Yes, painted by God," she replied, not quite truthfully.[37]

Malvina married in haste; Sallie took her time, trying out a number of

suitors. One friend wrote another in August 1844 with news that Sallie was going to marry John W. Shreve, the son of a prominent investor and banker, and according to a contemporary one of the city's "most graceful, best-dressed men." But the same friend expressed surprise that "she could discard Tom Kane, who is infinitely his superior in all respects. . . . What can she be thinking of?" In reality, she had not dropped Kane, an up-and-coming lawyer, though it would have been better for him if she had.[38]

On January 20, 1846, at the St. Charles Hotel in New Orleans, where at the biweekly dances she "reigned like a queen, for she was a vision of true loveliness, grace and refinement," Sallie and Kane danced the evening away. Trouble arose one evening after a ball when Kane found his seat at the table taken by a stranger. James W. Hyman, an Englishman, had evidently desired to sit next to Sallie and by some devious means had done so. Kane demanded his seat, Hyman refused, and words were exchanged. Hyman made an insulting remark, and Kane slapped him. Hyman challenged him to a duel, and Kane accepted. They met at seven the next morning at the Metairie racecourse. After ten steps, they turned to fire; both missed. Kane's seconds then proposed they shake hands and end it. Kane would apologize for the slap if Hyman would do the same for his words. Hyman refused. At the next exchange of shots, Kane fell from a bullet in his neck that had severed his carotid artery, dying within minutes.[39]

Sallie was responsible for yet another New Orleans duel, at least according to J. M. de Cottes, social editor of Alabama's *Montgomery Advertiser*. Miss Ward wanted the prestige of leading the quadrille on the St. Charles Hotel dance floor but found that, having arrived late, the place was already taken. When her rival's escort momentarily stepped away, Sallie persuaded her escort to join her in usurping the position. When the other man returned, he was enraged but withdrew with his lady and sat out the dance. Once the quadrille was over, he called out Sallie's escort. De Cottes reported, "A little later she was informed that her companion in the last dance was wounded unto death. She was waltzing. She finished out the waltz before exhibiting any interest in the affair, then left the ball room and found that the man who admired her, and had gratified her whim, was in consequence dead. But she had led the dance." De Cottes, born circa 1858, was relating an anecdote someone else had told her and for which I can find no independent confirmation.[40]

Sallie nearly provoked a third duel through her thoughtlessness. The difficulty arose in 1846 in Louisville, at a party where "an entertainment"— probably a musical performance—was to be offered. Customarily, guests selected in advance the place where they planned to stand on the floor, and

that place was sacredly respected for the evening. Sallie and her escort, Dr. Cary H. Fry, arrived late and boldly stood directly in front of a local belle and her out-of-town guest. The other couple had reserved their place legitimately; Sallie had not. The man whispered to Fry that he and Miss Ward were blocking his view and that of his lady friend. Fry laughed it off, only to be told that if he persisted in standing there he would be held personally responsible. The offended couple gave up and moved away. Later that evening the man sought out Fry and slapped him, saying he was satisfied, but if the doctor wanted satisfaction he would accommodate him at any time. The next morning Fry called on him to offer his apologies, saying he was sorry but that Miss Ward refused to leave and "I was powerless to move her." Both men thus satisfied, the duel did not take place.[41]

Fry, born in 1813 and an 1834 West Point graduate, was the author of an amusing account of Malvina and Colin's first attempt to elope in April 1846, observing of the Wards, as we have seen, that "obstinacy is their prominent characteristic." Now it is clearer what he meant in his letter to John Bullitt: he was alluding not only to Malvina but also to Sallie. By the time he wrote this letter he had grown disgusted with Sallie's insouciant obstinacy, but two months earlier had been in the first blush of infatuation. Bullitt's sister had written on February 2 that Fry "has just become acquainted with Sallie Ward, and I suspect is pretty deep in the mazes of flirtation with her." She writes also that Fry "seems to be the happiest man in existence; he has an office, but I don't think he is much troubled with patients—he visits, goes to parties, concerts, etc., and takes things as coolly as possible. I am very much afraid he will not do much." But by his own account, he was not happy at all: "I am, I believe, settled in Louisville for life, and have determined to continue in my profession, but really the prospect is very gloomy. I suppose I will be able to make a living after a while, but I don't believe I will ever be able to marry unless I can unite some other business with the practice."[42]

His coolness served him well in dealing with the man who slapped him, and Miss Bullitt's prediction that he would never accomplish much proved inaccurate. After his West Point graduation, he was promoted to second lieutenant and assigned to frontier duty at Fort Towson, Indian Territory (now Oklahoma). He resigned his commission after just two years, in 1836. He must have studied medicine at some point after that, for in 1845 he opened a doctor's office In Louisville. He returned to the Army to fight the Mexican-American War and at its conclusion tried medicine again, until 1853, when he rejoined the Army and spent the rest of his career as a paymaster, rising from Major to General. He saw no further combat, spending the Civil War safely ensconced in Washington, DC, and San Francisco.[43]

Some were still predicting as late as December 1846 that Sallie would marry John Shreve, but by that time she had met a more formidable suitor, T. Bigelow Lawrence, a Bostonian from an eminent family of wealth and standing. Sallie first met him in 1846 on a visit to Saratoga Springs. A Louisville friend wrote to John C. Bullitt on January 4, 1847, that he had learned that the two were engaged, with a wedding planned for the spring. "She certainly does not seem to be so much of a dasher as she was before her visit to the East," he added, alluding to the Wards' trip to Boston to meet the Lawrences and to Sallie's having toned down her flamboyance for the chance at such an advantageous marriage. Bullitt's mother wrote him a frank appraisal of young Lawrence, however, that was hardly flattering: "I dined with your aunt Speed a day or two ago, and Mr. Davis brought home with him to dinner Mr. Lawrence, Miss Sally Ward's betrothed; he is more deaf than Charlotte and very near-sighted, in mind about Dr. R—'s equal, but is worth half a million."[44]

Sallie Ward's intended was born November 22, 1826, and graduated from Harvard in 1846. During his undergraduate years, he came down with an illness that left him permanently deaf, "and necessarily interfered a good deal with the successful prosecution of his studies," according to a biographical sketch that appeared in the *Proceedings of the American Antiquarian Society* in 1869. He entered Harvard Law School, "but left to try the effects of foreign travel and the assistance of distinguished aurists in relieving his infirmity," returning in 1848. The wedding rumored in January 1847 to be planned for the spring of that year did not in fact take place until December 5, 1848, nearly two years later. One or both may have gotten cold feet, most likely Sallie; she was used to handsomer, if not wealthier, suitors. She was also, as we know, used to witty conversational exchange. That pleasure would be denied her in the company of a husband who had difficulty hearing. The delay, however, may have been due to his European journey in search of a cure for his deafness.[45]

Lawrence's father, Abbott Lawrence (1792–1855), had twice served in the US House of Representatives and was on his way to being named ambassador to the United Kingdom. A farmer's son from western Massachusetts, he had left for Boston with all his worldly goods tied up in a handkerchief, which he carried at the end of a staff on his shoulder. There he was welcomed by brother Amos, six years his senior, who was already in business. Together the two built up the largest wholesale trading house in the country, beginning with importing goods from China and England, and expanding to textile mills in Lowell and Lawrence, Massachusetts; the latter town was named for him. His politics were Whig, though of the "Cotton," as opposed to the

"Conscience" variety. The latter were opposed to slavery on principle; the former wanted to avoid arousing Southern ire to keep the cotton coming. Reinhard H. Luthin lists him as one of the four most important leaders of that movement: "To the Cotton Whigs, led by Winthrop, Appleton, Abbott Lawrence, and Everett, slavery was not so important as certain commercial problems. . . . Business demanded that peaceful social relations with the South be maintained, since Massachusetts textile mills depended on the slave-holding states for raw cotton." Robert J. Ward, of Ward, Jonas, & Co., Cotton Factors and General Commission Merchants, New Orleans, was one of those Southern suppliers. Thus the Ward-Lawrence family merger-to be was supported by the strongest of business ties.[46]

Two

A CLASH OF CULTURES

The wedding of Sallie Ward and Timothy Bigelow Lawrence took place on the evening of December 5, 1848; it was a splendid affair. A reporter for the *Boston Post*, having arrived in Louisville a day or two before, found the impending event was the only topic of conversation at the Galt House. He was told a lot about the bride: that she was the subject of books, poems, and operas; that yachts, racehorses, and steamboats bore her name; that every girl in the city dressed, talked, smiled, and flirted like her, and that she had a somewhat unusual conversational style. To his eye she not a stunning beauty, yet she had a way about her that people undoubtedly found attractive.[1]

He at first thought himself lucky to have obtained an invitation, but then realized that everyone else had one too, or so it seemed. Five hundred guests converged on the Ward mansion at the northeast corner of Second and Walnut streets in so heavy a downpour that it took his carriage over an hour to crawl three blocks. His coachman had to negotiate with the other drivers to get him within eight hundred feet of the door. The reporter described the house as fairly ordinary on the outside, but once within he was overwhelmed by the beauty all around him, both human and material. The three parlors were brilliantly illuminated, the conservatory flowers

impressive. A fine portrait of Zachary Taylor surprised him, for he knew
Sallie's father to be a member of the opposing Democratic party. He may
not have realized that Abbott Lawrence owed his upcoming appointment
to the Court of St. James to his fervent support of President Taylor, and the
painting may have been a thoughtful and welcoming gesture on Ward's part.
Nearby were tables filled with assorted wines and liqueurs, much frequented
by the invited politicians and other people of importance.

The *Post* reporter observed the wedding ceremony, noting that both groom
and bride appeared very pale, which he attributed to their awareness of
the solemnity of the occasion. They were married by Rev. Edward Porter
Humphrey, pastor of the fashionable Second Presbyterian Church. Sallie's
dress he found tasteful if expensive, rumored to have cost $5,000 (equivalent
to $150,000 today) and ordered from Paris. There were eight bridesmaids,
among them Sallie's cousin Margaret Flournoy Johnson and Katherine
Bigelow Lawrence, the groom's sister. An equal number of groomsmen in-
cluded Sallie's brother Matthews Flournoy Ward and a brother and a cousin
of the groom.[2]

The supper was served in the conservatory, with its massive pyramid,
supported by twenty-two cherubim, perhaps alluding to the Sallie's being
in her twenty-second year. The pyramid was surmounted by a beautiful
vase diffusing clouds of sweet incense. Among the distinguished guests were
Kentucky Governor John J. Crittenden, past governor R. P. Letcher, future
governor Lazarus Powell, members of the legislature, members of congress,
lawyers, military officers, and the glittering *elite* of Louisville, with its beauty,
wealth and fashion. The one sour note reported was that while Sallie's dress
was a wondrously expensive import, and her mother and bridesmaids were
arrayed in the latest fashion, the puritanical mother of the groom wore a
plain dress trimmed with cotton lace and mock pearls. The Wards were
shocked and insulted.[3]

After the wedding Bigelow's parents returned to Boston but the newly-
weds remained at the Ward residence for some time. Such was the custom
in those days, the couple expected to stay around a few weeks to receive
social visits. The society editor of the *Montgomery Advertiser* noting that
rumor had it Sallie's bridal chamber was on display so that callers could view
the exquisite bed and her expensive robe de nuit. Thomas D. Clark pointed
out that nowhere else could the Lawrences "go on a honeymoon and enjoy
the same elegance. Never before in the romantic Old South had so much
been spent on a bridal bower. Lace hung in profusion about the room, the
pitcher, bowl, and all other metal fittings in the room were of sterling silver.
Truly the room was a dreamland." Sallie and Bigelow remained at her par-

ents' house a full three months, until March 13, 1849. She may have been reluctant to abandon the comparative warmth of Kentucky for the rigors of a New England winter; once in Boston, she would indeed complain of the cold and of its baleful effect on her health.[4]

At last they traveled to Washington, DC, and from there to Boston. A Wisconsin journalist who met them en route could already see that marital happiness was going to be unlikely, for Sallie had been accustomed to idolatrous admiration. "She counted admirers by scores, and not a few awarded her that station among ladies that Pauline Bonaparte and Madame Recamier held in their palmy days among the French." Young Mr. Lawrence should have thought about the fact that she "could not drop all her gallants at once, and devote her smiles and fair words entirely to his gratification."[5]

Even during the honeymoon tour "young and gallant gentlemen flocked around the beautiful bride, paying her marked attentions. The green-eyed monster is roused in the husband—he undertakes to enforce his authority—she, a high-toned, honorable woman, will not yield to his whims." Among those pursuers may have been John W. Throckmorton, Colin's older brother. After his death in 1881 it was alleged that he had been "the lover of the beautiful Sallie Ward at the time when the bewitching Southern girl captured" the affections of Bigelow Lawrence and that Throckmorton followed her to Boston.[6]

On April 1, Sallie arrived at the Lawrence home, 7 Park Street, overlooking Boston Common, only to be met with disdain by Mrs. Abbott Lawrence, who was shocked to see her wearing a pink beige dress, flower-trimmed hat, and slippers. As a friend of Sallie's related in 1896, this mother-in-law from hell "immediately began to try to change the willful, spoiled Southern girl into a demure, straitlaced, plain Boston matron like herself, but her efforts were vain and the war began." She told Bigelow to make her stop using cosmetics. She insisted Sallie be on time for breakfast and not keep guests waiting. But she did, taking so long to dress that, after several urgent messages demanding she appear because the invitees were getting impatient, Sallie at last showed up in her dressing gown, laughingly saying she had not had time to get ready.[7]

There are indications that the newlyweds did not stay with the Abbott Lawrences but at the Tremont House, a four-minute walk away. The anecdotes about her showing up late for breakfast and for waiting guests could still be true if, as is likely, the guests Bigelow's parents had invited were waiting in one of the parlors of the Tremont House. It was large and luxurious, having indoor plumbing, unusual for its time, and having impressed Charles Dickens in 1842 with its amenities, colonnades, and piazzas.[8]

Perhaps Bigelow desired more privacy than could be found at his parents'
residence. He may not have wanted to be under the gaze of yet another set
of parents as he had for those three months in Kentucky. A New Orleans
newspaper would later complain, perhaps unfairly, that "to receive a deli-
cate and accomplished lady, two thousand miles from home, by preparing
hired rooms at the Tremont House instead of opening the doors of his
father's spacious mansion" did not seem very welcoming. A Boston paper
reported soon after their arrival that they were at the Tremont House and
that when summer came they would take up residence at Newport because
"Mrs. Lawrence has suffered much from hemorrhage of the lungs since her
marriage, but the fine air and splendid scenery of Rhode Island will restore
her to health."[9]

Pressured by his mother, Bigelow told Sallie that wearing rouge was not
acceptable in Boston, and that it was a husband's privilege to forbid it. Sallie
complained to her mother, who replied on April 15: "seem to obey, but do as
you please. If you use proper caution he can never know it." She wrote that
her daughter would look better with less rouge, but ought to do whatever
makes her happy. If that meant defying her husband, so be it. "Stick to it
with some of your mother's spunk. . . . Sallie, be a woman." She cautioned
her to burn the letter; fortunately for us, Sallie neglected to do so.[10]

Mrs. Ward was less than candid to Bigelow's mother, who had written to
complain of her daughter's disobeying the ban on rouge. "That she should
defy her husband's wishes and commands is really so new a trait in Sallie's
character that I am wholly at a loss to understand it." It may have been due
to ill health, depression, and homesickness, she said. "I have written Sallie
my wishes and commands upon all subjects relating to herself and your
family." That was true, but those wishes and commands were not quite what
she was implying they were. She begged the Lawrences to forgive and forget
and promised that Sallie would amend her behavior, perhaps counting on
her using so small an amount of rouge that no one would know.[11]

But apparently she used too much, and Bigelow could tell. He enlisted the
aid of his father, who gave Sallie a talking-to that seems to have worked. She
wrote her father-in-law a solemn promise henceforth to obey her husband.
In less than three weeks she broke it, on May 19 at a dinner party Bigelow's
mother gave for a friend; his father was away in Washington, and maybe
Sallie thought that without him there she could get away with it, but the
rouge was noticed. The following conversation took place after the dinner
guests had departed:

SALLIE, TO MRS. LAWRENCE: "Bigelow thinks I have been *rouging* today,
but it is not so; there is no paint on my cheeks."

BIGELOW: "I have nothing to say at all. Sallie knows best; I do not accuse her of anything."

SALLIE: "To convince you, mother, that what I say is true, about half an hour ago I was in the music room with Kitty and Abbott Jr., who said, 'How red your cheeks are. I should think you had been painting,' and he wet his handkerchief with cologne, and wiped my face with it. Now if there had been paint on my cheeks it would have come off. I call Heaven to witness that there is not any *rouge* on my cheeks."[12]

Asked about it the next day, Abbott Jr. denied the story. That evening, Sallie confessed to Mrs. Lawrence that she had painted her cheeks but vowed to stop. To demonstrate her sincerity, she gave her cosmetics supply to Bigelow, which included two dozen bottles of liquid chalk and red paint.

Her inconsistency perplexed her mother, who on July 21 wrote: "One day you are the happiest creature in the world; the next, the most miserable. You are at one time neglected by your husband; the next, he is all devotion." Three times Sallie's father was about to start for Boston to bring her home, and each time received a last-minute communication from Sallie telling him not to. Her mother never got over a frank letter from Bigelow's mother with suggestions for Sallie's improvement. "The woman says your education has been neglected. She does not know what education is. Sallie, only treat her with the coldest and most distant respect," she wrote. And in other letters: "Sallie, beware of her. She is a wolf in sheep's clothing." "May God forgive them all; I fear I never can." The turmoil was taking its toll on Mr. Ward as well: "Your pa drinks almost constantly."[13]

Thomas D. Clark related the following story:

> Sallie Ward . . . became a convert of the crusading Dr. Amelia Bloomer,
> who wished, if not exactly to put pants on women, to split the skirts and
> to gather the sections tightly about the ankles. The Lawrences gave a grand
> ball in honor of their Kentucky daughter-in-law, solely, one is led to believe,
> for the purpose of keeping up appearances. Sallie was to disgrace them; she
> appeared on the ballroom floor dressed in beautiful satin bloomers with jew-
> eled Persian slippers on her feet. The Bostonians were horrified, and so frigid
> did the company become that the impetuous Southern girl lost her temper,
> yanked off her bloomers in their presence and left the room. This was the
> end. She pretended that the weather was too vigorous for her health, packed
> her baggage and came home.[14]

The source for this anecdote may have been an article by Ella Hutchison Ellwanger that appeared in the *Register of the Kentucky State Historical Society* in 1918: "For all that month in the staid city of Boston, one Dr. Bloomer (female) had lectured and tried to urge her dress reform upon the

intellectual women of the 'Hub of the Universe,' and poor, little, impulsive Sallie Ward, in a glorious imitation of the Dr.'s garb, had thought to satirize the movement." Ellwanger herself was probably inspired to this flight of fancy by a passage in Virginia Tatnall Peacock's *Famous American Belles of the Nineteenth Century*, which seems to have been first appearance in print of the story of Sallie's bloomers. It resurfaced that year in an Atlanta newspaper, and in 1916 in the Louisville *Courier-Journal*.[15]

The problem is that in 1849, when Sallie was living in Boston as Mrs. Bigelow Lawrence, bloomers did not yet exist, for Amelia Bloomer had not yet come across the idea of the costume that would bear her name. It was not until January 1851 that her attention was drawn to that style of dress, the invention of Elizabeth Smith Miller, daughter of Congressman Gerrit Smith. Bloomer read an article about Miller's idea in the *Seneca Falls Courier*, then promoted it in her own newspaper, *The Lily*, in February of that year. Only later, in the spring and summer of 1851, did bloomers become a widespread topic of discussion.[16]

Bigelow's lawyers said nothing about such an incident in their detailed if tendentious account of the Lawrences' brief marriage. But something like it may have occurred. Sallie took nearly eighty dresses and costumes with her to Boston, and the collection could have reasonably included the Zuleika outfit (with "Turkish pantalets" gathered at the ankle) that had been such a hit in Newport three years before. She may have dared wear it in Boston, hoping for similar acclaim. What Elizabeth Miller wore that inspired Amelia Bloomer in 1851 was, by the latter's account, "Turkish pantaloons" beneath a short skirt, and Turkish pantalets are what Sallie wore at that costume ball. But whatever Sallie wore in Boston could not have been the result of her having become a convert to the crusading Dr. Amelia Bloomer, who was not yet herself a convert.[17]

According to Boston native Annie Attwood Pickering, Sallie was very popular in the city: "on every occasion when Mrs. Lawrence appeared at a public entertainment she was immediately surrounded by a group of admirers, who were unstinted in their praise of her wit and charm. Rarely if ever Boston paid more homage to a young woman. Her handsome toilettes were the topic of conversation. While they were as a rule in extraordinary good taste, occasionally she appeared in gorgeous raiment that equaled the sumptuousness of an oriental princess"—another allusion to the Newport costume. It likely would have displeased Bigelow's parents, and perhaps to some degree her Boston admirers, for Pickering indicates that in their eyes it was a lapse from her normal good taste.[18]

Sallie's cousin Margaret Johnson Erwin, whose mother and Sallie's were sisters, wrote to a friend in 1862 about her oriental costume, anachronistically calling the pants bloomers but otherwise describing what she had worn at Newport in 1846: "Sallie Ward's only sensible act took place during the early days of her marriage to Timothy Bigelow Lawrence and showed that a woman in pants is sometimes more effectual than a man with or without. Her behavior was scandalous, yet, I can not help but laugh when I think of those pinch-mouthed old witch-hunters' expressions when she appeared in satin bloomers, a turban and pounds of jewels."[19]

Among latter-day historians, Isabel McLennan McMeekin, writing in 1946, deserves congratulations for getting it exactly right: "the story goes that her first escapade in the Puritan city of her adoption was to appear at a fancy-dress ball in the costume of a houri. Her in-laws were scandalized at the idea of 'a lady wearing pants.'" She rightly makes no mention of bloomers.[20]

The chilly reception Bigelow's parents gave her costume was not, however, what made her pack her bags for home. Her departure was prompted by something much more serious. The newly married pair were staying at a Nahant, Massachusetts, seashore hotel when one blustery evening Sallie declined her husband's invitation to go for a ride in an open carriage because she was too thinly dressed for the weather. So he went without her. A little later two lady friends of hers came by, accompanied by a gentleman who may have been John W. Throckmorton, given the story that came out after his death in 1881 to the effect that he was so in love with Salie that he had followed her to Boston. The three invited Sallie to go for a ride. She at first declined but changed her mind when it was pointed out to her that theirs was a closed carriage that would protect her from the cold ocean breezes. As chance would have it, Bigelow spotted her as their carriage passed his. He forced them to halt, pulled open the door and ordered Sallie out. She refused. While they were arguing, the other man slipped away unnoticed, got into Bigelow's vehicle, and drove off, forcing Bigelow to return to the hotel with Sallie and her female companions. According to a Louisville acquaintance, "The story goes when he got her to the hotel he locked her in her room, gave her a good shaking, and boxed her ears. They returned to Boston next day, when she telegraphed her father to come for her immediately. When Mr. Ward reached Boston, he found his daughter all packed and ready to return home with him. They left for Louisville the next morning," which was August 18. The story was reported in various newspapers around the country, but not until the end of October; Sallie had been home since late

August. In Louisville, two friends of Sallie's, one of them David Yandell, bought up all the local papers that ran the story in the hope of saving her reputation "but after refusing to pay for them they were brought up before the court to enforce payment, making the thing much more public than it would have been had they not interfered."[21]

Bigelow's lawyers were well aware of the bad press the episode in Nahant had caused. "It is well known that certain stories have been set on foot, representing that personal violence had been exerted towards Mrs. Lawrence by her husband. To one and all such tales we can give an unqualified denial." They explained that people might have drawn the wrong conclusion because Sallie "was accustomed, whenever opposed, no matter how trivial the cause, to shriek at the top of her voice, and we leave it to others to say how long a time would transpire in a public hotel before such a peculiarity would give rise to stories of cruelty and abuse." One could add that his deafness also surely contributed to her speaking so loudly.[22]

Sallie had told Bigelow at the time of her departure that she was merely visiting her parents and would return in early October. When he later discovered she had taken nearly eighty dresses with her it occurred to him she had been planning a longer stay than that. On August 30 her father wrote him that Sallie would never in fact return because the Boston climate was endangering her health. He proposed, however, that instead Bigelow move to Louisville. He was well aware that his son-in-law had signed an expensive three-year lease for a house on Beacon Hill, but suggested he cut all his social and professional ties and come live in Kentucky. He gave him detailed information on how much it would cost to live comfortably there, or even extravagantly if he desired, and recommended certain business prospects and investments he was sure would be profitable. Bigelow returned a polite but firm no. He made a counter proposal: since Sallie was so sensitive to the cold, bring her to New York and they would sail to the West Indies or, if she preferred, Rio de Janeiro. Ward refused on September 19. In early October, Bigelow suggested the Mediterranean. This offer was likewise declined.[23]

In Sallie's absence, Bigelow was seen in "elegant Turkish dress" at the Grand Fancy Ball held in the Ocean House in Newport, the same venue where she had famously worn Turkish trousers in 1846. His mother was with him, not in costume but wearing a ball dress. Mrs. Abbott Lawrence was doubtless a poor substitute for his dashing bride. He was beginning to suspect that Sallie have had an additional motivation for returning to Kentucky. "We will not say what motives wedded her so closely to Louisville," he and his lawyers would later suggest, "or whether . . . other reasons than

those which lie upon the surface bore her to Louisville and bound her there."
Those other motives and reasons may have included John Throckmorton.[24]

Back in Kentucky, her health was improving wonderfully. On October 7,
she wrote a letter to a Lawrence relative with news of the social scene. A
fancy ball was to be given where she would appear as a Circassian slave,
and her beautiful new dress was ready. "Louisville has been extremely gay,"
she wrote. "We have had masquerades, fancy balls, tableaux, and parties."
Her behavior was galling to at least one local observer, likening Sallie's
escapades to Malvina's: "Mrs. Ward and her family in this affair, as in that
of Mrs. Throckmorton's, have set at defiance all regard for public opinion,
appearing as much in public as usual, giving as many parties and receiving
as many visits as if nothing had occurred. Dr. Elston is as much devoted
to Sallie as he was before her marriage. He is her constant attendant at all
places of public resort." To do so, he may have had to elbow his way past
Throckmorton.[25]

A Louisville acquaintance wrote of Sallie: "Here she is, her gude [sic]
man in Boston consoling himself as best he may. She is no longer the Sallie
Ward, nor the great Mrs. Lawrence, but apparently, nobody. Some put the
blame on her side, some on his, I do not know any thing about it of my own
knowledge but am told she is cheerful & says she will never live in Boston,
does not like climate or people." The same observer would say of Sallie
three months later that she has "lots of Beaux," is "as great a Belle as ever,
entering into all kinds of folly, just as desirous to be admired as formerly."
But she was starting to lose the esteem of her peers and their mothers: "It
is not excused as once it was by the more reflecting part of the community;
she is running a mad career." Her mother had left to join her husband in
New Orleans and left Sallie and her young siblings "to the guardianship of
Malvina and her hopeful Colin, who are not very capable of taking care of
themselves." Malvina had evidently returned to her parents' good graces.[26]

Ellen Gwathmey commented: "Sallie Ward is still flourishing. Very peculiar
is it not? It seems to me if I had a husband I should like to see him now and
then at any rate, for fear I would forget I was married and fall in love with
someone else, but she seems to be very well pleased without him." In 1854
Gwathmey herself would find a husband among Sallie's rejects, Cary Fry,
the man who had wisely refused to be lured into a duel on her behalf.[27]

Susan Forbes Silliman, the wife of a Yale professor temporarily residing in
Louisville, offered a perspective untouched by Kentucky sympathy or the ties
of a long acquaintance with the Wards. She judged Sallie to be a "much to
be pitied individual" and lumped her with Malvina as a victim of maternal

folly. "Her mother has educated two pretty daughters for the world and after having been made idols of they have both married strangely. Mrs. Lawrence is really very pretty, of winning address but she rouges shockingly." From Silliman we learn that Sallie kept track of her public image: she had seen a scrapbook of Sallie's valentines and press clippings, one of which was about her triumph at the 1846 Newport Fancy Ball and another about the social splash she made by her appearance at a Kentucky watering place, possibly Graham's Springs near Harrodsburg.[28]

Sallie needed a divorce. Bigelow Lawrence unwittingly made it easier for her to obtain one. On February 28, 1850, the *Louisville Courier* posted the following notice: "WHEREAS, my wife, SALLIE W. LAWRENCE, has wilfully and without cause deserted me; this is to caution all persons against harboring or trusting her on my account, as I hold myself responsible for no debts contracted by her. T. B. LAWRENCE. Boston, Feb. 18, 1850." He was treating her as a master might a runaway apprentice. It was an outrage, and Kentuckians treated it as such. Silliman observed:

> Yesterday was an eventful day to the people here, they had so much really to talk about. The repudiation of Mrs. Sallie Lawrence by her husband . . . publishing in the newspaper "Whereas my wife . . . has left my bed and board" and notwithstanding the improprieties of her conduct which the people here are unwilling for the most part to acknowledge they are ready to tar & feather or kill Mr. Lawrence if he was within Ky. Limits. Her brother is in Europe or they say he would revenge the deed. The one-sided view we hear in this city—we must wait till we come home to tell our opinion of what we have seen during our stay of this idol of fashion whose sway seems to have made more impression than ever I knew made by any other individual.[29]

Her brother Matt was indeed abroad, at that moment in the Holy Land, writing letters on his travels for the *Louisville Journal*.

Sallie's father enlisted influential friends, including *Louisville Journal* editor George D. Prentice, to prevail upon the legislature, which was on the eve of adjourning, to pass a law making "the unnecessary publishing of one party in a newspaper for alleged abandonment a sufficient ground for decreeing a divorce." Prentice and lawyer Nathaniel Wolfe rode relays of fast horses to the state capital, three of whom died of exhaustion. They went before the lawmakers and demanded that such an insult to Kentucky womanhood be expunged, and it was done.[30]

The trial for divorce was held on May 25, before Judge William Fontaine Bullock. Bigelow Lawrence prudently did not show up to contest it. Joshua F. Bullitt, a lawyer, was present and reported to his brother that there were few

spectators because few knew it was to take place. One of Sallie's lawyers wrote out and gave to the jury the verdict he wanted them to render. At the moment when it would have been normal that the jury retire for their deliberations, one or two of them did rise but, wrote Bullitt, but the rest made them sit down, "resolved to show the world that they had given the verdict without any deliberation at all. That was a struggle between two of them as to who would have honor of signing it as foreman—since with no jury deliberations, no foreman had been chosen. The one who won had grabbed the pen while the other was still putting on his glasses.[31]

Although Lawrence did not contest the divorce, the Attorney for the Commonwealth was required by statute to object to all applications for divorce and did so on the ground that Bigelow's offense of "publishing" his wife's name for deserting him had been committed before the legislature passed the law on March 7 making it a justification for divorce. Ex post facto laws are forbidden by the US Constitution, including by states. But Judge Bullock was on firm ground in ruling that irrelevant since the Constitution alludes only to penal and property law, not to divorce. Nevertheless, the judge strangely pretended he had no proof that Bigelow's "publishing" occurred before the law was enacted on March 7: "It does not appear from the allegations of the bill or the verdict of the jury whether the publication complained of was made prior or subsequent to the passage of the act. It is dated 'Boston, February, 1850,' but it does not therefore follow that it was actually published in the journals of This State at that time." But the *Louisville Courier* did indeed print Bigelow's statement on February 28, 1850, as everyone in Louisville knew, and that was what prompted Sallie's father to ask the legislature to change the law. Equally odd is the judge's assertion that the notice bore the date "Boston, February, 1850." That is simply not true. It bore the date "Boston, Feb. *18*, 1850."[32]

Nevertheless, Sallie got her divorce and could again call herself Miss Ward. As someone wrote at the time, alluding to the role the state legislature played in smoothing the way:

> Kentucky's Statesmen, it is believed,
> Each party's feelings have regarded.
> Mr. L. has been relieved,
> And Mrs. L. re-Warded.[33]

The *New York Daily Herald* commented on the cultural differences that contributed to the breakup of the marriage in a manner that absolved both spouses of guilt. "In Boston, all is sober, discreet, staid, formal, cold and

intellectual. In Louisville, all is impulsive, wild, free, unreserved, warm and lively. Louisville runs into the frolics of balls and masquerades. One city is the home of conventionalities—the other is the domain of impulses and action. Contrasted, they are opposite in ideas of elegance, refinement, gay life, liberty and happiness."[34]

Other newspapers were not so kind. From Iowa, the *Burlington Hawkeye* wondered why the two were ever married in the first place. Miss Ward "was not exactly fitted to be the wife of a reasonable man in sober Massachusetts." In comparing Louisville with Boston, the *New York Daily Herald* managed to squeeze in an allusion to Sallie's riding her horse through the Market House: "One would dash through the market place, in a feminine way, and only stop to pay a fine of twenty dollars, and be off again—the other would walk as demurely as a quaker, compared with the other earth-quaker, and never attract extraordinary attentions."[35]

The Richmond, Virginia, *Whig* called her "a petted and spoiled beauty"; similarly, the *Brooklyn Daily Eagle* said she was "the spoiled child of foolish parents." The *Mobile Advertiser* complained that her family's money procured special treatment from the state legislature, passing a law expressly for her benefit that made "the advertising of a wife in the public prints by her husband without cause," as Bigelow Lawrence had unwisely done, grounds for divorce. This "exhibits in strong colors the influence which wealth and high connections exert on legislative bodies. Had Mrs. Lawrence been the wife of a mechanic or a common laborer, we doubt much whether a Kentucky Legislature would have passed a law for her release. Belonging to the *upper ten* makes a wide difference."[36]

On August 7, the *Louisville Courier* regaled its readers with a humorous piece at Sallie's expense. It had appeared in the *New York Herald* the week before under the title "T. B. L.'s Lament"—pretending to give expression, that is, to the inner thoughts of Timothy Bigelow Lawrence, as well as the impression that the only problem with their marriage was Sallie's use of rouge.

> The circling skies of azure-tinted hue,
> Gem'd with bright stars, entrancing to the eye,
> I do admire—'tis a beauteous blue,
> Caught from the coloring of Nature's dye;
> And Nature in her colors seldom errs—
> And I am one of Nature's worshippers;
> But Sallie—Sal!
> I do not love to see a painted gal!

The gorgeous rainbow in the firmament,
With varied beauty charms the gazer's heart;
Forming an arch of Nature's perfect whole—
A sense of pleasure doth it not impart?
And many hail it with thankful strain,
And bless its bright bow after soaking rain;
 But Sallie—Sal!
There is no rainbow in a painted gal!

The yellow grain in midsummer looks sweet;
Its golden colors beautify the earth;
It borrows not pink saucers, chalk or rouge,
But had its beauty from its very birth.
And as we see it waving in the breeze,
What thoughts arise of plenty, peace and ease!
 But Sallie—Sal!
What do we think to see a painted gal!

My own plain thoughts I'll candidly confess,
And the disclosure do not deem unkind:
I did not think that rouging was your forte—
I saw it not—for love is ever blind;
But since our bridal 'twas a cruel stroke,
And now we'll break the inauspicious yoke—
 For Sallie—Sal!
Wedlock is awful with a painted gal!

Farewell! adieu! In uppertendom phrase,
A long adieu! Our paths are different far,
In Louisville thy artist skill will make
Thee once again a bright particular star;
But 'neath New England's cold, impassive sky,
Thy rare endowments would, discouraged, die
 For Sallie—Sal!
The Boston folks abhor a painted gal![37]

Actually, not all Bostonians objected to rouging. A book published in that city in 1834 rejected the use of white paint but accepted red: "we should plead for an exception in favor of rouge, which may be rendered extremely innocent." Another Boston publication, in 1831, made the same argument: "I cannot see any shame in the most ingenuous female acknowledging that she occasionally rouges." Sallie did, however, whiten her face with liquid chalk, though not the dangerous lead-based white paint against which both books warn their readers.[38]

In Sallie's grand- and great-grandmothers' time, rouging was a widespread practice. The strictures against it that she so blithely ignored were a recent, and peculiarly American, phenomenon. In the eighteenth century, Nancy Rexford observes, "In Europe, elaborate powdered hairstyles appeared above faces enameled with dangerous white lead paints and cheeks flaming with rouge. This extreme of artificiality was probably rare in America, but rouge, pearl powder, and patches were known." With the American Revolution came a rejection of all things English, and Benjamin Franklin even gave up his wig, with the result that "Obvious rouging of the cheeks ended soon after 1800," although less-obvious colorations continued. As an author on the subject observed in 1874, if a woman "must resort to artificial beauty, let her be artistic about it, and not lay on paint as one would furniture polish, to be rubbed in with rags."[39]

There was an important distinction between painting and rouging. Two stories appearing in *Godey's Lady's Book* in the 1840s suggest that the latter was still done. In one, a Miss Glapwell recommends that an ill-favored young woman "touch the tops of her cheeks with a little something from a pink saucer." In the other, a character laments, "I don't know when I saw so plain a young woman. . . . It is a great pity, poor thing, she rouges so badly. If a woman, particularly a young woman, must rouge, I think she owes it to society to put it on decently." As Nathaniel Parker observed in 1851, in a dispute with Horace Greeley, who denounced all cosmetics, "The only condemnation which can justly be given to improvements of the complexion . . . is the doing it so clumsily that it creates no illusion. . . . Ladies *do* rouge and blanch, take our word for it, dear Greeley."[40]

To celebrate her newly regained eligibility on the marriage market, Sallie's mother threw a party. The Grand Fancy Ball given on September 25, 1850, was almost as extravagant as her wedding. The Wards' three parlors were filled with the music of quadrilles, polkas, and waltzes provided by the James R. Cunningham Band, made up of Black musicians (unbeknown to the Wards, Cunningham, a free Black citizen of Louisville, was instrumental in assisting fugitives to escape to Indiana). By 11:00 p.m. the guests had arrived. The reporter for the *Louisville Courier* listed more than a hundred names, but those were only the ones he could recall later, and readily admitted there were probably many more. Most of the guests came costumed as historical or mythological figures: Rebecca, Rowena, Titania, Juliet, Dante's Beatrice, Bellini's Norma, Martha Washington, Madame de Pompadour, the Princesse de Lamballe, and Little Red Riding Hood, among others.[41]

Sallie's siblings were in costume as well. Matt, just back from Greece, was an Athenian prince; Robert, a page; William, Don Juan; Victor, a pirate;

Emily, an angel; Lillie, a sylphide; Malvina, Madame de Maintenon, who secretly married Louis XIV—perhaps an allusion to Malvina's elopement with Colin Throckmorton. Colin was a Spanish Don; so too his brother John, who, now that Sallie was again unmarried, may have wished to imitate his brother in more than costume by also wedding a Ward daughter.[42]

It was Sallie, of course, who attracted the most attention. Before supper, served at 1:00 a.m. in the conservatory, she was "Nourmahal, the Light of the Harem," from Thomas Moore's *Lalla Rookh*, wearing a diamond-studded bodice with silver embroidery and a pink satin skirt over gold-spangled satin trousers—a variation on what she had worn in Newport and Boston. She reappeared after supper as "Nourmahal at the Feast of Roses" from the same poem in a dress of white illusion dotted with silver, silvered veil, a wreath of white roses, white silk boots and silver anklets, bearing the lute to whose accompaniment her character sings a song to win back her lover. Sallie (or maybe just *Lalla Rookh*) had a following among some of the other female guests, for one of them was dressed as Namouna, the sorceress in Moore's poem who advises Nourmahal to sing the song; another was "a Turkish Lady" wearing a skirt-trouser combination (Bloomers *avant la lettre* yet again); another was Lalla Rookh herself, the Indian princess in the frame narrative who is told Nourmahal's story.[43]

Newspapers from New York, South Carolina, Maryland, Pennsylvania, Massachusetts, and Vermont quoted at length and approvingly from the account in the *Louisville Courier* of Sallie's pre- and postsupper outfits. But the Richmond, Virginia, *Enquirer* took a different tack: "Taking into consideration the unfavorable notoriety given to this lady in the late controversy about 'paint,' we have rarely read any thing with more disgust. . . . She has shown herself to be silly and foolish—but what must be said of her mother, who encourages her to make herself a public spectacle?"[44]

Three

A WHIRLWIND COURTSHIP

If Sallie been able to tone down her use of rouge and stay married to her husband, she could have attended a costume ball in a more impressive setting than her parents' mansion. Abbott Lawrence having been named ambassador to the United Kingdom, presenting his credentials in November 1849, and Bigelow later joining him as diplomatic attaché, the Lawrences attended a costume ball at Buckingham Palace on June 13, 1851. Queen Victoria and Prince Albert were there to bid welcome. Abbott, in blue velvet and gold lace, was John Winthrop; as Lord Baltimore, his son was bedecked in a doublet of crimson velvet with blue and white satin trimmings. The *Detroit Free Press* remarked it was too bad Bigelow did not have his former wife with him to supervise his costuming, for which she had a superior talent.[1]

If Sallie couldn't shine at Buckingham Palace, she at least achieved some measure of national fame thanks to the marketing of Sallie Ward Chewing Tobacco, which first appeared in late 1850 in Lynchburg, Virginia, then in Louisville, Nashville, Vicksburg, Pittsburgh, and elsewhere. It was soon to be joined by Sallie Ward Candy, which prompted a Missouri newspaper to observe that "children are said to cry for the latter, and young men for the former." Louisville editor George D. Prentice found the tobacco quite

tasty: "When a young man is pressing with his lips a piece of Sallie Ward tobacco, what sweet and beautiful and bewitching fancies and dreams must go floating through his brain." Sallie was no stranger to the weed; a Louisville acquaintance in 1845 said she smoked cigars and influenced other women to do the same. Chewing it, of course, was something else again.[2]

Despite her triumph at her mother's masked ball, Sallie was a divorcee, and it would take a suitor with the courage and financial independence to defy social and religious norms and make her his bride. Robert Pearson Hunt was just such a man. He was the last of twelve children of Kentucky's first millionaire, John Wesley Hunt (1773–1849), who had come to Lexington in 1795 from New Jersey to begin a mercantile career that expanded to banking and breeding horses.[3]

Hunt's name did not appear in the list of guests at the September 1850 ball, which would suggest he and Sallie were not yet acquainted. An unnamed "intimate friend" of Sallie's recalled years later that his family was against the match, because "Divorces were unusual in that day, no matter for what cause, and for a divorced person to marry again was regarded with horror. Indeed, I have heard an old Virginia gentleman say he had never seen a divorced person until he saw Sallie Ward, and then he was twenty-two years old, and he regarded her with the curiosity that he would have felt when first meeting any other strange thing."[4]

Divorce may have been unmentionable in Virginia and Kentucky, but when sociologist Harriet Martineau came from England to tour the United States in the mid-1830s "she was struck by the relative ease of divorce in America." In England only the rich could engage in it. In Massachusetts, she was glad to see, cruelty broadly defined was grounds for divorce. In North Carolina it was accessible even to women of modest means, according to historian Glenda Riley, who cites the instance of a wife divorcing her husband because he was a gambler and thus posed a moral and monetary danger to her and her children.[5]

Born in 1820, Hunt had been reared in Lexington, in the beautiful house originally known as Hopemont but after the Civil War as the Hunt-Morgan House, in recognition of his nephew, Brigadier General John Hunt Morgan, the Confederate raider. Growing up, Robert suffered the solicitude of a strict mother whose German background was perhaps a determining factor in her mania for neatness. When he was ten or eleven and she was on a visit to St. Louis, she sent instructions for his care: "I hope Robert is a good boy and that he comes home as soon as school is out and employs himself at home. He must go clean and neat. Take care of his Leghorn Hat." She allowed him to wear the plaited straw hat only when he went to church or

on special occasions, not when he was playing on the nearby Transylvania lawn. She gave orders for him to always keep the hat upstairs and put it away carefully. But she added, with a more maternal touch: "Poor fellow. He complains of being lonesome." The lonesome boy grew up to marry a woman very unlike his mother.[6]

He was educated at Princeton and at the medical school of Transylvania University in Lexington, after which he traveled to France and was one of the hundreds of young Americans who sought better medical training there than they could find at home. For one thing, Paris had cadavers in abundance and no compunction about using them; for another, French medicine was the most advanced in the world. Students followed eminent doctors as they made their rounds at Hôtel-Dieu and other charity hospitals, attended lectures, and watched operations and public dissections.[7]

After his return, the Mexican-American War broke out, and he enlisted on June 9, 1846, joining the Second Regiment of the Kentucky Foot Volunteers. He was not a member of the Louisville Guard or the Louisville Legion, to whom young Sallie had presented a flag and a banner in late May. His appointment as a military surgeon was approved by the US Congress on July 14, 1846. He became an aide-de-camp to General William Orlando Butler of Kentucky, who wrote in his official report on the Battle of Monterey (September 21–24, 1846): "Surgeon R. P. Hunt, my volunteer aide-de-camp . . . evinced great coolness, and conveyed promptly the orders confided to him." As a volunteer aide-de-camp, he was "on his own resources," and, as the son of millionaire John Wesley Hunt, he could afford it. Butler was wounded at Monterey and returned to the United States but went back to Mexico in September 1847. Hunt's term of enlistment had expired but he again offered his services to the general, who accepted, and together they went back to the war.[8]

When he returned to civilian life, Dr. Hunt did not have to solicit patients, for, "possessing large wealth," a friend later said, "he was never, we believe, a candidate for medical practice. He devoted much time to literature, to solid reading, and to the pleasures of friendship. He was one of the most delightful and fascinating of companions. . . . He was a gentleman by nature and education polished to the highest degree of refinement and elegance by constant intercourse with the best portion of the world." He had blue eyes and chestnut hair and stood at six feet two. He owned a 186-acre estate on the Ohio River eight miles down from Louisville. Fifty acres were under cultivation, the rest was wooded. It contained a house, slave cabins, stables, and smoke and ice houses. He had been instrumental in organizing his neighbors to build a plank road between it and Louisville.[9]

The aforementioned, unnamed "intimate friend" of Sallie's wrote, "It was at Drennon Springs. a famous Kentucky watering-place before the war, that Sally Ward captured her second husband." It was said that he "was very much prejudiced against her and made a brave fight to withstand her charms, but in vain. He was a charming, elegant gentleman and the idol of his family. A prominent society woman" found him "one of the courtliest men she had ever seen." Drennon Springs was located in Henry County, halfway between Louisville and Cincinnati. Known for its mineral waters, it was popular with Louisville residents wishing to escape the summer dust and heat. They could board a train to nearby Eminence, or the Blue Wing, a riverboat that steamed up the Ohio, and then up the Kentucky River to within two miles of the resort.

Cholera was widespread in Kentucky in the summer of 1849, but at first Drennon Springs was spared. The owners claimed the grounds were so healthful that it could serve as a safe harbor from the plague. The resort appeared not to have had a single case of the disease that year, but in July 1850, just as it was about to open for the summer season, several were taken ill, and suddenly all who could leave did so. Drennon Springs came back from the dead under new management in 1851, presided over by the renowned Aris Throckmorton of Louisville's Galt House. The *Louisville Democrat* predicted that the genial expertise of that perfect host "will bring back the thousands of delighted guests who were wont to loiter through the long piazzas [verandas], ramble beneath the cool umbrage, dance in the brilliant hall, or enjoy themselves at the groaning board. Again the voices of enjoyment and hilarity will be heard resounding from hill and glade."[10]

Given that Drennon Springs was temporarily closed in 1850, it had to have been in the summer of 1851 that Sallie persuaded Dr. Hunt to overcome his misgivings. One can imagine them taking long walks together in the cool glades, dancing in the brilliant hall, and dining at the groaning board. They no doubt attended the grand masked ball held Friday, August 15, along with the other several hundred guests. The season closed at the end of the month, to make way for the Western Military Institute, with which it shared the grounds and some buildings and whose school year began September 8.[11]

A correspondent for a Louisville newspaper visited the resort in July and apart from praising the large and airy rooms and the fine dining and drinking was struck by the sight of the tattered flag that the Second Regiment of Kentucky Volunteers had carried into battle at Buena Vista. That was Robert Hunt's regiment, and the flag beneath which he had served. With other flags from the Mexican-American War it had been put on display for the military school's commencement on June 26. The writer encouraged his readers to

come to Drennon Springs to see it: "Pierced with balls, rent with bayonets, each gash seemed eloquent with the proud but painful fate of McKee, Clay, and their gallant comrades. It is well worth a trip to Drennon to behold." It is likely that Robert and Sallie did so, and then she would have seen, in addition, the very banner she presented to the Louisville Legion on May 25, 1846, in that inspired publicity-grabbing act that brought her fame and glory. It was to the right of the stage, while that of Robert's regiment was to the left.[12]

That banner made her famous throughout the American army and may have come to Robert's notice. She was, for instance, toasted on the banks of the Rio Grande on July 4, 1846, with these words: "These silken folds above us give her name to the breeze in a language which I but interpret. But for her our Legion had been bannerless, the Guard without a precious adornment. May she yet enjoy the pleasure of hearing that her beautiful gifts have waved over battle fields won by those to whom she had committed them." Facing each other across the stage in that room at Drennon Springs, those two flags may have appeared to Sallie and Robert symbolic of a union they were conspiring to celebrate in a few weeks' time.[13]

Although Robert's family was opposed to his marrying a divorcee, both of his parents were deceased, so there was no one to prevent it from taking place. He did not invite any of his family to attend the small, quiet ceremony held at the Wards' home on October 1, 1851, knowing they thought he was committing an act which would send his soul to hell. But he said he would rather go to hell with Sallie Ward than to heaven without her.[14]

Four

TRAVELS

The Hunts spent their honeymoon in Europe, but they did not go alone. Sallie's brother Matt went along. A New York newspaper took note of their May 15, 1852, departure, noting that among the passengers "was Dr. Hunt, of Kentucky, and his celebrated lady, Mrs. Hunt, who is better known as the beautiful Miss Sallie Ward, of Louisville. She is accompanied, also, by her brother, Mr. Ward, who recently travelled over Europe and the Holy Land, and published a very interesting *brochure* of his journeyings. Mrs. Hunt is much improved since her unfortunate *séjour* in Boston. She is now one of the most magnificent and most beautiful women that ever Kentucky gave to the world, and no mistake."[1]

Her brother's "brochure" was actually a book, *Letters from Three Continents*, published in January 1851 to favorable reviews. It recounted his journey from June 1849 to September 1850 to London, Paris, Germany, Vienna, Constantinople, Egypt, and the Holy Land. The New Orleans paper, the *Daily Delta*, wrote: "The chief charm of these letters is their high American tone, their invincible spirit of Democracy" and the author's refusal "to be seduced and deluded by the gloss and tinsel" of the Old World. According to the *Boston Post*, the book was "entertaining, possessing an originality of

thought, a quaintness of expression, and delicate shade of humor and satire that imparts a constant freshness to the narrative." The *New York Daily Herald* opined: "Mr. Ward, we believe, was educated at Harvard College, and has come from that popular seat of learning improved and not made effeminate in character by the associations of the place. He has retained his own original spirit of thinking and expression, and has none of that mock sentimentality and those philosophical spasms which belong to the Carlyle and Emerson transcendental cliques." He was, most agreed, refreshingly American.[2]

As a seasoned traveler, Matt may have offered to serve as a guide to his sister and brother-in-law. One of the few details of what Sallie and Robert saw came from her reminiscence many years later of having attended a London exhibition of rare Honiton lace. The Hunts returned on August 18, Matt on September 18.[3]

Matt's Harvard studies had begun in the fall of 1843. While there he could hardly have missed meeting his sister's future husband, as T. Bigelow Lawrence was attending the college one year ahead of him and both were members of the same club, the Institute of 1770, in which members gave speeches for one another's critiques. Unlike Lawrence, Ward did not graduate but left after his sophomore year, living the high life in the summer of 1846 at east coast cities and spas.[4]

But in the fall of that year, he abandoned those glittering luxuries for a solitary existence on a plantation in Phillips County, Arkansas, on the Mississippi River. The Wards and Johnsons had extensive landholdings in that area. He lived in a log cabin, worked his slaves, raised cotton, and hunted bear and ducks. "How strangely my present life of quiet happiness and rural sports is contrasted with the gay scenes amidst which I moved" the preceding summer, he wrote in November. The cabin "is far more dear to me . . . than any brilliant saloon to which beauty, light, and music lend their enchantment." Far from his native Kentucky, he seemed to want to carve out a new identity as a backwoods Arkansan.[5]

He felt "an indescribable charm in feeling wholly alone, lost in the delightful mazes of reverie, which none can know but him who has too deeply drunk, and been too early sated by the feverish joys the world can give." He wasn't lonely, he wrote, because he had his books, his gun, his dogs, and his horse. He loved to ride through his fields, gaze at the cotton bolls, and look ahead to when they would be packed in bales for the New Orleans market. He loved the life of a planter, its freedom and independence, and especially liked having his enslaved workers look to him to provide for their needs, "human beings whose comfort, health and happiness are totally dependent

upon [my] will." He basked in what he thought was their love; he was their guardian angel and they idolized him. It was better than having a family: "no man who has ever witnessed the blind devotion of a slave in the South to a kind master can assert that there is in the domestic circle a relation productive of more real pleasure than that existing between master and servant."[6]

He had partaken of many pleasures in his life, the excitement of betting on a winning horse, the deep absorption of games of chance, the intoxication of dancing with beautiful women. But he needed a new sensation, and in Arkansas found it in hunting for bear. "Believe me, in comparison to the thrilling interest and almost painful excitement of this noble exercise, this manly chase, all former pleasures seem 'as tedious as a twice-told tale.'" It was a bright November morning, warm for the season, the blackbirds gaily chirping and a wren singing as if spring had come again. He and his neighbors saddled up and galloped to the woods behind the plantation, sending the dogs on ahead. Soon they saw in the distance an inoffensive bear leisurely viewing their approach. He scampered away when threatened by the barking and nipping dogs and climbed a tree. Seeing the men and hearing a gunshot aimed in his direction, the bear backed down the tree. Attacked on all sides by the dogs, he fought back, killing many by blows from his paw, shaking them off as best he could. A companion shot and missed and told Ward to "shoot quick or we are ruined." For the bear was killing all those fine hunting dogs. Ward needed a percussion cap, which his friend offered to provide but when Matt handed him the gun the friend shot again at the bear, this time wounding him, though not seriously. "Reload quick for God's sake," he said. At that moment Ward remembered that he had a rifle-barreled pistol in his belt, and with it rushed up close to the animal and shot it in the heart. His companion finished it off with a knife. The hunters conferred and decided to award Matt the hide for having contributed the most to the bear's demise. "Never was a hero of old so proud of the skin of a captured dragon, the guardian of some enchanted castle, as I of this first trophy of my success in sylvan sports. My knife and hatchet were withdrawn from my belt, and soon were they dyed in the blood of my first bear as I assisted in butchering him."[7]

Two letters dated from New Orleans, March 1847, reveal that he had not entirely given up city life and its amusements. In one, he reports that he attended the Mardi Gras festivities and took in several important cultural events. Hermine Blangy, a dancer from the Paris Opera, performed *Giselle* at the St. Charles Theater to great acclaim; he was smitten with "the witchery of her grace." He was less impressed with the thundering pianist Leopold

de Meyer, whom he thought played too loudly, and Henri Herz, who had a gentler touch but did not thrill him as he seemed to have thrilled others. But he was enthused by the violinist Camillo Sivori and thought him better than Ole Bull and Henri Vieuxtemps. He commented on several actors, but was moved to tears by only one, Henry Placide.[8]

The second letter reveals a distaste for opera. "Often during the evening I lounge into the French theatre, not that I experience . . . the ecstatic delight bordering on madness which many profess to enjoy, but merely because everybody goes there and I follow the crowd." The Théâtre d'Orléans opened in 1815 and thrived until it succumbed to fire in 1859. Ward did not enjoy five hours of "deep bellowing and loud screeching," occasionally broken by "really exquisite bursts of melody," but he loved the visual splendor of the building's interior and the magnificence of its stage productions, not to mention the dark-eyed belles who graced the boxes and flirted with their fans.[9]

"Who but a bear-hunter from Rackansack"—Arkansas, in the parlance of the time—"would dare to be so heathenish . . . as boldly to assert that to him this exquisite musical treat was a decided infliction, though hundreds of *numskulls,* whose musical tastes are about as highly cultivated as a bear's knowledge of a minuet, nightly roll their eyes with pretended rapture for fear of being thought to be from the interior." He of course was from the interior, and proud of it. Opera is artificial and cannot move the heart as can the simple ballads of Thomas Moore (he seemed to think Moore wrote the melodies, which he didn't) through the power of association, through the memory of some dear loved one having sung them in some distant past. Opera, like oysters, is an acquired taste. But even among those who claim to have acquired it, he saw in the audience that some were dozing, and even snoring. "When I witnessed these wonderful effects of music I confess I felt ashamed of my own insensibility, but concluded mentally that *mesmerism* was nothing to the opera."[10]

A year later, he seemed less enamored with his plantation. He walked the shores of his "lonely lake," recalling that it had been spring when he had last walked there, and that what little happiness he felt at that time was actually due to the prospect of a coming summer visit to Kentucky. Now he was sad to think that the splendors of autumn were but the sign of decay and death. He visited his duck blind, overlooking the spot where many of the birds had assembled to eat the corn he had set out as bait, and contributed his share to the death around him by slaying as many as his shotgun could manage. "By heavens, it was a richly exhilarating sight" to see the kicking and flapping of the wounded as the rest flew away. His hunting dog brought back seven and laid them at his feet. His bag and pockets filled with plump

fowl, he walked home with his dog, enthused by his prowess and looking forward to a tasty duck dinner.[11]

This account was one of several published in the *Louisville Journal*. Editor George D. Prentice prefaced it with praise for Ward's growing fame as a public speaker among the Democrats of Arkansas. When the state convention met at Little Rock on January 5, 1848, and an angry discussion threatened to split the party, "the young orator, scarcely more than a mere boy in his appearance, arose, and by his honeyed accents, his glowing rhetoric" was able to calm the waters and lead the convention to a harmonious conclusion. He was chosen to be a delegate to the national party convention in Baltimore, to be held in May 1848.[12]

In December of that year, as we know, he would be a groomsman at his sister's wedding to T. Bigelow Lawrence. The following year, in February, March, and May 1849, he again wrote for the *Louisville Journal* about Arkansas and New Orleans but now in the form of fiction, six installments from what appears to have been a novel in progress. Once more we hear of a bear hunt, this time told with humor at the expense of a corpulent New Englander named Catchpenny, who proved unable to cope with the demands of the Arkansas wilderness. After running from his first bear, he shoots a second after it is already dead. In scenes set in New Orleans Catchpenny and another character make fools of themselves at a restaurant and a hotel. Ward was attempting to imitate the southwestern humor tradition of Augustus Baldwin Longstreet (1790–1870) and Thomas Bangs Thorpe (1815–1875), whose tales and sketches were set in Arkansas, Tennessee, and neighboring states and in which bear hunts were a recurring theme.

It appears that Matt did not prolong this experiment in fiction. Instead, he became a travel writer, garnering some success with 1851's *Letters from Three Continents*. Abroad from June 1849 to September 1850, he missed the excitement occasioned by Sallie's Boston battles and ensuing divorce. After his 1852 trip to England with the Hunts, he wrote a sequel, *English Items*, a mean-spirited attack on the English character, which was much less well received.[13]

Some time after her return from that voyage, Sallie gave birth to a child that subsequently died. All we know is what is inscribed on the gravestone in Louisville's Cave Hill Cemetery: "Robert W. Hunt, aged 10 months." Assuming he was not conceived until after the wedding, October 1, 1851, and that she was not too far advanced in pregnancy to travel when she embarked on May 15, 1852, the boy could not have been born until several months after their return. They came back a month earlier than Matt did, and the reason may have been that by mid-August she was too far along to continue

and so they cut short a trip originally scheduled to end when Matt's did, a month later. She gave birth to a second child, Emily, on December 29, 1853, and therefore had been pregnant again since late February or early March of that year. The Hunts had left on a second transatlantic trip June 11, 1853. Sallie would have been about three and a half months pregnant then, as she may well have been with the first child when she sailed the year before. In that case, Robert W. Hunt would have been born around November 1852, and his ten months of life would have ended around September 1853.

On the eighth of that month Sallie's husband put his farm on the market: "For Sale: My place on the Ohio river, about 8 miles below Louisville. It contains 186 acres, of which about 50 are under cultivation, the remainder heavily wooded. The improvements, consisting of dwelling, slaves' quarters, smoke and ice houses, and stabling, are all new and of the most desirable kind. The Louisville and Cane Run Plank Road terminates within a quarter of a mile of the property. Terms moderate." Perhaps he had originally envisioned settling there with Sallie, but when their son was born decided it was no place to raise a child. It had none of the advantages of urban life that their combined wealth could easily afford. Sallie indeed may have never wanted to be a plantation wife, with enslaved workers, stables, crops to raise, and hogs to slaughter.[14]

Business must have been booming for Dr. Hunt's father-in-law at this time, for he was able to invest in a luxurious steamboat that would bear his name. The *Robert J. Ward* was built across the river from Louisville in New Albany, Indiana, between August 1852 and January 1853. It was three hundred feet in length, had six boilers, a water wheel forty-two feet in diameter, and could berth 140 passengers in its luxurious staterooms. The doors to the ladies' cabin were decorated with stained-glass windows of Gothic design, and the floor had a velvet carpet depicting landscapes. All the curtains, linens, and table cloths were of the highest quality. The boat took six days to reach New Orleans from Louisville and completed two round trips a month.[15]

A floating palace, the *Robert J. Ward* was pleasing not only to the eye but also to the tongue. The bill of fare for Tuesday, May 3, 1853, offered oxtail soup, redfish in oyster sauce, sheepshead in egg sauce, and broiled trout, ham, turkey, tongue, corned beef, mutton in caper sauce, escalloped chicken in port wine sauce, knuckle of veal in Harvey sauce, fricasseed calves' feet in lemon sauce, turkey wings in celery sauce, veal with peas, macaroni à la Neapolitaine, broiled pompano, stuffed crabs, roast beef and pork. Among the desserts were lemon, blackberry, plum, currant, cranberry, green apple, and pumpkin pies; gooseberry and damson tarts; pound and

tapioca pudding; lemon and calf's-foot jelly; Charlotte Russe; orange cream, cream Robinson, sponge and fruit cake; raspberry and blackberry puffs, almond custard, and lemon ice cream; oranges, bananas, apples, prunes, raisins, almonds, figs, and English walnuts. Among the wines were clarets and sauternes.[16]

That list of culinary delights came from a passenger who remembered boarding the *Robert J. Ward* at 3:00 a.m. and finding the Texas (the crew's quarters) lit up bright as day. He went up to see what was going on and "saw an assemblage of all the most noted gamblers in the South and West." One of them had just returned from California with $300,000 in gold (about nine million dollars in today's money) and the others were following him in hopes of winning some of it from him. These were professional gamblers, who knew what they were doing. But it was the captain's responsibility to prevent the abuse of amateurs. Near Helena, Arkansas, a young Mississippian, honest to a fault, was speedily taken in by skillful shuffling, and swindled out of two or three hundred dollars. Bystanders had tried in vain to warn him. Then the *Ward*'s estimable Captain Silas F. Miller came up and slapped one of the card sharps, raked down the stakes, made them give back their ill-gotten gains, confined them below, and put them off at the next wood yard.[17]

On May 21, 1853, Matt married eighteen-year-old Anna Key, the daughter of riverboat captain Peyton A. Key, whose side-wheeler *Belle Key* was considered the fastest boat of its time.[18]

When her father was overseeing the completion of his new steamboat in early 1853, Sallie, in preparation for her upcoming trip to England, asked John J. Crittenden to help smooth the way for her to be presented at court. A guest at her wedding to Bigelow Lawrence, Crittenden had long been a family friend. He was now the Attorney General of the United States. He wrote future president James Buchanan, soon to sail for England as ambassador to the United Kingdom, about Sallie's request, and he replied: "If she be the lady who was Mrs. Lawrence, she would be a fair and a distinguished representative of our American ladies at a foreign Court. I have always been on her side, since the time I made her acquaintance as a dashing and fascinating belle."[19]

On the transatlantic crossing, Sallie crossed paths, probably without knowing it, with the woman who would replace her in Bigelow Lawrence's affections, the beautiful Elizabeth Chapman of Doylestown, Pennsylvania. Chapman, whom Bigelow would wed the following year, happened to occupy the stateroom next to Sallie's. But because Sallie almost never left hers during the entire voyage, Chapman got only a brief glimpse of her face,

which she considered "neither handsome nor lady-like." Sallie was three or four months pregnant, perhaps suffering from morning sickness.[20]

But once in England, she recovered sufficiently to be presented at court. Bigelow Lawrence, now an attaché at the American Embassy, had heard of the charming American lady whose extraordinary beauty was bewitching everyone in London and eagerly sought an introduction to this enchantress, whom he did not recognize by her new married name and was astonished to be presented to his former wife.[21]

Five

MURDER IN THE SCHOOLROOM

On November 2, 1853, William H. Butler, a teacher at a Louisville private school, was fatally wounded in front of his students. The bullet was fired from a small pocket pistol bought that morning at Dickson and Gilmore's gun store. The purchaser was the noted Arkansas duck hunter, traveler, and rising author Matt Ward.

The day before, thirteen-year-old William Ward had come home from school complaining that he had been unjustly punished by his teacher. It was not the first time. Six months previously, he had been chastised for misbehavior by Butler's associate Minard Sturgus, who took him by the collar, shook him, and gave him a slap. William's mother demanded an accounting on that occasion, asking Sturgus "what I meant by treating a *Ward* in that manner." After he told her the full story, she regained her composure and said she was sorry for her outburst. When she hinted at the possibility of withdrawing William and his twin brother Victor from school, Sturgus said he and Butler would be happy if she did, as it would save them the trouble of expelling the boys. She asked to be told if they misbehaved again and promised to address it. Sturgus replied that there were some offenses that

47

had to be dealt with on the spot for the sake of class discipline. She did not object.[1]

Matt was present at this discussion. Butler and he were acquainted, for from 1848 to 1850 the teacher had served as tutor to the younger children in the Ward household. Butler now introduced him to Sturgus, whom Matt then said he had intended to assault for punishing his little brother. Matt changed his mind when he saw that Sturgus was older than he thought. Sturgus was only eight years his senior but evidently that was enough to make a difference to Matt.[2]

William had been caught lying in a previous school and punished. Matt showed up there the next day and tried to lure the teacher outside so that he could assault him. Believing Ward may have been armed, the teacher stayed inside. He tried to shut the door but couldn't at first because Matt was holding it open with his foot. After he finally got it closed Matt kicked it two or three times and shouted out menacing curses before finally leaving.[3]

Matt's threats were directed not only at educators. An enslaved servant of his father's had "annoyed" a grocer's family who lived one block from the Ward mansion. The grocer told him to stay away, but he kept returning. Finally, the grocer locked him in a room and went to get a policeman. Matt came with a shotgun and rescued the servant, threatening to shoot whoever dared to interfere. After all, he was Ward property.[4]

Emily and Robert J. Ward Sr., together with their son Robert Jr., had not yet returned from a trip to Cincinnati the day William was punished, so it was to Matt that he complained: "Mr. Butler whipped me and called me a liar. I don't care so much about the whipping, but I'd rather die than have the school believe I lied." But that was a lie, because he was perfectly aware that the other schoolboys not only believed but knew he was a liar, because they had seen him eat chestnuts during class and then deny it to Butler. He had done the same thing a month earlier. On that occasion as well, he was caught out by other students in the same lie about eating chestnuts during class time. Butler warned him that if he lied again he would receive a whipping, which is why the teacher had felt obliged to carry out the punishment.

In his tearful account to Matt, which Matt relayed to their parents, William had told two other untruths. He claimed that the whipping had been severe, which the other students denied, and that he was punished for eating chestnuts but the boy "who ate the chestnuts was not whipped at all." But there were two boys who ate chestnuts besides William: Algernon D. Fisher, who was whipped, and Henry C. Johnston, who was not because he had only recently entered the school and had not been aware of the rule against eating during class time.[5]

As for the whipping, Butler had taken a leather strap to the back of William's legs, but the blows were light. Another pupil who had been punished said the whipping was just like the one he had received and he did not consider it severe. A third student said that most of the six blows struck William's boots and not his leg, and that he did not appear hurt, merely insulted.[6]

Early the next day after William's classroom punishment, Matt took it upon himself to avenge the family honor. He walked a half mile to 52 Third Street and at 9:00 a.m. entered the store of Dickson and Gilmore, importers and dealers in guns and hunting supplies. He looked at several small pistols and chose the smallest, a self-cocking model with a two-and-a-half-inch barrel that could put a bullet through an inch-thick board at a distance of two feet. He insisted Gilmore load it for him and purchased no ammunition except what Gilmore loaded into the gun. As he was about to leave the store, he decided to buy a second one just like it and required it to be loaded too. He put them in his pants pockets, one on either side, and exited the store.

A witness happened to see him pass by, near the post office: "His appearance was unusual," she said. "His gait was more firm than usual, and excited. . . . He had one hand in his pocket, the other to his side." The hand in the pocket was holding one of the pistols. The gun store was on the west side of Third Street, just south of Main. The post office, recently built, was on the west side of Third between Green (now Liberty) and Walnut. He may, as she thought, have been walking toward Chestnut and therefore to the school for his confrontation with Butler. However, he seems to have changed his mind and turned left on Walnut to see if his parents had returned from Cincinnati. Or perhaps he intended to go home first in any case before heading to the school, which was on Chestnut, one block south of Walnut.[7]

When Matt entered the house, he found that his parents had indeed returned. Mrs. Ward had already seen William and asked him why he was not in school and why he looked so sad: "his eyes filled with tears and he said brother Matt would tell me," she recalled. Matt told her about the whipping and his brother's being called a liar, and said he was planning to ask Butler to apologize for his outrageous conduct.[8]

As head of the family, Robert Ward Sr. was prepared to talk to Butler, but Matt persuaded him to let him go instead. Mrs. Ward urged Robert Jr. to go with Matt. She must have known that Robert Jr. would be armed with the Bowie knife he always had with him and later explained that she thought Matt needed his protection should there be trouble. "Grab your hat and let's go," Matt said to Robert, and William went with them. On the

way Matt told Robert to let him handle Butler and not to intervene unless Sturgus did.[9]

It was a short walk to the school. From the Ward mansion on the northeast corner of Second and Walnut they went one block south down Second to Chestnut, then turned right. The school occupied a one-story brick cottage on the north side of Chestnut. The front door opened onto a hallway on either side of which was a recitation room which served both as a teacher's study and a place where small classes and review sessions were held. Sturgus's was on the left and Butler's on the right. The doors to these rooms were within the large classroom, where about forty students were sitting with their backs to the entrance.[10]

The three Wards opened the front gate at 10:00 a.m. and came up the walk toward the steps to the front door. Student Edward W. Knight saw them through the window of Sturgus's office. He suspected there would be trouble, because he had heard Victor Ward say the day before that "the matter was not over yet." Victor was not in school now; at 9:30 a servant from the Wards had come to get him and his books. Their father had apparently decided to take the two out of school, whatever the outcome of Matt's demand for an apology.[11]

William entered the schoolroom first and went to his seat. Matt asked for Butler, and a student went to get him. Butler politely wished Matt good morning, but Matt's response was stiff and cold. He said he had a little matter to settle. Butler invited him into his office to discuss it, but Matt refused, and asked, "Who is more to blame, the little contemptible puppy"—another student—"who begged chestnuts from my brother and then lied about it, or my brother, who gave him the nuts?" Butler once more asked him to come into his office and let him explain it to his satisfaction, but Matt refused, saying the classroom was the proper place for an answer and if he could not get it there, in front of the other students, he did not want it. Then he asked Butler why he had called his little brother a liar. He was gesticulating with his left hand; his right hand stayed in his pocket, holding the gun. Butler replied that would not answer unless he was allowed to explain. Matt began to speak very loudly, calling him a scoundrel and a damned liar. Butler took one step forward and placed his right hand on Matt's shoulder. Immediately Matt drew the pistol from his right pocket and pressed it against Butler's chest. He fired and Butler fell. Matt and Robert stood there until the teacher struggled to get up and staggered into Sturgus's office, saying "I am killed! May God forgive me! My poor wife and child!"[12]

Robert turned to the schoolboys in their seats and waved his Bowie knife around, warning them to stay where they were. Sturgus ventured out of his

office. Robert pointed the knife at him, saying, "Come on. I'm ready." Sturgus went back to his office, climbed out the window and went to get a doctor.[13]

Matt, William, and Robert Jr. headed home. Matt remembered he had left his gun behind, and Robert went back to get it. Students helped the mortally wounded Butler to the nearby residence of John H. Harney, editor of the *Louisville Democrat*; Butler and his wife normally took their meals there. Before reaching the house Butler collapsed on the sidewalk and students carried him the rest of the way.[14]

It had seemed to Mrs. Ward that her sons had been gone but a few minutes when they returned. They said Butler had violently attacked Matt, who shot him in self-defense. Matt's wife became very upset. He told her to calm down and said to his mother: "Ask Anna if she would have her husband beaten like a dog. I am very feeble and had no other alternative." His mother later claimed that she noticed that there was a red mark on Matt's left cheek and that his eye looked injured.[15]

By 11:00 a.m. Lawrence B. White, the city marshal, went to arrest Matt and Robert. On the way he met their father on the street, who said he would find them at home. When he rang the bell, Robert answered and said, rather flippantly, that his brother wasn't there, that he had "vamoosed." But Matt was within hearing and joined the conversation; he readily agreed to submit to arrest. Meanwhile, public outrage was growing that a son of a wealthy family had shot a beloved teacher. A crowd gathered outside the jail and was brought to fever pitch by the news that Matt and Robert were being given preferential treatment, having been put in a room instead of a cell. According to a correspondent for a Frankfort newspaper, had the jailer not soon complied with the crowd's demands by moving them to a cell they might have lynched them.[16]

Attended by his wife and several doctors, Butler died in intense pain at about 1:20 a.m. His wife was holding his hand when he died. The family pastor, Rev. John H. Heywood of the First Unitarian Church, later recalled that their infant daughter Edith, eleven months old, was "brought in to see her father as he lay in that deep calm sleep which knows no waking on earth, clapping her tiny hands in joy at seeing her father again," not realizing he was dead. In his eulogy of Butler, Heywood wrote of Matt Ward that he was "one who should have been a friend" but "ruthlessly brought that pure, lovely, useful, honorable life prematurely to an end." That they could have been friends is not inconceivable. They were just seven months apart in age; both had traveled extensively in Europe and published letters in the *Louisville Journal* about it. But that fact could just as likely have been for Matt an incitement to jealousy.[17]

On Thursday, November 3, the Wards were arraigned for the murder
of Butler in the police court before Judge John Joyes (the uncle of Patrick
Joyes, who had been Butler's companion on his European voyage). Four
students—Campbell, Benedict, Pope, and Quigley—gave first-hand accounts
of what happened on November 2; another student, Johnston, described
the whipping that William Ward had received on November 1. Gilmore
testified that Matt had come into his store that morning, bought two pis-
tols, and had him load them. Four doctors—Thompson, Flint, Caldwell,
and Yandell—spoke of their examination of Butler's wound. Thompson
testified that Butler had said Matt Ward had cursed, struck, and then shot
him. Minard Sturgus did not see the encounter between Matt and Butler
but emerged from his office when he heard the gunshot, saw Butler stagger
and fall, and witnessed Robert threatening the pupils with his knife.[18]

An excited and at times noisy crowd attended the proceedings. The Ward
brothers were represented by three lawyers: James Speed (1812–1887,
brother to Joshua Speed, a friend of Abraham Lincoln), George Alfred
Caldwell (1814–1866, a former US Congressman and brother to one of the
attending physicians, Dr. William Beverly Caldwell), and Edmund Pendleton
Pope (1809–1857). They had requested a delay in the proceedings, but Judge
Joyes did not grant it. After hearing the witnesses, the Wards' lawyers retired
to the clerk's office to consider their options. They chose not to request
another postponement or to contest the evidence but to await the judge's
decision. Joyes ordered Matt and Robert back to jail to answer the charge
of murder and refused to accept bail. The *Louisville Courier, Democrat,*
and *Times* gave full coverage to the arraignment, but the *Louisville Journal,*
whose editor, George D. Prentice, was closely allied with the Ward family,
refused to do so on the excuse that it would prejudice potential jurors.[19]

Butler's funeral was held on Friday, November 4. The procession of mourn-
ers to Cave Hill Cemetery was one of the largest the city had ever seen.[20]

On December 14, the grand jury indicted Matt and Robert; five days later,
the Wards' lawyers successfully petitioned for a change of venue. The judge
who granted it was William Fontaine Bullock, who had granted Sallie Ward
her divorce from Bigelow Lawrence in June 1850. His son, John Oldham
Bullock, was a close friend of Matt's and would testify in his favor at the
trial. By law, a trial could be moved only to a neighboring county. Ward's
lawyers having presented affidavits from Oldham and Shelby counties claim-
ing that a fair trial could not be held there, it was moved to Elizabethtown,
in Hardin County, forty-nine miles south-southwest of Louisville. Robert M.
Ireland notes the connection between Judge Bullock's son and Matt Ward

and comments that he did not want to try the case and assigned it to Hardin County because it was the only one that was outside his judicial district.[21]

In late January, the *New York Daily Herald* printed a letter from a pseudonymous Louisville correspondent. Ward's lawyers may have been responsible, for it put forth new and unsubstantiated arguments which they would use at the April trial. It was in direct contradiction to the testimony produced at the arraignment. According to the writer, "Four out of the six witnesses" at the arraignment "swore that a fight was going on when Mr. Butler was shot." This is doubly untrue, for there were only four eyewitnesses, all of them students, and none of them said that a fight was in progress. What they did say was that Matt Ward attacked Butler, who did not fight back. The other two alleged witnesses were Minard Sturgus, who did not see what happened because he was in his office, and Robert Ward, who did see but as a coconspirator could hardly be considered a truthful observer. "It would appear," the writer further charged, "that Mr. Ward's brother had been maltreated both by Mr. Butler and his assistant at the school, and that the latter had not disguised feelings of intense hostility to Mr. Ward." The claimed mistreatment was the same application of a strap that was meted out to other students in the class; Sturgus's supposed hostility to Matt was a complete invention, which the lawyers at the Elizabethtown trial would use to justify Matt's bringing pistols to the encounter with Butler. Another lie introduced here and which they would also assert at the trial was that Butler refused to explain to Matt why he had punished William. He did not refuse to give an explanation; rather, Matt refused his invitation to come into his office to hear it. Perhaps the most outlandish lie making its first appearance in the letter and insisted on at the trial is that Butler struck Ward "in the face, and seizing him by the collar, began to drag him to the door. In the scuffle the pistol was discharged"—as if by accident—"and Butler was killed." None of the eyewitnesses said anything like this at the arraignment, except one who said Butler placed his hand on Ward's shoulder.[22]

A correspondent for the *Boston Transcript* wrote that he had visited the Ward brothers in the Louisville jail toward the end of January and found them living in the lap of luxury, with carpets, paintings, and even a piano. When the letter was republished in the *St. Louis Globe-Democrat*, someone wrote in to say that he had visited them in their imprisonment and that there were neither paintings nor a piano and their cell was the same as that of any other prisoner—small and dark. There was an old piece of worn-out carpet, a cot for a bed, a couple of rickety old chairs, a camp stool, a small table, and a pine-board shelf for Matt's medicines. But he did not contest

the assertion that they dined well, as any prisoner was entitled to be fed by family and friends.[23]

It is hard to determine where the truth lay as far as the accommodations were concerned, though at least one other writer made a similar claim, a Louisville correspondent in a Cincinnati newspaper asserting that Matt Ward "occupies a large room in the second story of the city prison, is handsomely accommodated, and enjoys the fat of the land."[24]

The Boston correspondent wrote that he found Robert sketching scenes from memory and Matt preparing his defense on the grounds that William's punishment had been too severe. He also reported that their friends and family were fearful they would be convicted and hanged, "especially their sister, so well known in Boston, who feelingly told us she never expected to find happiness again."[25]

Sallie had probably been in New Orleans when her brother killed Butler on November 2 because she was about to birth to her second child, which was born there December 28. She was in that city on May 20, when that child died. But in the interval, she could have returned to Louisville with her infant by the time the Boston correspondent recalled speaking to her before the Ward brothers were transferred to Elizabethtown on February 1, 1854. That her husband checked into a New Orleans hotel on March 4 suggests she was indeed in Louisville then, for he would not likely have done so if she were in New Orleans.[26]

The trial was a torturous experience for the Wards. If found guilty, Matt and possibly Robert, too, faced death by hanging. But the family's wealth bought both a legal team that overwhelmed the prosecution and a lying witness. Among those lawyers was John J. Crittenden, who had just been elected US senator by the Kentucky legislature. He had served in that capacity three times before, as well as serving as the commonwealth's governor and, most recently, as US Attorney General. Because of a longstanding friendship with Robert J. Ward, he volunteered to defend his son for free. Other members of the brigade of eighteen lawyers for the defense included former Kentucky governor John L. Helm and US Representative Thomas F. Marshall. The prosecution team was tiny in comparison, with only four attorneys. Robert J. Ward had in addition summoned 120 witnesses, nearly all to testify to Matt's peaceable character. Many were from out of state and held high positions. Of the two hotels in Elizabethtown, the attorneys and prosecution witnesses stayed at the Warfield Inn, the Wards and their entourage at the Eagle House.[27]

The trial began April 18. Robert and Matt had been indicted together by the grand jury, but the defense asked that their cases be separated. Judge

Kincheloe consented, and the prosecution was allowed to name which would be tried first. They chose Matt.[28]

The prosecution called thirteen eyewitnesses from among Butler's pupils, including the four who had testified at the arraignment. All of them said that Ward kept his right hand in his pants pocket while he held his hat and gesticulated with his left, that Butler did not strike Matt, though he did place his right hand, which was crippled from a childhood accident, on Matt's left shoulder—at which point, having already drawn the pistol from his pocket, Matt placed it against Butler's chest and pulled the trigger. George W. Crawford related the crucial detail that Butler was alarmed enough by what Matt was doing with his right hand that he tried to prevent it with his left: "Butler with his left hand was catching at Ward's right hand, and laid his right hand on Ward's left shoulder." Another reporter gives a more explicit version of Crawford's testimony: Butler "with his left hand was trying to seize Ward's right hand as he was raising the pistol to fire."[29]

Though the youngest witness was thirteen, most were either seventeen or eighteen. They were neither, as the defense would argue, mere children easily confused nor, as the defense would also claim, malleable enough to have been drilled by Sturgus to all tell the same story. They did tell the same story, in bits and pieces, depending on their vantage point at the scene of the crime, but no student contradicted another. This was the case even though they could not hear one another testify, as the judge had ruled that no witness could be in the courtroom when not on the stand. Their testimony was impressive, as even a New Orleans reporter sympathetic to the Wards had to admit: The students "gave their testimony with great self-possession and precision," so much so that "it is alleged by the counsel of the accused that they have been drilled beforehand."[30]

Faced with this consistent and damaging testimony, the defense lawyers sought to sow doubt by introducing witnesses who claimed they had heard students say that Butler struck first. But not a single student would testify that he saw Butler strike Ward in the face. Matt, however, had thought he could get away with claiming such an injury. His mother testified that she noticed a mark on his cheek and a swollen eye. Testimony from witnesses who visited Matt in the city jail was inconclusive. George D. Prentice confessed he could see it only once it was pointed out. Matt's friend John O. Bullock, son of the judge who had granted Sallie her divorce from Lawrence, admitted under cross-examination that the redness might have been caused, as prosecution lawyers suggested, by vigorous rubbing with a coarse towel. Because he would not have had time during the short walk from the school to home to fake the injury, Matt probably had his mother's help once he got

home, and it may even have been her idea. They would have had to work quickly, as the marshal was coming to arrest him.[31]

The defense then called John M. Barlow, a carpenter who claimed to have heard the dying Butler say he had struck Matt Ward first. None of the attending physicians could recall seeing Barlow present to hear Butler say that, and there were several contradictions in his testimony. Nevertheless, the Ward attorneys pressed their case that Butler had struck first, and that Matt had only fired in self-defense. Barlow had been overheard to say on November 2 that there was no point in having laws if rich men's sons did not have to obey them, exhorting his companions to go to the jail and lynch him, but he changed his tune when he realized how he might profit from the situation. In mid-December Barlow paid a visit to the Ward mansion. A servant with a silver platter asked Barlow for his card. He said had none but had come to convey some important information to Mr. Robert J. Ward. Ward came in and invited Barlow into the parlor. Barlow asked if it would do Ward any good to find a man that would prove that Butler struck Matt first. Ward said, "Yes, that's just what we want. Where is the man?" Barlow replied, "I am the man." Ward jumped up and started to shake his hand enthusiastically, saying he was delighted to make his acquaintance and offering to introduce him to the family. Barlow declined that honor. Ward asked him to meet with his lawyer. Barlow said he was a poor man and could not afford to lose work for attending the trial. Ward told him not to worry, that he would be rewarded tenfold for his trouble.[32]

The defense called at least forty witnesses to attest to Matt's peaceable nature. George D. Prentice testified that Matt "was not in the habit of seeking the society of gentlemen, rather sought the company of ladies." Alexander Walker said he "never knew a man more gentle and kind; he was so to a fault" and later wrote in his New Orleans newspaper that that Matt had "always been remarkable among the fiery and impulsive young men of his circle of associates for gentleness, amiability and kindness, to a degree which was by many considered effeminate and unmanly."[33]

Incredibly, Judge Kincheloe accepted the defense's final outrageous move, to call Matt's indicted coconspirator to the stand. Robert Ward Jr. could hardly be an objective witness, for his own fate hung in the balance. If he succeeded in preventing his brother's conviction, then he too would be spared. Defense attorney John J. Crittenden as US Attorney General had himself successfully argued against allowing just this sort of testimony in an 1851 case. But of course Crittenden argued in favor of it now, citing two Kentucky cases even though they went against centuries of English and common-law precedent.

Robert then testified that Butler sprang forward, pushing Matt back against the door and struck him at least twice. No other witness said he struck him even once. Crittenden asserted that Robert's testimony made "order out of confusion," which is plausible only to the extent that it was a single view instead of thirteen, but the "order" it made was not based in fact. The divergence between Robert's testimony and the pupils' was far greater than any between one boy's account and another's.[34]

Next came the speeches. The most illustrative was Tom Marshall's for the defense. He began by contrasting Barlow with prosecuting attorney Carpenter, a native of New Hampshire, while Barlow was born in Kentucky, "where there are but two classes of people, gentlemen and slaves; and every man not a slave is a gentleman. Carpenter has brought with him notions not congenial to our soil." Among those notions was the idea of defending the mode of punishment Butler inflicted on William Ward: "A fashionable instrument, this broad strap; a vast improvement in the art of whipping negroes; can whip a negro nearly to death with them, without breaking the skin." William was thus "publicly flogged as a common liar by an instrument used in whipping slaves!"[35]

Its application to the enslaved made whipping a man with cowhide an insult so dishonorable that some juries found it justified murder. In 1851 one North Carolina lawyer was publicly cowhided by another. The victim waited three weeks for a chance to avenge the insult, shooting him in a courtroom in full view of judge and jury. When his case came to trial the defense argued that a man who had cowhided an honorable man had forfeited his right to live. The jury agreed and found him not guilty. In December 1853, just six weeks after Matt Ward killed the schoolteacher for taking a leather strap to his brother, Richard H. Collins, the editor of the Maysville, Kentucky, *Eagle*, and in 1874 the author of a well-regarded history of the state, was warned by Luther Dobyns that if he did not retract statements he had published about Luther's nephew—Charles Dobyns Kirk, who by coincidence was the *Louisville Courier* reporter covering Matt's trial—he would cowhide him. Collins refused to retract, and Dobyns approached him on a Maysville street with the whip in his hand and raised him arm to strike. Collins fended off the whip with one hand and with the other fatally shot Dobyns. A jury found him innocent on the grounds of self-defense.[36]

Marshall brought up Matt's *Letters from Three Continents* as proof of his sterling character, alluding to his visit to Mount Sinai, where God produced the Ten Commandments. "Could I read you his reflections there, you would see that he was of too high and pure feeling to harbor malice to a fellow being." Prosecution lawyer Gibson retorted that it was too bad Matt

couldn't remember the commandment about not killing. Defense lawyer Nathaniel Wolfe countered by inflicting on his listeners a thousand words of the Sinai passage and five hundred more on Matt's visit to Calvary, the site of Christ's crucifixion, before concluding that the author of such lines was incapable of malice. As Robert Ireland points out, the prosecution should have answered that with some salient passages from Ward's other book of travels, the vituperative *English Items*. "Such quotations would have done much to counter not only the image of a pious and humble Matt Ward, but also to create a verbal portrait of an impetuous, arrogant, cynical, and hypersensitive man who might well have drawn and fired his pistol without being justifiably provoked."[37]

During all these speeches, Matt was looking on, together with Anna Key, "his devoted little girl-wife," as Alexander Walker put it, "with her large, sorrowful loving eyes."[38] Both Walker and Kirk sketched Matt's demeanor. According to the former, "The poor accused seems to grow weaker and weaker. They are speeching him to death. His face wears a distressing expression of physical debility, pain and suffering. He can scarcely hold himself in an erect position." Kirk reported that Matt's "appearance . . . was that of an intensely excited listener. He would frequently rise from his seat, and, with an eager look, gaze upon the speaker, often moving his lips and twitching his features from great and overpowering nervousness." Walker noted that when Crittenden, the most prestigious of the defense lawyers, characterized Matt as a gallant son of Kentucky with the blood of the pioneers coursing in his veins, "the accused, for the first time during the trial, evinced considerable emotion. He placed his hands upon his eyes, and big tears coursed down his pallid cheeks. Indeed, there were few dry eyes in the whole assembly." Crittenden drew out pathos at another moment too, saying of Matt's mother that she was too feeble to attend the trial but that she was listening at the window of a neighboring building, and he pleaded with the jury to be merciful and spare her having to hear bad news.[39]

When all the speeches were finally done, the jury went upstairs to deliberate. But the court remained in session, everyone in their places, the expectation being that a verdict would soon be reached. As the sun set behind the neighboring hills, there was a tense silence as Matt Ward "sat with immovable features," according to Walker. "His face was ghastly palled and expressionless. His eyes were glazed, dull and leaden." Anna Ward "hid her face in his breast and grasped him tightly, as if she feared the approach of the executioner." Robert J. Ward Sr. sat nearby, his face "full of grief and anxiety."[40]

After an hour, the announcement came that the jury had not yet reached a verdict. Court adjourned, and everyone left; Matt was carried by his friends

to his cell. His wife fainted from exhaustion. A long night of suspense lay ahead. Walker wrote that the Wards and their friends were not optimistic. The most they felt they could hope for was a mistrial. Dreading the outcome, they returned to the courthouse the next morning, Thursday, April 27, and learned that a verdict had been reached. The jury came down the stairs and took their seats at 9:00 a.m. The judge asked the foreman how they voted: not guilty on both counts, murder and manslaughter. The prosecution announced it would not proceed against Robert.[41]

Spectators applauded; the judge called for order. Anna was sobbing, along with Matt's father. Matt himself seemed insensible, rooted to his chair, though "his whole frame shook with deep emotion." His friends pried him up and took him across the street to the hotel where his mother had taken to her bed. She rushed toward him, falling into a swoon.[42]

The night before, as soon as the jury had retired, a vote was taken and eight were for acquittal on the ground of self-defense. After another poll the number rose to ten. The two holdouts were for manslaughter. One of the pair, McIntire, changed his vote to not guilty, and tried to persuade the other, Crutcher, to join him. The two retired to a private room to talk it over. It seemed to turn on Quigley's testimony. Crutcher said he couldn't remember what it was; McIntire showed him the notes he had taken and persuaded him that Quigley said Butler pressed Ward back to the wall. Quigley had actually said he was pressed to the door and the door was open, but McIntire and Crutcher seemed to have forgotten this. More likely, all they could remember was what the defense lawyers had said in their concluding speeches. Three minutes before the jurors walked into the courtroom the next morning, Crutcher later said, he changed his vote to not guilty.[43]

The *Louisville Democrat* reported the "common talk of the whole community" was that one of the jurors had been indicted for burning his neighbor's barn, another had previously committed perjury, another had visited the prisoners in jail and repeatedly said they were innocent but swore before the judge that he had not formed an opinion on the case. A humorous piece in the *Louisville Courier* praised the honesty of one juror who after the trial paid off all his creditors, while another treated his wife to an expensive coat. Four of the jurors were indicted for perjury, but when one of them was acquitted in December, charges against the rest were dismissed.[44]

John J. Crittenden had refused a fee from Matt's father, but the latter insisted on presenting him with a silver service. Crittenden had been elected by the Kentucky legislature to Henry Clay's old US Senate seat in January. "It was well for Crittenden that the election came when it did," writes his biographer Albert D. Kirwan, for if the election had been held after the trial he would

probably have lost. His conduct in the trial, condemned by every paper except the *Louisville Journal*, "brought his popularity to its lowest ebb."[45]

Henry Clay played a similar part in an 1846 case. Lafayette Shelby, son of Kentucky's first governor, shot a boarder at a Lexington hotel when the latter gave him an angry stare for taking his place at table. Clay so befuddled the jury that they could not reach a verdict. Another trial was scheduled, but in the meantime Shelby fled to Texas and was never caught. An article in a New York newspaper in the lead-up to Ward's trial drew a parallel, accurately predicting that, like Shelby, Matt Ward would escape punishment because of his family's money and influence.[46]

Thanks to the same wealth and influence, Sallie had escaped a difficult marriage and Matt the hangman's noose.

TOGETHER IN NEW ORLEANS

When the Robert J. Wards returned to Louisville with their exonerated son, it was rumored that they were planning "to give a congratulatory ball on his escape from justice," perhaps along the lines of the one they had given Sallie after her successful suit for divorce. An Indiana paper complained, "It would be right hard to conceive a grosser outrage on propriety and right feeling than such a display. . . . It would hardly be more monstrous if they could place the corpse of his unavenged victim in the ball room and dance around *that*."[1]

But a storm was brewing that would make any celebration unlikely. News of the acquittal reached Louisville on Thursday, April 27, resulting in widespread shock and anger. On Friday morning, perjured defense witness John M. Barlow, with money in his pockets for perhaps the first time in his life, tried to treat himself to breakfast at the Brown Hotel but was thrown out by the proprietor. Later that day defense lawyer Nathaniel Wolfe was jeered at by boys in the street and his house was attacked with rocks and rotten eggs.[2]

On Saturday twelve thousand citizens, an astounding number, met at the courthouse to pass resolutions condemning the verdict. At the same time

about two thousand "quietly proceeded to the residence of Robt. J. Ward, Esq., bearing in their midst effigies of Matt and Bob Ward. They entered the house but found it deserted, whereupon the effigies were then and there hung in the door way." Boys in the crowd threw stones at the windows, and the glass conservatory with its priceless collection of plants and flowers was destroyed. The effigies were set on fire and the one of Matt, thrown against the front door, threatened to set the house ablaze. Fire bells rang, firemen arrived, and the building was saved.[3]

According to A. J. Webster, who had been a student in Butler's school but absent the day of the murder, Matt hid at the home of *Louisville Journal* editor Prentice, who himself at midnight mounted a horse and fled to a place of greater safety, for his own effigy was among those burned by the crowd. According to a story that surfaced in 1948 and whose ultimate source was a neighbor who lived across from the Ward mansion, Matt "was put in a coffin and hearse followed by a burial cortege and carried to Mr. Jack Jones' farm. Hence Mr. Ward was concealed in the woods and secretly fed until he could get out of the state." The Jones farm was near the Louisville-Nashville Turnpike, which offered a macadamized surface on which a carriage could easily travel eighteen miles south to West Point, an Ohio River town in Hardin County. In West Point, Matt joined up with his wife and at midnight on Saturday, April 29, they hailed a passing steamer and with difficulty persuaded the captain to let them board.[4]

Matt and Anna landed at Cannelton, Indiana, the afternoon of the next day, where they were received by John James Key (1817–1886), a cousin of Anna's father. On Wednesday morning, May 3, the pair boarded the steamship *Eclipse*, arriving at Evansville that afternoon. By then Matt's parents had joined them. A fellow passenger described him as "a mere skeleton of a man," "very effeminate," and a "crushed and withered thing."[5]

Sallie had remained behind in Louisville with her husband and infant daughter, for on Tuesday, May 2, the *Louisville Courier* reported that despite the damage of the preceding Friday the Ward mansion "was as habitable as ever and occupied by Dr. Hunt and his family." The Hunts, however, must have been absent when the crowd arrived, for those who ventured inside found the house deserted.[6]

That the Hunt family left Louisville for New Orleans within a week or two is apparent from the report in the New Orleans *Daily Delta* of May 21 of the death the day before of "Emily, infant daughter of Dr. Robert P. and Sallie Ward Hunt, aged 4 months and 23 days." Sallie's husband and parents were with her. The child died of "cholera infantum,"

which was not a form of cholera but a gastrointestinal illness. This must have been a shattering blow to Sallie, whose first child, Robert W. Hunt, had lived less than a year.[7]

Matt, Anna, and Robert Jr. had been in Little Rock and Hot Springs, Arkansas, but by June 1 arrived in New Orleans in time to board the *Robert J. Ward* when it departed for Louisville. The entourage now included Sallie, her mother, Matt, Anna, and Robert Jr. Sallie's husband and her father remained behind, for June 1 was the beginning of Dr. Hunt's association with the New Orleans firm of Ward and Jonas, Cotton Factors and General Commission Merchants.[8]

A fellow traveler offers this description of the Wards:

> On our return home from our recent trip, we took passage on the mag-
> nificent steamer *Robert J. Ward* at Vicksburg, and to our surprise found the
> whole Ward family on board, returning to Louisville. They endeavored to
> pass incognito, only occasionally appearing in the cabin, and never eating at
> the table with the other passengers. The great belle, "Miss Sallie Ward," now
> Mrs. Hunt, is certainly the handsomest woman we have ever seen. She is a
> lady of great conversational powers—frank and easy in her intercourse, but
> too verbose and fond of high flown language in detailing common every-day
> incidents. Mrs. Ward, the mother of the family, is a large, proud, domineer-
> ing, overbearing looking lady, and bore the impress of trouble upon her
> haughty brow. We were agreeably disappointed in the appearance of Matt. F.
> Ward, the murderer of Butler. He could not walk without the aid of a crutch.
> He looked pale and emaciated, and there was something fascinating in his
> countenance which beamed with intelligence and amiability.[9]

The haughty and domineering Emily Ward as here depicted, and as she had shown herself to be in trial testimony, seems fully capable of having been the sine qua non of Butler's demise, as a New Albany, Indiana, newspaper asserted: "It is generally understood that Matt Ward was instigated by his mother to the attack on Butler. Whatever sympathy, therefore, the public may have for Robert J. Ward, the father, who is represented as an excellent man, the mother should have none."[10]

As Matt's mother had urged him to defend the family honor, a cousin of hers on the Flournoy side would resort to violence to defend Matt's. An Arkansas planter, Thompson Breckinridge Flournoy (1810–1861) had offered his arm to the defendant as he came into the Elizabethtown court-room on crutches. He had not been on crutches at the time of the murder, but at the trial they proved a useful prop. On August 7, Matt was spot-ted in Paris, Kentucky, by newspaper editor Samuel Pike, who had the

temerity to describe him in print as "the great *unhung*" and as an object of curiosity to the townsfolk whom P. T. Barnum could have made a fortune exhibiting. Flournoy was enraged. Characterized by Pike as a "remarkably large, rough-looking man," a few days later he swung an enormous club at the editor's head in Lexington, almost killing him.[11]

Many Louisvillians, however, would have agreed with Pike that Matt Ward should have been hanged, for a handbill was circulated calling for another mass meeting at the courthouse when he returned to the city in September. Matt and Anna boarded a steamer south just in time to escape the citizens' fury. She needed peace and quiet because she was pregnant with their first child; Emily Ward was born on their Arkansas plantation December 2. In the meantime, Matt oversaw the cotton harvest, each of his enslaved men picking five hundred pounds a day. Thanks to their unremunerated toil, he could winter in New Orleans, occupy the most prominent seat at the opera and be the "lion of the streets" as he sported "a span of bay horses, beautifully caparisoned, and a splendid carriage, and upon the box sit two colored gentlemen, with blue suits, white gloves, black hats, a green band around, and a small feather upon the upper edge." Yet, according to another witness, at the St. Charles Hotel "every lady who knew what he was refused his hand in dancing, and no father or brother would introduce him to their relatives. He is considered here as a murderer, and an outcast, with the mark of Cain branded on his brow."[12]

Back in August, at about the same time Flournoy was assaulting Pike in Paris, Sallie was observed in Louisville wearing mourning for her daughter but not without a certain sense of style. She was dressed in "white laméd crepe and black trimming," an acquaintance wrote, "in a state of resignation from her waist down and mitigated grief from her waist up." Thus attired, she rode through the streets of the city "astonishing the natives with her new carriage. Her father gave her the harness and her mother the horses" The harness cost $600 and the horses $800. "It is a very pretty carriage, almost exactly like the Hunts" themselves. But the "horses are by no means equal as paired—and the harness is decidedly vulgar."[13]

Were the Hunts a well matched pair? The seven years they spent in New Orleans gave the impression they were, at least as long as the money kept flowing. Once Robert became a full partner in her father's cotton business on June 1, 1854, he purchased a mansion on Rampart Street where they lived in palatial splendor, surrounded by rosewood furniture and white satin, marble statues and plashing fountains. On July 7, 1854, Sallie's Mississippi cousin Margaret Johnson Erwin wrote from New Orleans, "Whenever I am

in this city now the more I hear of Sallie W. She is giving the natives a taste of the grandiose. An enormous house and dinners for fifty, with music by the opera orchestra. What a performance! . . . Granted she had been and done and seen just about everything . . . but I have a feeling she is in for a fall comparable to Eve's." Elizabeth Ellet, relying on what Sallie told her, wrote in 1867 that the Wards' "dining room opened on a marble court, in the center of which was a beautiful fountain with jets arranged so as to play in figures. One of these was turned on every day just before dinner was announced, and the freshness and music of falling waters were an agreeable adjunct in that warm climate to the enjoyment of the meal."[14]

The Hunts frequently attended the opera at the Théâtre d'Orléans, located on Orleans Avenue between Royal and Bourbon Streets. Halévy's *La Reine de Chypre* and Bellini's *Norma* were presented in December 1854, and Donizetti's *Lucrezia Borgia* in January 1855. Sallie may have attended the masked ball there on February 2, as she had attended a grand ball at the St. Charles Hotel on another occasion, when she wore a Parisian gown worth a thousand dollars with a train many yards in length. As she led the cotillion, the train "was continually getting in the way of the dancers, and the men had to make many a quick overstep to keep from planting their feet on it. But Mrs. Hunt bore herself with such gracious dignity and such perfect unconcern that not once did she deign to cast a look at her train, smiling and bowing to right and left in the queenly way which was all her own."[15]

Sallie's obliviousness was again evident in October 1855. She was visiting Louisville and went to the theater, arriving late. The play had already begun, as the actress Agnes Robertson recalled years later.

> The house was crowded. . . . I had just come down to the front to read an important letter, when all at once there was a great commotion in the house, and a lady and half a dozen gentlemen . . . came down the parquette to front seats. The lady was Sallie Ward. I do not think ever again any society woman will have the power that that Louisville beauty had. She was absolute queen of all. Her words were like the nod of Jove. Wherever she went she had a sort of triumphal progress. She sat down lovely to look upon, and deliberately turning her back on the stage began to chat as if the parquette were her boudoir.
>
> I waited. She talked on, not in a whisper, but an audible flow of small talk that could be heard all over the theater. I took a chair, sat down, and being in boy's clothes, crossed my feet and waited patiently. The audience moved a minute between their interest in the play and their fear of Sallie Ward, then

they cheered. She turned to see what 'twas all about, gave a look, and went on with her talk; then I stood up and said that when the performance in the house came to an end, that on the stage might go on. The culprit turned, reddened, then was quiet, and the play proceeded.

The following evening Robertson and her husband, actor Dion Boucicault, attended a ball where Sallie and Robert asked to be introduced to her. "She put out her hands and said: 'Oh, Mrs. Boucicault, can you ever forgive me for my rudeness last night? Indeed I did not mean it,' and so it all ended pleasantly."[16]

Sallie's sister Emily married William Johnston in Louisville in 1857. A correspondent for a Pennsylvania newspaper wrote that the local papers did not cover this wedding as they had Sallie's and explained, "The truth is, the Wards are not so popular as formerly." No doubt the public's anger at Matt's escape from justice was the reason for the family's fall in esteem. Emily Johnston and her husband were spotted at White Sulphur Springs in August of that year. She had just turned sixteen and appeared to the observer "a child-like bride." She wore diamonds and lace on that occasion but for the rest of her life stayed out of the spotlight, dying childless in 1883 at the age of 41. Matt had been with her at White Sulphur Springs, displaying "the perfection of a finished gentleman."[17]

Sallie could not have been there with them, for she was about to give birth to her third child, the only one to survive. John Wesley Hunt, named for his paternal grandfather, was born in Louisville on August 30, 1857. When he was ten, Elizabeth Ellet, relying on what Sallie told her, wrote that she was "engrossed by the employment of teaching her only child, a bright and noble boy, forming and developing his character for the greatest usefulness in life."[18]

In December 1858, Illinois Senator Stephen A. Douglas visited New Orleans. "Private business, it is said, brought Mr. Douglas to this city. Perhaps to look after his plantation interests in Mississippi. He is accompanied by his beautiful young wife, while the celebrated belle, Miss Sallie Ward, forms part of his suite. They frequently show themselves to the people at the theatre and opera." Sallie was yet again displaying her talent for getting attention. But her father was also in public view, escorting Douglas's wife through the crowd to a reception for her husband at the St. Charles Hotel.[19]

Sallie's brother Victor was likewise in the spotlight. In February 1856 he was charged with carrying a concealed and deadly weapon. In 1859, he got into an argument with a fellow steamboat passenger, a doctor. They were standing at the bar when one of them invited the other to take a drink and

some kind of misunderstanding arose. Accounts differ, but according to one of them the doctor took exception to a remark Victor made and slapped him in the face, whereupon Victor drew a pistol and shot at him, the bullet grazing his lower lip. No arrest was made. But four months later, on May 26, 1859, Victor died. Returning to his Arkansas plantation after visiting his parents in Louisville, he succumbed to "a brief but painful illness" in Helena, Arkansas. The nature of that malady was not disclosed, but according to one source it was "delirium tremens."[20]

The month before this, the *Louisville Courier* featured news of Sallie's brother Robert, the one who had threatened Sturgus and his pupils with a Bowie knife as Matt dispatched Butler. "Little Bob" Ward, as he was called, was living on his plantation at Bayou Granicus, Mississippi. High water had flooded much of the terrain, and little farm work could be done until it subsided. A horse race would have been a good way to pass the time, but there was no track sufficiently dry. Ward challenged his cousin Matthews Flournoy Johnson of nearby Lake Washington to a boat race on that long and crescent-shaped oxbow lake, formed by a change in the path of the meandering Mississippi. The distance would be one mile and the purse a thousand dollars. Quite a few spectators, all in their own boats, watched the spectacle. Each of the two skiffs was propelled by six enslaved oarsmen, with Bob and his cousin at the helm. Bob's crew had their hair done up in blue ribbons that streamed in the breeze. By the time the race was over, six minutes and some seconds had passed and the Granicus boat was fifty yards ahead. As soon as their boat struck the shore, the oarsmen lifted Bob up on their shoulders and sang a celebratory song to the tune of *Camptown Races*. But on July 2, 1860, Bob would catch a chill in a pond near Georgetown, Kentucky, and he, too, would die.[21]

By now, the Ward family's finances were worsening. Railroads were replacing steamboats, and Sallie's father was unable to pay $30,000 he owed on the *Robert J. Ward*. He put it up for sale in New Orleans in August 1859. No buyer appeared, so it was put on the auction block at a sheriff's sale in March 1860. The purchaser later tried in vain to sell it, deciding at last to auction off its contents separately. Going under the hammer on May 24 were rosewood and mahogany furniture, dining chairs, cotton and spring mattresses, feather pillows, comforters, table and bed lines, fine French plate, mirrors, carpets, china and glassware, cutlery, iron safes, platform scales, bells, chains, hawsers, ropes, blacksmiths' tools, cooking stoves, and chandeliers. It was a sad end to a glorious run. At the same time, Ward was trying, apparently without success, to sell off his sons' plantations. Bob's in

Washington County, Mississippi, had six hundred acres, twenty-five enslaved persons, plus mules, stock, and farming implements. Matt's included seven enslaved persons on 890 acres in Phillips County, Arkansas, with good cotton land on Old Town Lake and a wood yard on the Mississippi frequently visited by steamboats needing fuel.[22]

In the midst of these financial difficulties, more precisely in the spring of 1860, Robert J. Ward engaged American artist George Peter Alexander Healy (1813–1894) to paint at least seven portraits of the Ward family in the artist's New Orleans studio at a cost of at least $2,800, nearly one-tenth of what he owed his creditors for the steamboat. The portraits included one each of Sallie, her infant son John Ward Hunt, her brother Matt, Matt's wife Anna, Matt and Anna's two daughters, Sallie's sisters Emily and Lillie, and her mother. These paintings offer a priceless glimpse of a wealthy family on the edge of ruin. Sallie, by then in her early thirties, had lost some of her youthful glow, but was still of striking appearance. Her cousin Margaret Johnson Erwin commented, "Her portrait by Healy is very pretty. But it seems to simper." Vaughn L. Glasgow, writing for a 1976 exhibit of Healy's New Orleans paintings, alludes similarly to Sallie's "impish qualities" and "coquettishness." Healy, he writes, "captured the malapertness of the successful social hostess in the tilt of the head, the knowing glance and the artfully artless clasp of the hands. The painter relied on quantities of yard goods such as the moiré and reembroidered lace of the gown and damask of the table covering to creatre an extraordinary visual richness as French painters such as Ingres had done in the preceding decade."[23]

Sallie continued to be as spendthrift as her father, her cousin Margaret observing in 1860 that "her house in New Orleans has taken on an even grander air—imperial it seems to me. . . . I do think she is losing sight of the earth itself at times." But Margaret offered a half-measure of praise as well, astutely summing up Sallie's contribution to her sex: "Sooner or later women will be on a level with men in all matters but we are far from that today. My cousin, Sallie Ward, seems to have made more progress in that sort of emancipation than any female I know. But her efforts are through flightiness and folly and little thought for others or any worthwhile thing— utterly brainless."[24]

But by December 1860, Sallie's husband was showing signs of strain, looking "pale and dejected," Margaret thought, adding: "I saw Cousin Sallie at another of her soirees. I think no empress of our time ever put on as many jewels—or as many airs. But the evening was made worth my time by meeting Adelina Patti there; she and Sallie seem to know each other well. . . . Sallie is not beautiful—but she is radiant!" The Patti reference allows us to

date her letter, for the singer began her engagement with the New Orleans Opera on December 19, 1860, and had not been in the city since 1856. South Carolina seceded from the Union on December 20, which explains why Robert Hunt looked so dejected that day. The cotton trade on which his income depended was in dire peril.[25]

The partnership of Ward, Hunt and Co. was dissolved May 1, 1861, Robert J. Ward Sr. and his brother George leaving Sallie's husband in charge of the business. Hunt continued it for another month before its name and his ceased to appear together in advertisements.[26]

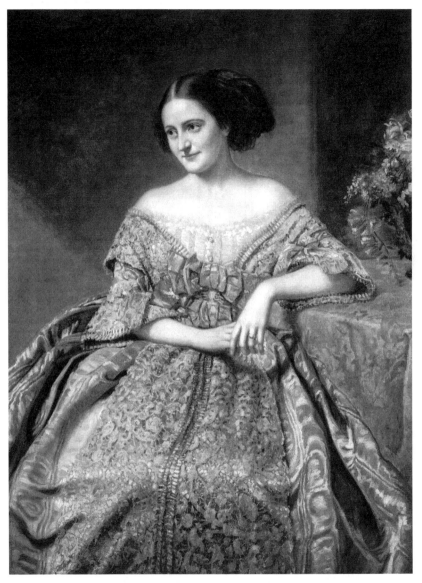

George Peter Alexander Healy (American, 1813–1894), *Portrait of Sallie Ward (1827–1896)*, 1860. Collection of the Speed Art Museum, Louisville. Gift of Mrs. John W. Hunt and Ruth Hunt.

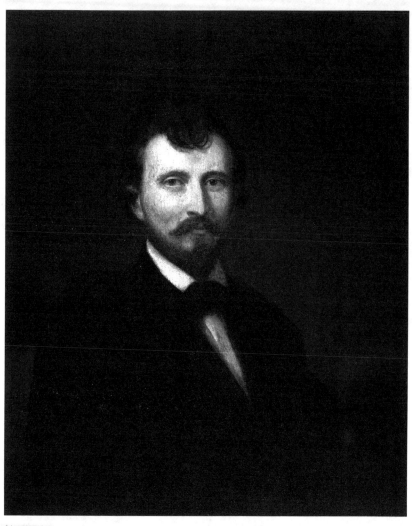

George Peter Alexander Healy, *Matthew Flournoy Ward (1826–1862)*, 1860.
Courtesy of the Speed Art Museum, Louisville, Ky. Murdered William H. Butler
in 1853 but was found not guilty.

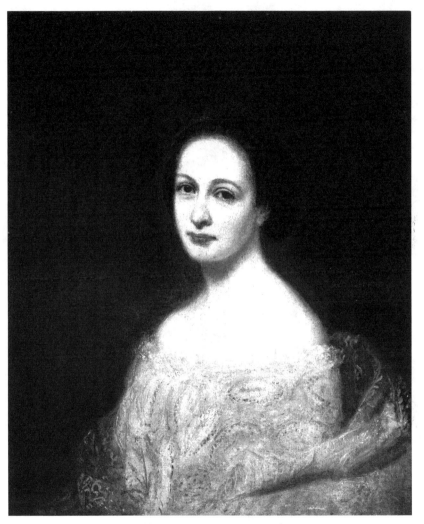

George Peter Alexander Healy, *Anna Key Ward (1835–1917)*, 1860. Courtesy of the Speed Art Museum, Louisville. Photograph: © 2023 Mindy Best—All Rights Reserved. Daughter of a riverboat captain, Anna married Matt Ward in 1853, became a widow in 1862, ran his Arkansas plantation and smuggled contraband to the Confederacy in the Civil War.

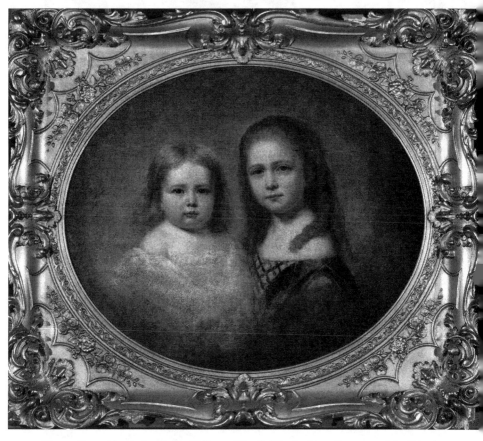

George Peter Alexander Healy, *Sallie and Emily Ward,* 1860. Courtesy of the Speed Art Museum, Louisville. Matt and Anna Ward's daughters, Emily Flournoy Ward Irwin (1854–1931) and Sallie Ward (1858–1866).

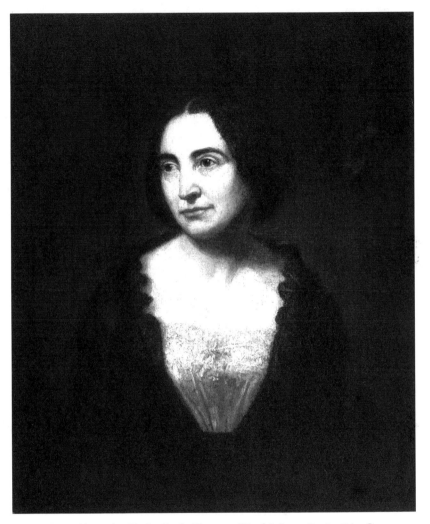

George Peter Alexander Healy, *Emily Flournoy Ward (1810–1874)*, 1860. Courtesy of the Speed Art Museum, Louisville. Wife of Robert J. Ward; mother of Sallie, Matt, and six other children. She encouraged her son to confront the schoolteacher who had punished a younger brother's for misbehavior, with disastrous results.

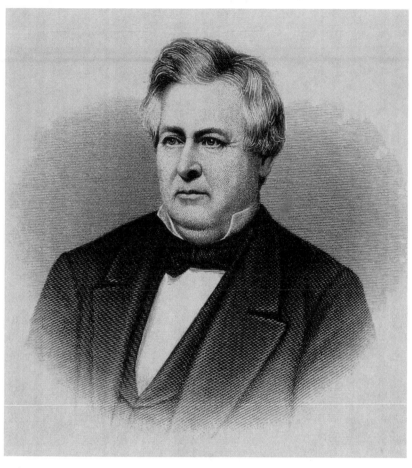

Robert J. Ward (1798–1862), father of Sallie and her siblings. His mercantile success led to immense wealth and spoiled offspring. From *History of the Ohio Falls Cities and Their Counties* (Cleveland, 1882).

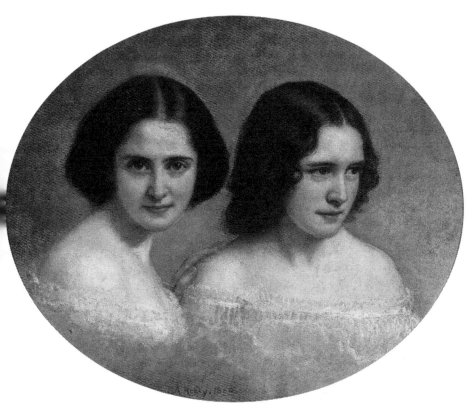

George Peter Alexander Healy, *Misses Emily and Lillie Ward*, 1860. Collection of the Speed Art Museum, Louisville. Bequest of Miss Emily Sidell Schroeder. Two of Sallie Ward's sisters. Emily Ward (1841–1883) married William Johnston in 1857 and died childless; Eliza Longworth "Lillie" Ward (ca. 1846–1872) married John Louis Schroeder in 1866 and was the mother of Emily Sidell Schroeder (1868–1933).

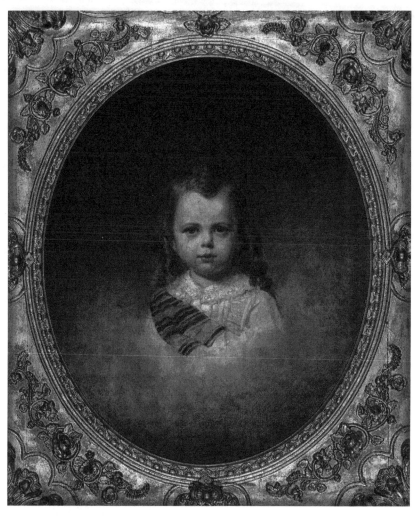

George Peter Alexander Healy, *John Wesley Hunt, 1857–1911*. Collection of the Speed Art Museum, Louisville. Gift of Mrs. John W. Hunt. Sallie Ward's only surviving child, he was the father of Ruth Hunt (Diana Bourbon). Like his father, he fell to his death.

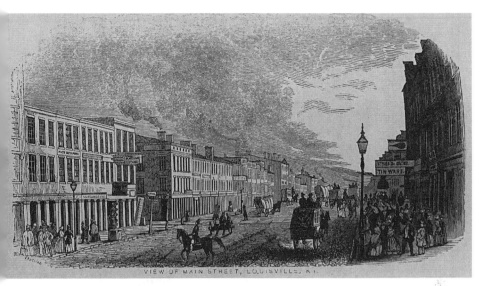

Downtown Louisville, from Lewis Collins's 1847 *History of Kentucky*.

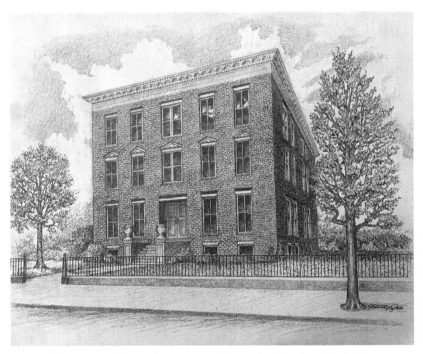

The Ward mansion at the northeast corner of Second and Walnut, Louisville. Drawn by Tim Pack from photographs in the *Louisville Courier-Journal* of July 12, 1896, and February 11, 1912.

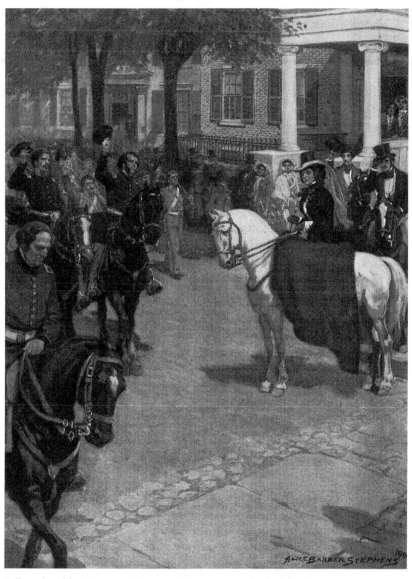

Sallie saluted by Mexican-American War veterans who had fought under her banner. *Ladies Home Journal*, March 1901.

Tombstone designed by Sallie Ward for her second and third husbands, Cave Hill Cemetery, Louisville. The inscriptions read "A Wife's Memorial" and "Vene P. Armstrong and Robert P. Hunt. Honored and loved upon earth for deeds that won a home in heaven."

Sallie Ward's epitaph. "Her's [*sic*] was a mind that knew no wrong. Her's [*sic*] a tongue that spoke no evil."

Tombstone for Matt Ward. Over time, or in a storm, it lost the huge cross that once surmounted it.

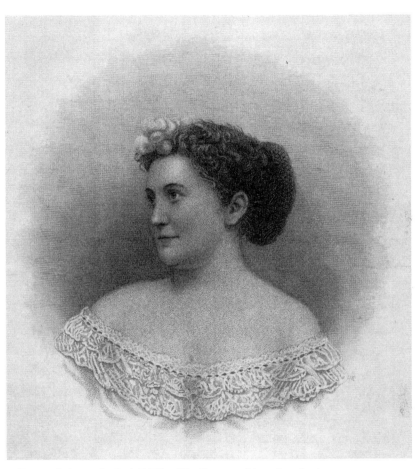

Sallie Ward, from Elizabeth F. Ellet, *The Queens of American Society*
(Philadelphia, 1867).

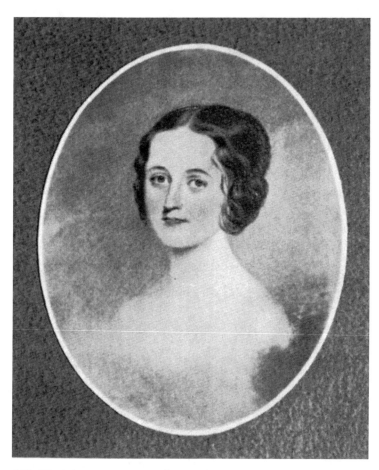

Sallie Ward, from Virginia Tatnall Peacock, *Famous American Belles of the Nineteenth Century* (Philadelphia, 1901).

Seven

ALONE IN LOUISVILLE

Before June 18, 1861, Sallie had left New Orleans for Louisville, taking young John Wesley but leaving her husband behind. That summer Mildred Bullitt wrote her son with the account of a conversation between Sallie and Caroline Throckmorton Adams, wife of Louisville businessman Benjamin Adams and the sister of Colin Throckmorton, husband of Sallie's sister Malvina:

> Ellen Fry told me that she and Puss Graves were at Mr. Ben Adams' the other evening, sitting near the front door. Mrs. Adams went down the front steps to speak to one of the children, when Mrs. Hunt (Sally Ward) commenced talking to her about the *reports* of her (Mrs. H's) political opinions, and asked Mrs. Adams to say to *every* one that she was a southern rights woman; she talked loud, and long; repeating the same thing over, and over again; all of them at a loss to determine what her object was, nor do they know now, unless it was to hear herself talk. The next day a long, perfumed note was handed to Mrs. Adams from Mrs. Hunt going over the same thing time and again, winding up with the warmest professions of friendship for Prentice, and asking Mrs. Adams to tell any body that her friendship for Mr. Prentice was unalterable, no matter how they differed in politics; and Mrs.

Adams is in blissful ignorance still as to the *point* of the conversation, or the letter.[1]

The point was evidently to give the impression that Sallie was sympathetic to the Confederacy, which Benjamin Adams certainly was. On April 16, soon after the firing on Fort Sumter, he was a signatory to the announcement of a public meeting at the Louisville Courthouse of "All those opposed to the war policy of the Lincoln Administration, its armed invasion of the Southern States, and its manifest intention to subjugate them." The politics of George D. Prentice's *Louisville Journal*, with which Sallie claimed to differ, were pro-Union.[2]

Mildred Bullitt prefaced this passage in her letter with an anecdote about Prentice that was going around at the time. His son Clarence asked him if he would give fifty dollars to a young man who would take fifty young secession men out of the city of Louisville. Probably imagining that the fewer Confederate sympathizers there were the better, Prentice senior said he would most gladly do so. Clarence then informed his father that he was that young man. "He *has* gone to Memphis," wrote Bullitt, "but I know not who went with him, or if he got his fifty dollars." Clarence survived the war, only to die in a buggy accident in 1873. His brother, William Courtland Prentice, also joined the Confederacy, and was killed by friendly fire in Augusta, KY, on September 21, 1862. Bullitt's letter also tells us what the mood in the city was like: "The time has been, that Louisville would have seemed so gay to me, with the beautiful flags floating over it, from every point. Alas, they seem a perfect mockery, for never did I witness more mournful expressions of anxious countenances before. Empty stores, shut up shops, moving families, anxious people begging for work; poverty, and distress at every corner; the flags, the fine houses, the blooming flowers: anything bright seems to make the gloom that wraps the people greater, if possible." Those flags were not Confederate ones: "Your aunt, cousin Peachy, and various other of your cousins, have flags on their houses (Union, of course), and cockades on their children." She urged her son Thomas, then studying in Philadelphia, not to come home. "Your father is exceedingly anxious for you to remain where you are for the present. . . . I long to see you, but you are better off I'm sure where you are." He did not heed his mother, but joined the Confederate ranks. Thomas Bullitt rode with John Hunt Morgan, was imprisoned with him in Ohio, and, of necessity, was left behind when Morgan and several of his men escaped by a tunnel.[3]

As Robert Emmett McDowell observed, in Louisville "The great mass of the people were pro-Union, but Secessionists dominated the upper class."

Sallie's social circle was that upper class, and she wanted to keep on good terms with her friends, especially Caroline Adams, who during the 1850s "was one of the most prominent leaders of fashionable life in this city, and their home on Walnut street was the center of a generous and elegant hospitality."[4]

But by Sallie's own admission there were certain reports that she favored the Union. Caroline Adams seemed to suspect she was protesting too much to be believed, whereas her cousin Margaret agreed with the reports, complaining that Sallie had abandoned the South, though not for ideological reasons: "She deserted the home of Dr. Hunt, and crossed over to the enemy for just one reason—she does not want to lose an inch of her petticoats, or be inconvenienced to the least extent."[5]

There was no ambiguity about where Sallie's father stood. Despite his financial difficulties, he was sufficiently in funds to finance a contribution to the Confederate cause that he proudly named Ward's Lancers. On land he owned in Oldham County, he hired a Colonel Jack Allen to drill a ragtag group of volunteers in August 1861. Allen had in April tried to form a regiment in Louisville, inviting volunteers to his office on Fifth Street and promising free transportation to join the ranks of the Rebels.[6]

Near Beard's Station (now Crestwood), Allen trained Ward's recruits above a store belonging to Owen Dorsey. On one occasion, Ward invited them to practice their maneuvers on his nearby farm and in lord-of-the-manor style "gave them a splendid champagne supper" according to Dorsey's wife. Their training completed, they ventured south to join the Army of the Confederacy, but four were arrested by the Kentucky Home Guard in September, most wearing self-designed Confederate uniforms, one with only a cap.

Noble Butler, the brother of the schoolteacher whom Matt Ward murdered and a resident of Pewee Valley, near Beard's Station, wrote a letter to General Robert Anderson in Louisville requesting they be pardoned. He enclosed a letter from another Pewee Valley resident who argued that "a good effect would be produced in the neighborhood"—that is, of Floydsburg, their native village, a pocket of secessionist sympathies—"by liberating them on taking the oath of allegiance. I believe myself," wrote Butler, "they would stay at home and behave themselves."[7]

These expressions of support arrived too late. The four had already been sent to the prison at Fort Lafayette, New York. Secretary of State William Seward commissioned an investigator to see if they should be pardoned. His report concluded: "They are very inferior men. They are not conspirators

and have no influence in society. I think we can fill all our forts and prisons with much better men who are much more dangerous than they. They are of no use as hostages on whom to execute the *lex talionis*, for if they were hanged few would know it and fewer still would care." Seward then ordered their release. Thus passed the glory of Ward's Lancers.[8]

As for Sallie's husband, although he had told her he was contemplating a trip to Europe, he instead enlisted in the Confederate army and by September 6, 1861, held the post of aide-de-camp to General Albert Sidney Johnston. When Johnston was mortally wounded at Shiloh on April 6, 1862, Dr. Hunt may have regretted not being close enough to prevent him from bleeding to death, but at any event he was now without an assignment.[9]

In New Orleans on April 15, 1862, the contents of the Rampart Street house were sold at auction. Advertising "the largest and richest assortment of household furniture offered at auction this season," the catalog gives us a glimpse of what their life must have been like for those seven years: rosewood furniture upholstered in brocade, a rosewood piano, mirrors, lace curtains, marble-top tables, mahogany sofas, hat racks, bedsteads, armoires, washstands, lounges, toilet tables, rockers and armchairs, hair and moss mattresses, Brussels carpets, elegant glassware, decanters, goblets, wine and champagne glasses, chinaware, window shades, paintings, books, servants' furniture, two pairs of horses, and three carriages. The advertisement stated that the items belonged to R. P. Hunt, Esq., "who sells on account of the disruption in his business, and his desire to remain in the army until the close of the war."[10] After his stint on Johnston's staff, and his subsequent association with Morgan's Raiders, by Feb. 3, 1863, Hunt had become a surgeon in the army, and in August 1864 was placed in charge of the Lee Hospital in Columbus, Georgia.[11]

The Civil War did not come to Louisville, but in the fall of 1861 its citizens had reason to fear it might. In September 1861, Rebel advances caused "consternation and fright" in the city. Simon Bolivar Buckner seemed to be heading there, Felix Zollicoffer was moving on Frankfort, and Louisville's defense was woefully deficient, for few Federal troops had completed their training. Henry Villard, journalist for the *New York Tribune*, wrote, "I could not help thinking at the time, and still am of the opinion, that if Buckner and Zollicoffer had really pushed vigorously on, they had a good chance of compelling the at least temporary abandonment of Kentucky by the Federal Government and getting possession of the important city of Louisville." According to Robert Emmett McDowell, "The rumor that Buckner had two Indian regiments added the final thrill of horror to the situation. . . . The

people of Louisville half expected to be scalped in their beds." But soon Union soldiers were pouring in from Indiana, Ohio, and other states, and Buckner did not advance much beyond Bowling Green.[12]

In September 1862, Confederate General Braxton Bragg was hoping to take the city, General Kirby Smith having captured Frankfort on the third. On September 22, Union General William "Bull" Nelson ordered women and children to depart for Jeffersonville, Indiana; pontoon bridges were built and ferries made available for them to do so. Nelson announced that he would try to defend the city but that if he failed he would turn his cannons on it and reduce it to rubble. "The panic on the wharf," writes Bryan S. Bush, "reached a crescendo. Children and weeping women held one another tight." Sallie may have been among them, hoping to take her young son to safety. After camping out in Indiana for several uncomfortable nights, the refugees were able to return home when Union General Don Carlos Buell and his troops arrived on September 26.[13]

Meanwhile, Matt Ward on his Arkansas plantation was beset by scenes of war, alternately visited by Union troops and Confederate guerrillas. A correspondent with the Union army in Helena wrote that Matt had been growing cotton with the help of fifty mules and a hundred enslaved persons, yet "appeared a broken and gloomy man, shrinking from society." The plantation was surrounded by "cypress swamps, low lands and alligators" and its owner was "a cadaveric-looking gentleman" whose appearance indicated that he had once frequented genteel society.[14]

Once the Union army arrived on July 13, 1862, his enslaved workers began to disappear, some crossing over to Union lines, others stolen by Confederate guerrillas. In August, Union regiments were ordered to harvest Matt's cotton, along with that of neighboring plantations, and take it for themselves.[15]

Interviewed a quarter-century later, Anna Key Ward gave her version of what happened on September 27. They were living on the plantation near Helena, and Matt's father was with them. When Confederate cavalry commander Archibald Dobbins, who lived two miles from the Wards, learned that Union soldiers were picking Matt's cotton, he

> came sweeping down that day with a strong force of guerrilla cavalry. They drove off the Northern troops, and were seizing the negroes to carry them within the Confederate lines. We heard firing one morning during the raid, and my husband went out to see what the trouble was. He had just walked off the porch into the yard when a negro came riding furiously up to the gate, and ran to my husband. He was from the plantation of our cousin,

Tom Johnson, and was pursued by a squad of guerrillas. Seeing Matt, whom he knew well, he fled to him, begging for protection. The guerrillas were firing fast as they pursued the negro, and continued it as he ran to my husband. My husband was wounded, as was the negro. We took him to Helena, not thinking his wound was dangerous, but a few days later he died.[16]

Matt Ward died September 30, leaving a widow and two orphans: Emily, now eight, and Sallie, four. Colonel Dobbins's men told him they had been under the impression that Matt, who by chance was wearing a blue coat, was a Union officer. "The fact was," Anna Ward said, "they were firing recklessly, and didn't care whom they killed." An account in a St. Louis newspaper accords with hers with regard to the enslaved persons, though it adds, perhaps incorrectly, that they were armed: "some guerrillas or Confederate soldiers . . . were near. . . . Ward's residence attempting to arrest some armed negroes; the negroes, in trying to escape, ran through" the yard. Ward, "hearing the report of fire arms, came from his house and unfortunately stepped in range of a shot aimed at one of the negroes" and was mortally wounded.[17]

She called the interviewer's attention to a painting over the mantel— Healy's portrait of Matt reproduced on p. 72 above. "It doesn't look like the face of a bad man, does it?" she said. The reporter later described it as having "an almost oriental cast of features, a light beard and mustache, clear eyes and countenance lit up with intelligence. It brought to mind the pictures the old masters have painted of Christ."[18]

Matt's death was news across the nation. No one compared him to Christ, but soon after the murder of Butler he had frequently been likened to Cain, and the comparison cropped up again now: the aforementioned correspondent wrote from Helena that Ward "had been driven forth like Cain, the red mark of blood upon his brow, and sought a refuge" in Arkansas. The reporter's landlady in Helena had lent him a copy of *English Items*, and he quoted with delight Matt quoting George William Featherstonhaugh's humorous description of Arkansas residents from that volume: "Gentlemen who had taken the liberty to imitate the signatures of other persons; bankrupts, who are not predisposed to be plundered by their creditors; homicides, horse-stealers and gamblers, all admired Arkansas on account of the very gentle and tolerant state of public opinion which prevailed there in regard to such fundamental points as religion, morals and property." He thought that Matt's seeking refuge from his criminal past in such a place and among such a population altogether fitting. In recounting the crime, the reporter described Matt as "an educated and popular specimen of southern

chivalry" whose "southern blood" was "so inflamed with passion" when he learned of his little brother's whipping that he shot the teacher who inflicted it. The correspondent apparently spoke in Helena to persons who knew Matt and Anna well, and he very possibly saw her there. She was, he wrote, "a very beautiful, accomplished and energetic lady" who "pursued, and by her influence upon the commanding officers here, Gens. Curtis and Steele, recovered many" of the enslaved.[19]

News articles about Matt had begun appearing as early as August, when a Union brigade landed at Old Town Landing on the Mississippi, where his plantation was. Among the regiments was the 33rd Illinois, known as the "School Master Regiment" because many of its men were professors and teachers-in-training from Illinois State Normal University. Because he had murdered a schoolteacher in 1853, Matt was afraid someone in this regiment might shoot him, as Major General S. R. Curtis testified at a military proceeding in 1863:

> Q. What do you know concerning a person in Arkansas named Matt Ward, and any transaction he may have had in cotton, or that persons may have had with him? A. I know he had about one hundred and eight bales of cotton. He came to my headquarters and told me who he was. He was terribly frightened, and especially at the school master regiment, commanded by Colonel Hovey, which happened to be picketed close by his residence, and they seemed to be very much prejudiced against him. I gave him the privilege of selling his own cotton. He seemed very much afraid that somebody was going to shoot him, and he was afraid to go down to the house where the men bought the cotton. But he sold his cotton, and I think he got twelve and a half cents per pound for it. . . . Any man that claimed to be a Union man, and was not connected with the rebel service (and there was no particular instance of his complicity given to me), I generally allowed them to sell their own cotton. Ward was afterwards killed at his own door by guerrillas who came to attack some of our soldiers. The cotton was delivered at Oldtown, I think, under the charge of Gen. Hovey's picket, and by some thought to be cotton that ought to be confiscated.

> Q. How did you regard Matt Ward—as a Union man or a rebel? A. I thought he was actually a Union man. I so regarded him, and I did not think the shooting of a man ten years ago had anything to do with the present war. I state this because there was a great prejudice against him and some prejudice against me because I did not persecute him.[20]

A reporter for the *St. Louis Republican* thought Matt supported the Confederate side: "He is reported by his acquaintances to have furnished

transportation and negroes to the rebel army, and otherwise aided the
rebellion by manufacturing articles of clothing, etc., for the use of the army,
and is heart and soul with them." Yet a North Carolina paper called him "a
Lincoln sympathizer" before concluding that "Vengeance slumbers some-
times, but is sure to overtake the murderer."[21]

Matt's death was followed two weeks later by his father's, who had come
down to Arkansas to live with him on the plantation. Robert J. Ward Sr.
died in his bed at age 64. We do not know the cause of death, but accord-
ing to A. J. Webster, he had been "ruined physically" as well as financially
by his son's murder of the schoolteacher. From a letter Sallie's cousin Emily
Johnson Bartley wrote from Louisville to her stepdaughter we learn that
Sallie's sister Emily and her husband came down to bring her father's remains
home for burial. Because he had been underground so long, they could not
open the coffin but placed it in a zinc-lined box to which they added silver
handles and a plate for his name, which Bartley thought "made it quite
genteel." The funeral was held in Louisville on the afternoon of December
3, with interment in the family plot at Cave Hill Cemetery. A "very large
number of sympathizing friends" were there, but not Sallie's mother, who
had been too incapacitated to leave the home in the country where she had
gone to recover from an illness. According to the *Louisville Journal,* "It was
a pleasant and touching sight, when the grave was filled, to see the little
grandson of the deceased, a lovely child of six years, advance and lay three
beautiful and superb wreaths of flowers upon the solemn mound—a sweet
and appropriate farewell to the venerable object of his young heart's love
and idolatry." That child was doubtless John Wesley Hunt.[22]

Bartley had other news. Emily Johnston "brought up Sallie's silver, but
more than half is gone." The Mississippi plantation belonging to Bartley's
father, Henry Johnson, "has nothing in the house or on the farm. Every
negro is gone. His meat, corn, every thing. Since Anna Ward's return to
Helena, the Confederates won't let her pick a pound of cotton, threaten to
burn the fields if she attempts it, as it is to go to speculation. . . . I would not
be surprised if the Yankees give her a guard to enable her to pick it." Sallie
"has lost 20 pounds of flesh . . . which I think is a great improvement. She
is very much grieved at her father's loss."[23]

Traveling as "Mrs. Robinson," Anna Ward was arrested on a Mississippi
River steamboat near Tiptonville, Tennessee, in February 1863 for trying to
smuggle uniforms for Confederate officers in her trunk. "She was released
from arrest after a slight admonition that a future similar transgression
would be severely punished." A year later, she was at it again, arrested with
two other women. In perhaps an excess of politeness military authorities

"swore Mrs. Ward to examine her female friends to see if they had any goods concealed about them; but of course, she found nothing" and they were allowed to continue their journey.[24]

In June of 1864, several newspapers claimed that she had been ordered to leave eastern Arkansas by Union General Napoleon Buford because "She has been playing double-face with rebels and federals and violated her oath of allegiance." But according to the *Louisville Journal* the assertion was "entirely without foundation. Mrs. Matt Ward is living upon her fine plantation near Helena, disturbing no one and disturbed by no one. She has received every kindness from Gen. Buford, and possesses, as she deserves, his entire confidence." A native of Versailles, in Woodford County, Kentucky, Buford may well have been a longtime friend of the Ward and Key families.[25]

On September 29, 1865, an Arkansas creditor sued for payment of a promissory note on the plantation, the defendants being the entire Ward clan: "Emily Ward, Robert Hunt and Sallie Hunt his wife, William Johnston and Emily Johnston his wife, Colin Throckmorton and Malvina Throckmorton his wife, Lilly Ward, Anna Ward and Emily Ward and Sallie Ward her children" (Anna's daughters Emily and Sallie were then aged 11 and 7). Two weeks later, the following advertisement appeared in the *Louisville Journal*: "Wanted—A Partner to Take a Half Interest in a highly improved plantation in the South, which is capable of producing 400 bales of cotton. The original labor is on the place, and can easily be put in working order. For further information apply to Mrs. R. J. Ward, corner Second and Walnut streets." It appears she had no takers. But she did manage to sell a copy that George Caleb Bingham had made of his " County Election" that her husband had purchased from the artist in New Orleans in early 1853 for $1200, though she could get only $500 for it. Bingham had left the original with a Philadelphia engraver in October 1852, and was showing the copy in New Orleans and elsewhere to persuade customers to sign up for printed copies. Ward graciously allowed him to continue to do so, while retaining possession.[26]

Although Mrs. Ward did not find a partner to invest in the Arkansas plantation, another solution presented itself, and the plantation saved, when on November 1, 1866, Matt's widow Anna was united in matrimony by a Catholic priest from Helena to Major William Hemphill Govan, lately of the Confederate army and a man of wealth and standing. Matt Ward had been received into the Catholic faith in 1859 and joined the Helena parish in which Anna was likewise active. The ceremony was performed at the plantation.[27]

Sallie Ward Hunt and her young son John continued to live with her mother in Louisville, but it appears they were not alone. A. J. Webster

recalled in 1930: "Once during the Civil War, passing through, while on duty
I reported at General Buell's headquarters, located in the old Ward Mansion
at Second and Walnut Streets." Buell took over from William T. Sherman
in November 1861. That the Ward mansion was used by the Union army
in some capacity was also indicated by the *Courier-Journal* in 1917: "Dur-
ing those unforgettable days of the War of the Sections the quaint floors
resounded with the martial tread of soldiers."[28]

Professor H. E. Whipple of Hillsdale College, an antislavery school in
Michigan, visiting Louisville in July 1863, found the city to be heavily
militarized. Soldiers patrolled the streets, standing sentry at every corner
and hotel entrance. No one could enter or leave the city without a permit.
But he also found an alarming amount of Confederate support among the
citizens. On Sunday morning he attended services at the Second Presbyte-
rian Church, whose pastor, Stuart Robinson, had fled to Canada for fear
of being arrested for disloyalty. "The exiled Dr.," the Whipple wrote, " is
still cared for by his flock who no doubt regard him as a martyr for the
divine institution of slavery." While in Canada, Robinson published a book
justifying slavery as an institution permitted in the Bible from Moses to the
Apostles. Second Presbyterian was the church that Sallie and her parents had
attended when Rev. E. P. Humphrey had been its pastor. Whipple observed
that Union soldiers' graves in Cave Hill Cemetery were often unmarked and
suffered from neglect, whereas the flower-covered Confederate ones all had
substantial headstones. He then paid homage to the impressive monument
erected to the memory of the teacher Matt Ward killed. He termed both
the murder and the acquittal "a melancholy illustration of a state of society
founded upon slavery. But an avenging Providence followed the murderer,
and he has fallen by the hand of violence."[29]

The same newspaper page reported the arrest of Nathaniel Wolfe, the
Ward family friend who had hastened with George D. Prentice to Frankfort
to help Sallie get her divorce in 1850, and who so ably defended Matt at
his trial in 1854 that he was pelted with eggs upon his return to Louisville.
He had just been arrested and sent to Ohio for complaining that the war
was "a John Brown raid, a war against slavery" and saying that "he hoped
every true Kentuckian would rise in opposition to it."[30]

Unionist that she was, despite her protests to the contrary in 1861, Sallie
must have found herself among some enemies in her native city. But her
loyalty to Lincoln would serve her well in an effort to retrieve possessions
she had left behind in her jouse in New Orleans. She had saved a few items
from being auctioned off with the rest in 1862 and had left them with her

uncle George Ward when she moved to Louisville in 1861. Three years later she prevailed upon Mary Todd Lincoln to help her get them back:

> Louisville, March 31st, '64
>
> Mrs. Lincoln.
>
> Dear Madam
>
> Some weeks since I addressed a letter to Mr. Joshua Speed, then in Washington, relating to the releasement of some white satin chairs, piano and vases presented to me, by my Mother, several years since. On his return, Mr. Speed informed me that he had placed the matter in your hands; fearing that in the multiplicity of your engagements so trifling a matter may escape your memory, I write to beg your influence in procuring the necessary papers for me. The articles mentioned are endeared to me, by association as a musician, my piano, I love, as a friend. Dr. Hunt sold our residence in New Orleans before the war, intending to go to Europe; the chairs etc. he preserved because of their being my mother's gift; in leaving New Orleans, I left them in Mr. George Ward's house until my return. You know, dear Madam, what followed. I have not been in New Orleans for four years. By restoring to me these articles, the act of justice will be enhanced by your kind influence, in my behalf—for which, believe me, I will be truly grateful. The authorities acknowledge the justice of my claims, but refuse me; it is necessary to procure the papers from Washington authorizing them to act. Relying upon your enormous kindness of heart, I hope soon to hear from you.
>
> With respect and esteem
> Sallie Ward Hunt.[31]

Mrs. Lincoln must have spoken to her husband about it, for he took action quickly, writing, as William Townsend explains, the following letter to "one of [his] confidential advisors in Kentucky," and enclosing her letter with his.[32]

> Abraham Lincoln to Whom It May Concern, April 11, 1864
> I know nothing on the subject of the attached letter, except as therein stated. Neither do I personally know Mrs. Hunt. She has, however, from the beginning of the War, been constantly represented to me as an open and somewhat influential friend of the Union. It has been said to me (I know not whether truly) that her husband is in the rebel army, that she avows her purpose to not live with him again, and that she refused to see him, when she had an opportunity, during one of John Morgan's raids into Kentucky. I would not offer her, or any wife, a temptation to a permanent separation from her husband; but if she shall avow that her mind is already, independently and fully, made up to such separation, I shall be glad for the

property sought by her letter to be delivered to her, upon her taking the oath
of December 8, 1863.

A. Lincoln[33]

The raid into Kentucky conducted by Robert's nephew John Hunt
Morgan to which Lincoln refers was probably the one occurring in July
1862. Morgan and his raiders spent the night of the sixteenth in Georgetown,
which Sallie could have reached had she wished; on the seventeenth he was
in Cynthiana, on the eighteenth in Paris. Lincoln's confidence that Sallie was
an open friend of the Union contrasts with what she told Caroline Adams
in 1861 but is in line with the reports she sought to contradict.

An unnamed Union general wrote after the war of an hourlong conversa-
tion he had with her in 1861 in which she gave some indication of Unionist
sentiment:

> It was at an evening party in Louisville, shortly after the opening of the
> war, but before there had been any conflict of arms in Kentucky, that I met
> for the first time Mrs. Hunt, formerly Miss Sallie Ward. . . . The trivialities
> of fashionable conversation . . . gradually gave way to more serious subjects,
> and some of these were indeed abundantly serious. The matter of politics
> was at that time a delicate one in Kentucky. . . . But she did not avoid it,
> and managed it gracefully. . . . She did not speak as a partisan, but with
> admirable good sense as a patriot, while maintaining the delicacy of a
> woman and a wife as she spoke of those amongst whom a husband and
> her nearest friends were arrayed.[34]

In other words, she expressed support for the Union despite the sympathy
for the South displayed by her closest friends, particularly her husband, and
her wish not to offend their sensibilities. She was a patriot, not a partisan.

It is important to bear in mind that in Kentucky to favor the Union
was not the same as to favor the North or the abolition of slavery. At the
beginning of the Civil War, a substantial number of Kentucky slaveowners
rejected secession because they saw the federal government, especially since
the passage of the 1850 Fugitive Slave Law, as a better protector of slavery
than the seceding states could possibly be. As Patrick A. Lewis points out,
"they were not about to rid themselves of the Union and the Constitution,
which had ever been the shield and sword of Kentucky slave masters since
the founding of the republic."[35]

In addition to turning down the chance to visit her husband when John
Hunt Morgan ventured near enough to Louisville for that to have been
possible, Sallie refused to see him on a second occasion. According to Olive
Pendleton, Dr. Hunt "was taken prisoner after one of the famous battles and

the story goes that when Mrs. Hunt was told—by a friend who had passed through the lines—of her husband's wretched condition, she exclaimed: 'Robert in rags! I could never endure the sight.' Of course she did not visit the prison nor minister to her 'Robert' in affliction."[36]

The last surviving Ward son, William, whose schoolboy punishment precipitated the murder that darkened the family's name, died of tuberculosis on August 3, 1865, at the White Sulphur Springs in Delaware County, Ohio, where he had gone in the hope of regaining his health. Olive Pendleton remembered him as the good-looking boy who once took her older sister to a fancy-dress ball. The sister went as the Queen of Hearts and William in a Turkish costume with white satin trousers and golden lacings, an outfit that his sister Sallie had once favored. "His hair," wrote Pendleton, "was of a beautiful yellow and hung on his shoulders in waving locks. Altogether he was a prince out of a fairy tale." She could not remember the details of Butler's death "but I know Matt Ward went unpunished and that the incident rather added to the prestige of the family. The public seemed to think that their fast, handsome, dissolute young bloods were in a measure exempt from everyday obligations." William "never paid a visit without his colored servant. He was a charming, ideal sort of fellow. Not at all suited to everyday life but a picture of a past time when the southern planter was a prince in his own right. I have heard these men boast that they had never earned a dollar in their lives, nor could they do so."[37]

Dr. Hunt was free to return to Louisville after taking the oath of allegiance on May 23, 1865. But he did not do so for the greater part of a year. Sallie's refusal on two occasions to see him may have still rankled. In his absence, his brother-in-law William Johnston won a suit against him for debt and five contiguous lots Hunt owned were auctioned at the courthouse door on October 2, 1865.[38]

In October and November 1865 Hunt was living in Memphis, advertising for patients. In December he tried again, this time in New Orleans: "Dr. R. P. Hunt, late of the Confederate Army, having permanently resumed his residence in this city, respectfully offers his Professional Services to the citizens and visitors."[39]

But that permanence was short-lived, for by May 1866 he had at last returned to Louisville and to his wife. To make ends meet, the two of them, in association with another married couple, would preside that summer over a resort hotel in Trimble County known as Bedford Springs, forty miles east of Louisville. The "medicinal virtue of its waters, its healthful and airy locality, its delightful pleasure grounds and choice and well ventilated apartments" were among the attractions. So, too, the smokehouse

and larder were "well supplied with all the substantials of good living, the bar abundantly stocked with the most choice liquors." There was a house band, together with bowling alleys "and other rational amusements" to entertain "the young and gay."[40]

Sallie would have had to play hostess, a role to which she was long accustomed, but never before for money. It must have been quite a comedown. "The two excellent ladies of the proprietors, Mrs. H. and Mrs. B., will be found no less efficient than their worse halves in contributing to the wants and comfort of their guests. Added to all, Doctor Hunt is a most accomplished and skillful physician, and will always be ready when required to minister to the health of his guests."[41]

Yet on the positive side, because Sallie and Robert had begun their courtship at Drennon Springs, the very similar Bedford Springs may have brought back happy memories. They might have considered it a last-ditch effort to save their marriage. Advertisements for the resort appeared from May 10 until September 6. On July 13 and 20 and then again from September 12 to 26, Hunt in addition advertised that beginning July 13 he had opened a medical practice in Louisville at 126 1/2 Second Street. By September he had moved the office to "34 West Jefferson street, up stairs." The last advertisement for his Louisville medical practice appeared on September 25, 1866.

Sallie had purchased the building at 34 West Jefferson, installing the white satin chairs and piano that Lincoln had helped her retrieve on the second floor, together with all her belongings, and renting out the downstairs to a barber. Such a thing was unheard of in Louisville.

> A wave of horror went over the city when it was announced that Sally Ward Hunt had furnished rooms over a little barber shop on Jefferson street, and intended living in them with her young son. It was not the custom in those days to have elegant apartments over business houses, and then "people who lived over stores were nobodies." . . . However, little recked Sally Ward what people said. She owned the little house and little else besides, and had made up her mind to live there, and there she lived. It took a great deal more than the opinions of the citizens of Louisville, or of the United States, for that matter, to make Sally Ward change her mind when once she had determined on anything. So there she lived, and there she was visited by some of the best people of the city.[42]

She lived in that apartment for the next ten years, with her son—and her husband, too, for a while. But by January 1867 Robert had left again, this time for Chicago, with the intention of starting a successful medical practice.

Her father's death and the evaporation of Robert's fortune had greatly reduced Sallie's income, but she still had her jewels and her expensive tastes.

Elizabeth Ellet wrote from New York to a friend on May 26, 1867, to complain that "Mrs. Sallie Ward Hunt has been spending some time here, at Fifth Ave. Hotel, paying twelve dollars and a half a day for herself and servant! For tea and toast in her room, a dollar extra each time! I spoke to her about wearing so many diamonds in a hotel: she had on ten or 20 thousand dollars' worth the other evening. . . . She called here yesterday, perfectly magnificent." In today's money her hotel room would have cost $375 a night, tea and toast $30, and her diamonds $600,000.[43]

While Sallie was enjoying a luxurious stay in Manhattan, Robert was not doing so well in Chicago. On the night of July 8, 1867, he fell—or jumped—from his second-story office window. The next morning, his body was found lying face-down in a pool of blood on the sidewalk near the corner of Madison and Clark Streets. A witness said that Hunt had been "in the habit of drinking excessively, and was considerably intoxicated" the night of his death. A Louisville acquaintance commented that Dr. Hunt "could not meet with fortitude the troubles and reverses brought on him by the war."[44]

His body was brought to Louisville, where he was buried at the Ward family plot on July 12, the funeral procession beginning from the Ward mansion at Second and Walnut, where Sallie's mother was still living. His fellow Louisville physicians gathered to pay him tribute: "we deeply deplore that, while Dr. Hunt had no enmities toward others, he was himself his only enemy. But when we contemplate his many and rare virtues, while they come in troops at memory's call, we feel that on this occasion we should 'Be to his virtues very kind, / And to his faults a little blind.'"[45]

Eight

A CHANGE OF FORTUNE

_B_igelow Lawrence died from a sudden illness in March 1869, leaving his second wife a million dollars. Could Sallie have had second thoughts about having passed up the prospect of such a windfall? But how could she have lived with such an insufferable spouse for that many years? He was, a Georgia newspaper remarked, "a sordid miser, refusing to allow her to live in that style of magnificence which he could well afford and which she demanded as her due."[1]

He "was never anything but a kind of runt in the Lawrence family," said the _Memphis Post_. Unlike his more distinguished father, he never rose high in the diplomatic service, having to settle for the post of Consul General to Florence. When the Civil War began, "in a spasm of belligerency," he forced himself on General McClellan in Washington as a voluntary aide-de-camp but because of his deafness could make no real contribution. "The eccentric cast of Mr. Lawrence's patriotism attracted some attention at the time, but he soon found that his connection with the army was more honorary than otherwise, and he returned to private life."[2]

Newspaper articles about his death reminded readers that he had once been married to the famous Sallie Ward, while offering opposing views

of her character. The *Macon Telegraph* gushed that she was "perhaps the most beautiful woman ever born in America," with "intellect, education and refinement equal and superior to her personal charms." She had done well, it added, to separate herself from the stingy Bostonian who refused to provide for her needs. By contrast, the *Memphis Post* ridiculed her for being "a very fast girl" who "claimed to be the belle of Kentucky" and "hoped to make a sensation in Boston, as she had in Louisville, by her loud talk . . . and disgusting *empressement* of manner."[3]

The Ward mansion, which had been the headquarters of Buell and other Union generals during the Civil War, and large enough that Sallie and her mother could still live there, became in November 1866 the headquarters of General George H. Thomas, Commander of the Division of the Tennessee. In 1868 it housed the Freedmen's Bureau, which served to protect formerly enslaved persons as well as free Blacks from violence, set fair wages, and set up schools. In 1870, Sallie's mother sold the house to the Cook Benevolent Association at what the latter "considered a bargain." In other words, for not very much. She then bought a smaller house on Fourth Street, past Broadway; Sallie still lived above the barber shop in the house she had earlier bought. The Cook Association intended to convert their new purchase into a home for destitute old men but was unable to do so for lack of funds. Instead, for the rest of the nineteenth century it rented out the building to a succession of boarding house operators, adding such improvements as "bathrooms and water-closet on each floor," electric bells, and a telephone connection. Sallie must have been sad to see the scene of her parents' famous banquets and her social triumphs be brought so low.[4]

In the summer of 1871, it was reported that she was going to publish her life story. To be called "The History of a Belle," it might have become a best seller had she written it. But as the *New York Tribune* remarked, "Mrs. Hunt has never been known in any literary capacity, and she is said to have undertaken authorship to console herself for the loneliness of her widowhood." The *Santa Few New Mexican* declared, "No one better than Sallie Ward can give the career of a fast and fashionable belle, if she sees fit to do so. But we doubt very much whether Sallie, or any other fashionable flirt, will give the true career, with its final downfall and bitterness and disappointment and wreck of a belle." But she was not yet ready to retire from the scene and was aware there was no need to bare all if there was still the chance of finding a proper husband.[5]

Some claimed she had a candidate in mind, one more wealthy than willing. According to a story telegraphed across the country at the same time (August–September 1871) as the one about her writing an autobiography,

she was planning to sue wealthy Louisville businessman Horace Newcomb for $300,000 for reneging on a promise of marriage. He had just divorced his wife with the help of the Kentucky legislature. The first Mrs. Newcomb had been confined to a Massachusetts insane asylum since she tried to kill her children in 1852 by throwing them out a third-floor window. She succeeded with the first two, but a quick-thinking servant saved the others by placing a mattress under the window while they were clinging to the sill. The divorce was granted in May 1871. On June 14, however, Newcomb married not Sallie but Mary Cornelia Smith, forty years his junior. She had been promised in marriage to his son, Herman Newcomb, one of the defenestration survivors, but he had died from an opium overdose.[6]

It gave occasion for a Virginia newspaper to make some cogent observations about Sallie's character:

> The lady and her family have been noted in the annals of the country. Twenty years ago she was a belle in Louisville, and her personal charms brought numerous admirers to her feet. Those who knew her well, and remember the events of that period distinctly, say that her attractions were by no means overrated. She was of the softer blonde style of beauty, tall and stately, with all those qualities of face and figure that delight and enchant the beholder. Her manners were winning, rather because of their ease and negligent abandon, than because of the quiet ease and good breeding that came of thought and culture. Her education is of the superficial type common in the South a quarter of a century ago. . . . The appearance of Mrs. Hunt again in public, and with such peculiar concomitants cannot but be painful to her friends, and will revive all the old disagreeable reminiscences. How can those who worship fashion and sin expect a better fate?

The assertion that her winning ways were due to her "negligent abandon" instead of to culture and good breeding parallels Margaret Erwin's observation that Sallie's contribution to women's emancipation was due not to any worthwhile intent on her part but rather to her "flightiness and folly."[7]

Though the rumor of her suing Newcomb was later asserted to be false, the notoriety was uncomfortable for her, and it may indeed have had an element of truth. Perhaps she had at least been angling for him and had said something to someone about how upset she was when he married Miss Smith. The story seems to have started with an article in the *Dayton (OH) Journal* that was picked up by the *Cincinnati Commercial* and subsequently appeared in papers as far away as England. The *Journal* claimed that "the public pulse in Louisville beats for Sallie, and bets are made two to one that she gets a big slice of Newcomb's estate." Eventually the Cincinnati paper issued a retraction: "We are advised the whole story is without foundation,

that Newcomb never courted the lady, and has not seen her for two or three years, and that the lady herself is disturbed and distressed by the story."[8]

Despite her reduced circumstances she still had her jewels—until March 1873, that is, when thieves emptied the safe deposit boxes of the Falls City Tobacco Bank. "Many of the fashionable ladies of Louisville were robbed entirely of jewelry by the raid, the famous belle Sallie Ward Hunt losing a valuable collection of diamonds."[9]

In April 1874, Louisville was transfixed by the spectacle of a trial involving one of Sallie's former suitors, John Throckmorton, brother to Malvina's husband, Colin. "Since the famous Matt Ward trial of nearly a score of years ago, no case has excited so much attention in this city," said the *Courier-Journal*. "The lives of the two principal parties were the topics of conversation on every street corner, at the hotels, in private houses, between hurrying passers-by, on the street cars and the railroads." Throckmorton had once courted the older sister of Ellen Godwin, then—accounts differ—Ellen herself. That was in 1851. She claimed that he promised to marry her, then seduced and abandoned her. He maintained he had never even asked her out. She vowed a peculiar vengeance: she began to follow him wherever he went in the city, walking half a block behind, waiting outside in the snow and the rain when he entered a building, then trailing him again when he emerged. Her tall, gaunt figure, dressed always in black and veiled, was a familiar sight in Louisville, earning the nickname "Throckmorton's Ghost." When he tried to flee by traveling to another city, she mysteriously showed up there, too, whether it was St. Louis, New Orleans, Philadelphia, or New York. His only respite came when he fought for the Confederacy. But afterwards, there she was again. She so tormented him that he tried to frighten her off: "I caught her one evening on the street, when she tried to escape in an alley, and told her that I was going to kill her, and she said, 'Kiss me first.' . . . I have seen her run after the buggy and street cars in which I was riding; I tried to compromise with her, but she would never tell me what she wanted except to see me; I once agreed to visit her once a week and sit on the porch for her to see me, but refused to enter the house, as I did not want scandal; after a little time she commenced following me again."[10]

After twenty-three years of this, he tried to have her committed to a mental asylum. A jury would decide if she was sane. The court assigned her a legal team. The trial lasted eight days, with witnesses for both sides, including doctors specializing in diseases of the mind. She testified in her own defense and the jury was so impressed with her eloquence that they quickly voted she was sane. An immense cheer of approval rose from the crowded

courtroom that could be heard outside on the street. Every member of the jury shook her hand. Afterward, she declared that she had accomplished her purpose, which was to shame Throckmorton in the eyes of the public, and never troubled him again.

When Throckmorton died in 1881, a man who had heard that roar of approval as he passed by the courthouse that day seven years before, and who had a "lady friend" who had come to know Ellen Godwin at the time of the trial and to whom Ellen had written letters, found it an opportune moment to write an essay on the case for a Louisville newspaper. He began it by alluding to Throckmorton's earlier pursuit of Sallie Ward.

> Today came news of the death in Mississippi of Major John R. Throck-morton of Louisville, a man of leisure and of style, a bachelor of sixty-five, a famous beau of a quarter of a century ago, and the lover of the beautiful Sallie Ward at the time when the bewitching Southern girl captured the son of [Abbott] Lawrence, of Massachusetts. When the young bride went with her new husband to Boston, Throckmorton followed. It is asserted that jealousy of Throckmorton, which Mrs. Lawrence was too proud to resent by explanation, was in reality the cause which led to the separation of Lawrence and his wife. Sallie Ward came back to her father's house, and a divorce was granted. . . . Throckmorton still hovered around devotedly, but was not rewarded by the lady's hand.

She married Robert Hunt instead. Now "the handsome widow drives about in the finest private turnout the city affords, and has paid no more attention to the addresses of the Major than in the days of her girlhood. . . . [T]he persistency with which the Major followed her gave him a certain interest in the eyes of the multitude, but this alone would not have made him the notorious man he is. Yet it was another woman that held him up to the gaze of mankind, a woman who shadowed him more constantly than he haunted the path of the famous belle." The author of this account was prompted to write it not just by the occasion of Throckmorton's death but also by his visit to a "lady friend" of his who had been a close friend of Godwin's and who showed him letters Godwin had written her, several of which he published with his essay. It would seem that Godwin, via his "lady friend," was the ultimate source for his assertion that Throckmorton had assiduously pursued Sallie, even in Boston, and had been a factor in her divorce. As we have seen, Bigelow's seeing her in the other carriage with another man led to his physical attack on her that resulted in her telegraphing her father to come get her. That other man could have been Throckmorton. This is suggested not only by the assertion in the 1881 article that he had

pursued Sallie in Boston in 1849 but also by that intriguing remark in
Bigelow Lawrence's *Exposition of the Difficulties Between T. B. Lawrence,
and his wife Sallie Ward Lawrence* about certain "motives [that] wedded
her so closely to Louisville," certain "other reasons [that] bore her to Lou-
isville and bound her there." Those words indicate that Bigelow believed
that his wife was attracted to a competing suitor from Louisville, which
Throckmorton appears to have been.[11]

Sallie's mother died on August 8, 1874. "Mrs. Ward has been very ill for
several months past, and her death was not unexpected. From the beginning
of her illness until her death her children and other descendants and friends
were continually at her bedside, devotedly administering to her wants and
making easy her last days upon earth." Her daughter was now free to enter
upon a new venture, and did, going on a lecture tour with another famous
Southern beauty, Octavia Le Vert (1810–1877). A published author, Le Vert
read from her works and told of her travels and notables she had known;
Sallie sang and gave readings too, perhaps from her memoir-in-progress.
They were both widows whom the war had reduced to poverty. Interest-
ingly, each in her youth had appeared in Turkish trousers at a masked ball at
the Ocean House in Newport, Rhode Island, Sallie in 1846 and Octavia in
1848. Octavia was costumed as Nourmahal, a character in Thomas Moore's
Lalla Rookh, and Sallie as Byron's Zuleika; at her parents' masked ball in
Louisville in 1850 Sallie would also dress up as Nourmahal.[12]

The two had appeared "before a large and polite audience " at Louisville's
Galt House in the summer of 1875. That it was polite suggests it may have
been less than enthusiastic. From there they went to St. Louis and other cities.
In the parlors of the Grand Pacific Hotel in Chicago on June 1, 1876, "The
two ladies," aided by a singer, a pianist, and an elocutionist, "had gotten
up a most pleasing entertainment, alternating vocal music and recitations
with reminiscences of by-gone times and heroes of this and the Old World."
Sallie's father had once paid for her singing lessons from a member of the
New Orleans Opera and in later years it was said that she kept up her music,
both vocal and instrumental.[13]

It had been advertised that Le Vert and Sallie Ward would continue their
lecture tour into northern cities, but Sallie did not go with her. Instead, she
found a bigger and more reliable source of income in the person of a third
husband, Venerando Politza Armstrong.[14]

The sudden announcement of their union shocked Louisville society to its
foundations. Sallie, who had been born into what passed for royalty in that
city and had first married a Boston aristocrat's son and then a scion of one
of the most prominent of Bluegrass families, was now to marry into trade,

and the pig trade at that. Her intended, a pork packer who had started out as a shoeshine boy, was nevertheless a very wealthy man. The ceremony took place in her apartment above the barber shop at one o'clock in the afternoon on Friday, June 23, 1876. After accepting the congratulations of friends and family, the Armstrongs took the Short Line Railroad to Cincinnati and from there a train to the east coast to visit the Philadelphia Centennial Exhibition on their bridal tour. A Louisville correspondent for the *Cincinnati Enquirer* wrote that Sallie was "the most discussed, the most misunderstood woman in the land. Some call her a heartless, vain woman of the world, whose sole happiness lies in her diamonds and laces and satins. They boldly assert that she is too fat; that she is an intrigante; that her complexion comes in the morning and goes at night; that lines and hollows are to be seen in the once fair face. But was there ever a beautiful woman who escaped calumny?" She was nevertheless still "in her glorious prime, a woman to captivate hearts." Vene Armstrong, until then known as "the prince of pork packers," would have to give up that distinction and be known until the end of his life as the husband of Sallie Ward. He did not seem to mind. He was infatuated, so much so that he changed his will to leave her nearly the entirety of his estate.[15]

What the Louisville elite found so upsetting was that she married a man of such humble origins. He was born in 1824 in Washington, DC. His father had been a typesetter for a newspaper there; after his father's death Armstrong's mother remarried and came to Louisville, where she opened a grocery that started with practically bare shelves but eventually prospered. When Vene came of age he relocated to West Point, Kentucky, where he failed in business but succeeded in getting elected for two terms to the Kentucky legislature. When the war came, he returned to Louisville. With partners he opened a hog business that prospered, becoming the leading one in the state. Thanks to his political skill and legislative connections, he secured lucrative government contracts. For example, on November 7, 1864, as historian Richard Collins recorded, he was made the authorized agent of government for purchasing hogs in more than a dozen Kentucky counties. He "will pay in cash, not in vouchers as many fear." In addition, his friendliness and vast store of anecdotes endeared him to many, and he became one of the most popular men in the city—as he had been when a legislator in Frankfort. On one occasion, the House could not get a quorum even after visiting all the bars to find its missing members. Then they heard a report that the absentees were congregated in the Senate Chamber, so they marched over there to demand their return. They found the speaker's chair occupied by a newspaper humorist "and Vene Armstrong, a Senator and a funny fellow, on the floor singing a comic song, in the chorus of which

both Senators and Representatives joined." The rightful Speaker took over the chair, rapped for order, and the delegation from the House declared the Senate in rebellion. "'The Senate stands adjourned,' shouted the Speaker, and amid much laughter both Houses adjourned for another drink."[16]

Something else that made him objectionable to Sallie's friends, if not to her, was his "ugliness, his entire lack of education, of elegance. . . . and his inveterate disregard of the requirements of genteel life, even to the extreme of a gross neglect of his person and his garments." But she rose to the challenge, and her docile pupil was soon patronizing the most fashionable tailors, bootmakers, and barbers, and buying expensive furniture, paintings, and bibelots so they could entertain in style in the imposing stone-fronted house he built on the northwest corner of Third and Ormsby. And she could ride in style, too, now that he had presented her a $3,000 pair of horses.[17]

But their bliss was brief: Vene died after a few days' illness on April 20, 1877, less than a year into the marriage.[18]

His son, William O. Armstrong, contested the will, understandably irate that Vene had rewritten it to award the bulk of his $200,000 estate to Sallie, reducing his son's share to one dollar on the grounds that he had already given him at various times at least $10,000. He was fully justified in doing so, for not only was his son "a man whom dissipation has made a sad wreck in looks," but just a few weeks after his father's marriage, the son attacked him on the street with a knife, intending to kill. His father's new marriage, he said, was the reason.[19]

Sallie wisely compromised, giving the son $20,000 in exchange for not contesting the will. Soon afterward, she placed a monument above the grave of her last two husbands in Cave Hill Cemetery. It depicted an angel clinging to a cross and writing the words "A Wife's Memorial." On the front was a scroll bearing the inscription "Vene P. Armstrong and Robert P. Hunt: honored and loved upon earth for deeds that won a home in heaven."[20]

She moved into the Galt House, and her social life blossomed. At a performance of Gilbert and Sullivan's *H.M.S. Pinafore* in September 1879, Kentuckians thronged Louisville's Macauley Theater, enjoying not only the opera but the spectacle provided by Sallie and her party and *Courier-Journal* editor Henry Watterson and his occupying the two proscenium boxes on opposite sides of the stage in full view of the audience. "The furor created equals anything ever aroused by grand opera," a correspondent for the *Chicago Tribune* opined. Gilbert and Sullivan and Watterson alike were upstaged when Sallie, ensconced in her box amid chairs and hangings brought from home, showered the spectators with iridescent gleams from her diamonds.[21]

When Ulysses Grant came to town in December 1879, Sallie made a grand entrance as Marie Antoinette, wearing an off-the-shoulder dress of pale blue velvet brocaded in butterflies of darker blue. After a change of costume, she appeared at the Galt House ball swathed in gold and velvet, a "tall lady of great amplitude of form, difficult to support on her tiny feet." This is not the only indication that she had gained some weight; "there were still traces of her beauty although she was very stout," an acquaintance recalled in 1924. But her diamonds may have helped divert attention from the plumpness. The hat she wore to the ball was "a gorgeous structure, and two diamond stars, as large as a policeman's badge, ornamented her coiffure; diamonds in her ears as big as hot cross buns; diamond necklace, diamond bracelets, a very Golconda of diamonds, graced an extremely affable and attractive lady, who seemed still to be the ruling spirit of Louisville society." Her late husband's wealth had evidently enabled her to replace the jewels stolen from her safe deposit box in 1873.[22]

When Chester Arthur came to open Louisville's Southern Exposition in 1883, Sallie was on the scene. The President was handsome and a widower. According to what the correspondent for the *Savannah (GA) Morning News* heard from "the Galt House ladies" the prevailing gossip was that the occupant of the White House during his brief stay "played the devoted to the celebrated belle and beauty and still fascinating widow, Miss Sallie Ward Armstrong."[23]

Nine

FINAL YEARS

As early as November 1878, it was rumored that Sallie Ward Lawrence Hunt Armstrong was to wed her fourth husband, Major George F. Downs, a now-wealthy Louisville clothier who had once humbly waited on her, "pleased to show her silks and satins, with uncovered head, obsequiously awaiting orders at her carriage door." He had been a guest at the masked ball the Wards gave back in September 1850, costumed as a Knight Templar. Despite the 1878 rumor, several years passed before they wed, in her parlor at the Galt House on the evening of April 7, 1885. "Mrs. Armstrong being a devout Catholic, the Right Rev. William George McCloskey was asked to perform the ceremony and consented," reported the *Louisville Commercial*; McCloskey had been Bishop of Louisville since 1868. He had been Sallie's first choice to preside over her previous marriage, to Vene Armstrong, but could not because he was out of town.[1]

There were few guests. Sallie's son, John W. Hunt, could not arrive from New York in time; consequently Mr. Downs did not invite any of his own family except his son and daughter-in-law. According to the *Louisville Dispatch*, "Only the household and a little girl witnessed the ceremony, while hundreds of callers were disappointed at not being admitted." The little

girl was Bertha Cooper, aged seven. She stood by Sallie's side and held her hand during the ceremony. Sallie was attired in cream serge with gold thread, trimmed with a fringe made of gold coins, as were her necklace and bracelets. It seems a little odd, given she had over the years been accused of marrying for money, that she would have adopted such a motif on this occasion.[2]

She appeared younger than her fifty-eight years (one reporter said she looked forty-five), but she had evidently lied to Downs on that score, saying she was four years younger than she really was, for he noted in his account book the following: "Sallie Ward Downs. Born 29th September 1831." She was indeed born on September 29, but in 1827.[3]

George F. Downs was thirteen years her senior. He grew up in Corydon, Indiana, and came to Louisville in 1832. He began as a clerk in a wholesale dry goods store, dealing in fabric, thread, and cloth. He was soon promoted to manager. He became an expert buyer, spending six months of every year in New York. It was said that he could close his eyes and by the touch of his fingers instantly judge the quality of a fabric. He served on the city council, striving for improved sewers, streets, and public buildings. He acquired much real estate and was often called upon to appraise properties. His first wife died in 1872, leaving a son and daughter. He was genial and handsome, said to bear a striking resemblance to President Millard Fillmore. Like Vene Armstrong, who had always been the life of the party, he too had a treasury of anecdotes and songs with which to amuse his friends and guests.[4]

Mrs. Downs enjoyed an active social life for the next decade, sponsoring debutantes, chaperoning at balls, and a prominent presence at the theater. Every afternoon she rode her carriage through the streets of the city, sure to attract attention. "I was visiting in Louisville in the late eighties," a woman recalled in 1930, "and my hostess called my attention one day to a handsome victoria being driven past in which sat a very elegant old woman shading her face with one of those parasols" with ivory handles that were jointed so that they could fit in a purse. "She was very old at this time, and it was whispered about that she went to Paris once a year to have her face enameled. I remember distinctly the air of elegance with which she held the tiny parasol to keep the sun from her eyes, and also the fact that she seemed very remote from the time, a breath from the past, as was the parasol." The enameled face was noticed as well by a trio of little girls sitting on their front steps to watch the Derby Day parade go by in the 1880s. "It was difficult for us to stay seated," one of them recalled, "when such characters as Sally Ward Armstrong Downs, a muchly married belle, went by in her expensive landau. It was whispered that she had rejuvenated her beauty

with an enameling process which smoothed the wrinkles out of her face but made it impossible for her to smile. We held our breaths hoping to see the enamel crack!"[5]

Her impending visit to St. Louis in the fall of 1890 was an occasion for newspapers to celebrate her, yet also hint that she was no longer as young as she used to be. The *St. Louis Republic* praised her intellect and learning, recalling Sallie's having been immensely touched that an Englishman who met her for the first time in London and who when asked what he thought of the American belle said, "I am attracted by her beauty, but found it totally eclipsed by her intellect." The *Philadelphia Times* congratulated St. Louis for being honored with her forthcoming visit, calling her "socially the most distinguished woman of America."[6]

Alas, it was not to be. Sallie canceled all her social obligations for the fall and winter of 1890, including the visit to St. Louis, when she learned of the death of her niece Emily Throckmorton Hawes, Malvina's daughter. Emily and her husband had each died just hours apart of typhoid fever. Emily Ward Johnston having passed at age 42 in 1883, Malvina was Sallie's last remaining sister.[7]

Malvina, it will be recalled, had eloped with Colin Throckmorton in 1846, marrying against her parents' wishes. Some time passed before they were again in the family's good graces. The Throckmortons were repeatedly beset by tragedies. Their first home outside of Louisville, nine miles down the Ohio River, was destroyed by fire in June 1850, soon after they moved into it. They relocated to Daviess County near Owensboro in 1855 and somehow survived even though Colin "never worked at anything, except sometimes over a poker game." Their first son to grow to adulthood, Aris, was murdered at age nineteen in 1870 by Peyton Kincheloe, a distant relative of the Judge Kincheloe who had presided over Matt Ward's trial. Malvina and Colin found their son's body on the road as they were driving their carriage into town. When the case finally came to trial, the jurors were out only twenty minutes before returning a verdict of not guilty. It is likely that they were persuaded that Kincheloe's action was justified because Aris had slightly wounded his wife when shooting at partridges on Kincheloe's property a few weeks before.[8]

Malvina, a widow after Colin's death in 1878, suffered the loss of yet another child in December 1888, when her son Maurice, the thirty-five-year-old postmaster of Birmingham, Alabama, was killed while trying to persuade a lynch mob not to attack the city jail. He fell in the fusillade of bullets fired by the sheriff and his deputies, as did many in the crowd.[9]

Sallie returned to the social scene the following season, appearing as a

chaperone at a dance sponsored by the Southern Ladies' Society in July 1891 and occupying a theatre box with a party of four from New Orleans and Cincinnati at a performance of *Ben Hur* in September. In 1892 she again served as chaperone for the Satellites of Mercury ball as she had done in previous years. In December she announced that she was no longer accepting invitations to receptions. Nevertheless, it was reported that she still ruled in matters of Louisville fashion. And perhaps of carriage painting as well, for she had recently ordered a barouche from New York that would feature wheels painted blue with white stripes. But the coach maker refused to follow her instructions, and, when it arrived, she had it repainted in Louisville according to her specifications, thereby starting a new trend.[10]

Sallie always had a kind word for everyone. When a fire broke out at the Galt House one night the hotel guests descended the stairs to the ground floor in various state of dress and undress. She was elegantly attired as always. When a portly old gentleman passed by in his long-sleeved, bright red flannel union suit, Sallie greeted him with a smile, saying, "All in red and still handsome." When everyone arrived downstairs, someone asked where her husband was. She calmly replied, "I never hurry the Major."[11]

In August 1894, she became so ill that her doctors thought she might not recover. Word got out, and newspapers across the country not only reported that she was gravely ill but took a step further and wrote that she had died. One from New Orleans asserted that she still possessed "in her 75th year"—though at the time of her death she was not quite sixty-nine—"the remnants of her once famous beauty. . . . But her years of conquest passed, and though loath to part with them, the time came when the bootblacks no longer turned to look after her. But though the Kentucky princess has passed away, her memory will pass into history as one of the most beautiful representatives of a state famous for its fair women."[12]

If in reading her own obituaries Sallie came across this one, she might not have been pleased to see herself described as that much older than she really was. The obits were still coming out in October, even though she had recovered by then, and resumed her daily afternoon carriage rides through the streets of Louisville. The *Owensboro Messenger* reported that "several papers in distant states published elaborate obituaries which have amused Mrs. Downs very much. But it is now time for the obituary business to cease."[13]

Yet in the summer of 1896, ill health returned, and this time she did not survive. She died from a ruptured stomach ulcer at 10:45 on the morning of July 7, before her son John W. Hunt could arrive from New York City. Present at her death were her husband; a cousin's wife; and Mary Weaver,

a formerly enslaved woman who for many years had been Sallie's personal maid. "She worshiped Mrs. Downs and never left her during the years of adversity that were hers about the close of the war. Mary Weaver was with her during her final illness, and, weeping bitterly in speaking of her mistress, said: 'Miss Sallie is the best friend I ever had and ever want to have. I lived with her over thirty years. I never had an unkind word from her, or heard her speak ill of anybody.'" A reporter interviewing Mrs. Weaver a quarter-century later, when she was working at the Churchill Downs Jockey Club, recorded that she said the way women dressed and smoked and perfumed themselves in 1921 made her nostalgic for the past. A distant look came into her eyes, and she sighed, recalling when she "looked at the beautiful Mrs. Downs and thought her reign and the gay life of traveling from New York to New Orleans or White Sulphur would never cease."[14]

Sallie's last night on earth was disturbed by a raucous party across the hall from her Galt House room. At three o'clock in the morning a party of boxers and chorus girls arrived, boisterous and drunk. The night clerk tapped on the door and announced, "There's an old lady dying across the hall. Her nurse telephoned begging us to stop the noise." They did. The next morning, the night clerk returned to thank them. Ed Rucker, one of the boxers, asked, "How's the old lady?" "Cashed in an hour ago," the clerk replied. "Used to be a famous looker. When her youth faded, she tried to beat old age. Had her face enameled. They say it looked good for a couple of years. Then the enamel wrinkled. She moved to the Galt House and never left her room." The daily carriage rides had ended.[15]

She was placed in the lavender casket she had chosen, clothed in the white satin shroud she had purchased during her serious illness two years before, with antique lace she had bought in England. The service was held at St. Mary Magdalen Church, 817 S. Brook Street, and conducted by its pastor, Father Louis G. Deppen. The casket was kept closed. As Sallie had requested, Charles Gounod's "Ave Maria" was sung. Her remains were taken to the Ward family plot at Cave Hill Cemetery, and she was buried next to her second and third husbands, Dr. Robert P. Hunt and Vene Armstrong. A medallion was added to the back of the monument she had designed for them, with the inscription "Sallie Ward Downs. / Her's [sic] was a mind / That knew no wrong. / Her's [sic] a tongue that / Spoke no evil."[16]

Ten

DIANA BOURBON

John Wesley Hunt, born in 1857 and the only one of Sallie's children to reach adulthood, was the principal legatee of her will as well as its executor. She wrote the will herself, on July 20, 1895, without legal assistance, and included the provision that if he died without issue then the estate would be shared by her sister Malvina Throckmorton and Emily Sidell Schroeder, the daughter of her late sister Lillie Ward Schroeder. An article appearing in the *Owensboro Messenger* soon after her death alluded to that provision, and said of Mrs. Throckmorton and Miss Schroeder that "quite naturally they are anxious to have the estate put into such a form that it cannot be disposed of, as it is probable they will be the heirs of John W. Hunt. He has not yet married, and his marriage is looked upon as improbable." The *Messenger* was wrong in predicting that Malvina would inherit from Hunt, for she died before he did, in January 1897. It was also wrong in predicting he would never marry.[1]

But Emily Sidell Schroeder was still counting on the unmarried Hunt's dying without children. In July 1897, Hunt sued Schroeder in the hope of having a judge, Alexander Pope Humphrey (1848–1928), chancellor of

Louisville's chancery court, resolve the uncertainty in the will one way or the other. He alludes to this in an August 30, 1897, letter to George F. Downs:

> My affairs still hang fire, but I have Judge Humphrey's assurance that they will be brought up this fall. Emily Sidell has written me on the subject. She does not seem to view my desire to escape a trustee with favor, but I am still hopeful that the matter may be settled without anger. It is my purpose to abide the construction of the will by the court whether in my favor or not. I certainly will not enter into any contest.
>
> I have written to Darcy [Mary Darcy, his fiancée, whom he would marry November 7, 1897] that I have no intention of trying to revoke any provision of the will. If I get the estate in my own right, I shall still regard it as held for her in the event of my dying first without immediate heirs, and I have so written her. You know, I am sure, that my wish is purely to have the question construed by a competent authority and have it done with. The commissions and storage charges alone are almost four hundred dollars a year. Repairs, taxes and commissions on the house last year ate up almost the entire rental. The estate is too small to stand such charges, but I would say not one word if I felt that my dear mother intended it to be so. I know, however, that her wish was the direct reverse.[2]

That is, he did not feel that his mother would have intended for a future Mrs. John W. Hunt to be denied the inheritance if she survived her husband. The commissions and storage charges were for the furniture and personal effects in his mother's estate, and the house to which he refers is the one Vene Armstrong built for Sallie on the northwest corner of Third Street and Ormsby Avenue. She had advertised it for rent in February 1896.[3]

John Wesley Hunt's relationship with his mother was not a close one. The *Louisville Courier-Journal* in 1912 recalled that when he came to Louisville for her funeral in 1896 "he had not returned to his old home for a period of five years, and he and his mother had not met in the last few years of her life." This means that he did not come to see her when she thought she was dying in August 1894. That sounds like an estrangement. Was his childhood with her an unhappy one? The same article noted that "As a boy in [his] twenties he left the city to make his home in the South, going into business in New Orleans." The St. Charles Hotel in that city noted the arrival in February 1879 of a "John W. Hunt, Louisville," which was very possibly him, then in his twenty-second year. She by that time had married and lost to illness her third husband. The article reported that Hunt was "remembered in Louisville as a young man of engaging personality and distinguished bearing, being about six feet two inches with brilliant coloring and erect carriage." After living in New Orleans, he returned to Louisville and was an

agent for an Eastern firm. "Then drifted into journalism," working for the *Louisville Commercial*. By 1890 he was city editor of the *New York Press*, and by 1894 was night city editor of Joseph Pulitzer's *The World*. "The death of his mother put him in possession of an income, but he continued to do newspaper work for a while," according to the *New York Sun*. On January 6, 1899, Hunt applied for a passport, as he and his wife were planning to go to England. His address at that time was 18 West 75th Street, and his physical description shows that he inherited his father's height. He was over six feet tall, with a high forehead, blue eyes, a straight nose, light and wavy hair, a ruddy complexion, and a full beard.[4]

Ruth Hunt, their daughter, was born in Manhattan on August 28, 1900. In June of 1901, the family moved to England. Mary Ellen Darcy Hunt wrote on her 1915 passport application, "We came over on account of my husband's health," and in a 1920 application said that her husband had been ordered by his doctor to go to England for his health. In 1902 they were living on the Isle of Wight, perhaps reasoning that the sea air would prove healthful. But one does not need to cross an ocean to live by one. Nor did England necessarily offer better doctors, for he went to the United States in 1902 to seek medical care. According to a letter he wrote on December 13, 1902, he "was about to undergo an operation in New York and he wanted to convey the information to the Fidelity Trust Company that he desired it to be appointed trustee for his little daughter, Ruth Hunt, who at the time was living with her mother at Auckland House, Shanklin, Isle of Wight, England." It seems likely that he thought he might not survive the operation if he wanted the bank to serve as trustee for his daughter. By 1911 the family had left the seaside and were living in St. Marylebone, NW, London, and he was the manager of a motor car company. The Hunts seemed to be doing well financially, for they had a cook and a maid.[5]

Hunt sailed from Liverpool for the United States on December 23, 1911. He had frequently made that crossing, according to his wife. On Christmas night he was, according to initial news reports, washed overboard in heavy weather, his body never recovered. But in fact, the seas were smooth that night and the weather calm. In contrast to his previous voyages, he traveled not in first class but second, with a roommate whom he did not know, Ernest Stead, a young motor engineer from Leeds. Hunt did not speak to him from the moment he entered the stateroom but was constantly muttering to himself. On Christmas morning Stead observed Hunt going through his papers and talking to himself. Now and then he would take from his suitcase photographs of his wife and child and stare at them for minutes at a time. He spoke to no one all day but paced the deck with his hands

clasped behind him, head bowed and lips constantly moving. That evening he spent an hour in the smoking room, then abruptly left. No one ever saw him again. It was assumed by Stead and others that he went to the rail and leaped to his death—as his father may have done through a window in Chicago forty-four years before. It would be fruitless to speculate as to why Sallie's son took his life, but one cannot help wondering if he had suffered some financial loss that would explain his traveling in second class. Or was he afflicted with fatal disease? Or had he been haunted all his life by the memory of his father falling to his death? And had Sallie's behavior toward Dr. Hunt played a role in his death and consequently that of her son?[6]

This was not the end of the story. Ruth Hunt grew up and was educated in England, although she and her mother made three extended visits to the United States, on at least two of them going to Kentucky. She studied ballet with Pavlova and played children's games with Noel Coward. During World War I she served as a volunteer nurse's assistant at a London hospital for military officers. She drove an ambulance and narrowly escaped death in an explosion. Those were "nightmare years," she recalled, because every man she knew was in the air force, and evry one of them was killed in the war.[7]

On Friday afternoon, June 27, 1919, King George V and Queen Mary held court in the garden of Buckingham Palace. It was the first such event since before the war, and 2,500 debutantes had come to be presented to their majesties, among them Ruth Hunt. According to an eyewitness, she "wore one of the most beautiful creations seen, which had, strangely enough, been made out of one of the court trains worn by her grandmother in her day." Whether or not Sallie Ward ever succeeded in being presented at the English royal court—the most likely date for her doing so was 1853—her grandchild did. The mantle had been passed, in a moment fraught with symbolism. If Ruth Hunt knew anything about her grandmother it was that she had resisted restraints placed on her sex. Ruth reveled similarly in a spirit of independence. "I'd been a rebel—always. Perhaps because my life was so clearly mapped out ahead of me. When I was a child, I learned to ride; to behave 'like a lady' (mysterious phrase, mysterious accomplish-ment); to speak foreign languages. I was presented at Court (the English one). And that's as far as it went. The rebellion started shortly afterward. It's been going on, intermittently, ever since." She went against expectation by not going to Oxford, although she could have, passing the entrance examination with distinction at the age of fourteen. Instead, she enrolled in the Royal Academy of Dramatic Art in London and took up an acting career. She became Diana Bourbon, both her stage and a pen name in London and New York theaters and in her frequent contributions to the *New*

York Times, the *London Evening Standard* and *Cosmopolitan*. Journalism had been her father's calling, after all.[8]

Her new name was an intriguing choice. Early in her acting career, she played on her great-grandmother's French heritage, the *Kansas City Star* of February 13, 1921, falsely claiming descent from "the renowned Bourbons of France." She also invented a Kentucky connection, as the San Pedro, CA *News-Pilot* of March 14, 1932, asserted: "Miss Bourbon was born in Kentucky, the home of the liquor known as Bourbon, and likes the beverage." The first name had its own associations: the goddess was feminine, beautiful, but undomesticatable. As huntress she outdid men at their own game; as the moon she was inconstant and unpredictable; chaste, she refused to submit to men, as instanced by her killing Acteon for seeing her nude, an effective way of dealing with the male gaze.

Diana Bourbon made her London debut as Lady Agatha in James M. Barrie's *The Admirable Crichton* in January 1920. In America she toured with the Shubert theatrical chain. She played the female lead in a new John Galsworthy play in both London and New York in 1922.[9]

She became a columnist for the *New York Times*, publishing fifty-six articles between November 19, 1922, and April 10, 1927, from England, Europe, and America. She courted controversy from the start, writing in her first column that "brains play absolutely no part in stage success, that comparatively few actors have any anyway, and that they would probably be better off without them!" The playwright has done all the thinking for the actors, who have no need to improvise.[10]

A month later she again drew from her theater experience, complaining of audience members who loudly converse with their neighbor and thereby destroy the atmosphere the actors are striving to create. She may not have known that her grandmother had been guilty of just such a disruption, arriving late in a Louisville theater with an entourage with whom she loudly held court, causing the actress to have to stop and wait for her to finish.[11]

In another column, Bourbon described herself as a feminist and a progressive, and despite her British accent, an American. She took pride in "the infinite superiority of the American woman," praising her for always trying to look their best, in contrast to England's frowzy shopgirls. Some, however, did wear too much makeup. Quoting Oliver Goldsmith, and perhaps relishing the irony of criticizing her own grandmother, she writes: "Like an ill-judging beauty her colors she spread, / And bespattered with rouge her own natural red." She could have been describing Sallie.[12]

In a Christmas column she seemed to grow nostalgic for a grandmother she had never known. One of those "Christmas necessities which know no

substitutes" and which no department store can supply is "a white-haired grandmother, who has shared in all your Christmas memories, to sit beside the fire." Not that Sallie would have ever permitted her white hair to show. One has to wonder if Diana in writing this column was thinking of her father, who had died so sadly eleven Christmases back. Perhaps indeed she did, for she also writes that "To the wanderers of the earth—to the rolling stones," among whom she counts herself, "to . . the homeless and familyless of the more 'fortunate' classes, Christmas is the saddest time of year. There is no occasion on which loneliness is felt more acutely, or when the realization that one is unwanted is more bitter." She asked her readers to take pity on the homeless like herself, "the Children Who Are Left Out!"[13]

For other columns she interviewed H. G. Wells, Georges Clemenceau, Emma Goldman, Lady Astor, professional gigolos, and actors in the Co-médie française company angry over having to wear bathing costumes on the stage. She reported on villages on eastern France still devastated by war; on resorts at Deauville, Biarritz, and the Côte d'Azur; on the jazz craze taking over England and the Continent; on the poor housing conditions of British miners; on being invited to an English country house and feeling out of place for sharing none of the other guests' passions for tennis, golf, or bridge; on Cockney theatre aficionados who make opening nights an ordeal for actors, stage managers, and playwrights; how Shakespeare was box office poison in his own country, and the new fad of riding to hounds in a motor car.[14]

William Marshall Bullitt of Louisville, whose grandmother Mildred Bullitt had written to his father in 1861 about Sallie's loudly insisting on her devotion to Southern rights, received a letter from Ruth Hunt in 1925. It was about the George Peter Alexander Healy portrait of Sallie made in 1860. Diana's mother wanted to give it to the Louisville Public Library. She did not want to part with it, but yielded to her mother's insistence, and was writing to Bullitt to arrange for its transatlantic voyage. The letter thus reveals that she had grown up with the portrait, which surely led her to wonder who her grandmother was and pose questions about her life and personality. Until her eleventh year she could have asked her father, who was undoubtedly as well informed as anyone on the subject.

Bullitt had in a previous letter mentioned that he was planning to send his sons to England for their education. Diana replied that this would be a grave mistake. If the boys were to live and work in America their British acculturation would be a terrible handicap, for they would then be "neither fish, flesh, fowl nor good red herring." That sort of international education

is "one of the most disastrous things that can happen to a child. And I say this to you out of the fulness of my own experience."[15]

Her rebellion continued, as she gave up her father's (and grandmother's) inheritance. "For many years I knew the security a settled income gives. When I was quite old enough to know what I was doing, I gave that income away of my own free will, to someone who was dependent on me." She does not say to whom she gave it, but it was probably her mother. "That income had always stood like a bulwark between me and the world; if you like, between me and the consequences of my own folly. But from the moment of parting with it to the moment when I arrived back in New York a few days ago with twenty-five dollars in my pocket, I have never regretted parting with it." Like Sallie, she cast caution to the winds, though unlike her she cared little for money—perhaps because she had more options for earning it herself.[16]

It is not known why she stopped writing for the New York Times after April 1927, though the decision was more likely hers than the paper's. Editor Adolph Ochs was certainly happy with her work, giving her a bonus every year. In 1927 she was associate editor of the Weekly Sphere and drama critic of Britannia and Eve, two British magazines that merged in 1929. When she worked for the New York Times, "I knew that wherever I might happen to be, in any quarter of the globe, I could cash checks at any moment for almost any amount I cared to name." But "the job doesn't exist that won't in time make you a slave to it." She wanted freedom more than anything, more than financial security. Indeed, she positively desired insecurity: "If you want to stay alive with every fiber of your being, you've got to Live Dangerously, out on the edge of things." Money is only good to buy freedom with. "But freedom is precisely what most people sell in order to get it."[17]

In 1928 she surprised many of her friends by getting married, to British journalist Keith Norman Hillson. An article she published that year in Cosmopolitan explained why she did: "Not one woman in a thousand could earn a better living by her own efforts than she receives as a wife." But like Sallie, who had also married for money and regretted her choice at least on the first occasion, she divorced within two years.[18]

Diana's life would be forever transformed when she left New York for Hollywood in March 1932. Two of her stories would be made into movies, and she would begin an entirely new career in radio. CBS began broadcasting Hollywood Hotel on October 5, 1934, and it became the most glamorous show on radio, thanks to the film stars it featured. Diana was named

casting director in August 1934 and put in charge of scripts the month after. Every current film star except Greta Garbo was a guest on the show during its four years, getting in return only a carton of soups from the Campbell Soup Company, the sponsor of the program and Bourbon's employer. But the celebrities were generally happy to appear, for the publicity increased their ticket sales. The show had been the idea of newspaper columnist Louella Parsons, who was so powerful she could force even unwilling stars to appear by threatening to badmouth them in her column.[19]

By April 1936, Diana began producing another popular program, the *George Burns and Gracie Allen Show*. For both productions, she was an island of calm in the control room, having in rehearsal meticulously timed to the second every song, sketch, and commercial. She was, as the *Los Angeles Daily News* noted, the only woman producer of a big network show on the West Coast, and "largely responsible for [its] recent noticeable improvement."[20]

She later recalled a particularly nerve-wracking moment.

> Once I produced a Burns and Allen show without Burns and Allen. George phoned me at 11 p.m. the day before the broadcast saying that Gracie had laryngitis. He was a perfect dear about it. We called the writers and went into an all-night session. We rewrote the script around the idea that this was a rehearsal, that Dick Powell and Frances Langford were putting on the Burns and Allen show and, by heck, they were going to do it.
>
> Of course, we added a lot of music. It turned out to be quite funny. Everyone was constantly making mistakes and correcting everyone else.
>
> It was then I discovered that in radio anything you might do is better than doing nothing at all.[21]

At one point in 1938, CBS had moved *Hollywood Hotel* from its comfortable studio to a new one that did not have enough space, and so rehearsals had to be held at two different sites simultaneously. Bourbon had to bicycle back and forth between them and was "breathing hard and developing sore muscles." She and the other producer complained about it and after a week they were allowed to resume work in their old studio. She had her hands full with the other show, too. "almost everybody in Hollywood is trying to 'sell' Miss Bourbon singers, comedians, announcers, tap dancers, castanet clickers and a little bit of everything else in the entertainment line for the new Burns and Allen show."[22]

Orson Welles's success with the frighteningly realistic radio broadcast of H. G. Wells's *War of the Worlds* on October 30, 1938, led the Campbell Soup Company to decide to sponsor his *Mercury Theatre on the Air* and change the show's name to the *Campbell Playhouse*. As account executive for the

Ward Wheelock advertising agency, Bourbon was chosen to be the liaison with Welles, but she "acted as producer-in-fact, and she was not afraid of offering Welles, 'often somewhat undiplomatically,' as he described them, whatever comments she felt like making. She was intelligent, well-read, aggressive, thoroughly self-assured, and possessed an uncanny knowledge of show business and theatrical matters of all kinds."[23]

In the course of their tussles, Diana wrote to Ernest Chappel, the announcer for the show and the sponsor's representative in Hollywood, to warn him about Welles. "Orson sings a siren song to anyone who will listen. Don't be hypnotized by him. He's dangerous." When Welles learned of this, he wrote her to complain and denied having such powers. "You hypnotize in spite of yourself," she replied. "You can't help it." Interviewed in 1950, Diana praised him to the skies: "He was most stimulating to work with and so painstaking! Once he spent hours trying to find out what sound grass made as it fell from a lawn mower. I had a terrific time trying to convince him that the grass itself made no sound at all."[24]

Welles did not renew his contract with the *Campbell Playhouse*, but Diana continued on for another year, directing Laurence Olivier and Vivien Leigh in George Bernard Shaw's *Pygmalion* and Lionel Barrymore in Dickens's *A Christmas Carol* in December 1940. By 1940 she was in addition directing five fifteen-minute shows a day.[25]

On August 4, 1943, she left New York for London to take charge of the radio division of the Office of War Information. Her fluency in French became an asset when she was put in charge of psychological warfare in connection with the French Resistance. Her broadcasts were meant to deceive the Germans at the same time they sent coded messages to the French.[26]

She returned to New York in May 1945, and was soon again working in radio, but it seemed "pretty dull after the excitement of my wartime work," she told an interviewer. At that time she was producing Edward R. Murrow broadcasts and two other shows. She retired in August 1950, moving back to Los Angeles.[27]

Bourbon had a brief speaking part in a 1963 episode of the TV series *The Fugitive*; appeared as a strikingly beautiful extra in the Ascot scene in the 1964 film *My Fair Lady*; and, looking her years, played a dowdy yet steely Madame Pollon in episode 1, season 3, of the TV series *Mission Impossible*, with just a hint of her British accent.

Sallie Ward's last descendant died on March 19, 1978, in Los Angeles. As Diana Bourbon, Ruth Hunt achieved renown in a different sphere than her grandmother, and certainly in a different way, but with an energy and independence akin to hers.[28]

Eleven

SALLIE REMEMBERED

\mathcal{I}n the summer of 1915, a pageant of scenes from the history of Louisville was staged by schoolchildren costumed in their grandparents' clothes. Among the events reenacted were the arrival of the first steamboat, Henry Clay campaigning, and Sallie Ward presenting the flag to soldiers bound for the Mexican-American War. In 1941, a banquet for four hundred students at the University of Kentucky honored "ten of the state's outstanding women," portrayed in "living pictures." They included women's rights activist Madeline McDowell Breckinridge, the first woman schoolteacher, a scientist, Nancy Hanks Lincoln, Rebecca Boone, the hatchet-wielding Carrie Nation, and "Sallie Ward Downs, Louisville beauty." In 1999, a tongue-in-cheek list of "Kentucky's Greatest"—including such celebrities as Colonel Sanders, Duncan Hines, D. W. Griffith, Johnny Depp, Henry Clay, Zachary Taylor, James Still, Jesse Stuart, Muhammed Ali, Hunter Thompson, Robert Penn Warren, Happy Chandler, Thomas Hunt Morgan, Belle Breezing, and Irvin Cobb—found room for "Socialite Sallie Ward."[1]

Thus, though her national fame had faded, she was still remembered in her native state as late as 1999. During her lifetime, her celebrity, if not her notoriety, was perhaps matched by that of Octavia Le Vert (1810–1877) of

Mobile, Alabama, her lecture tour partner in 1875–76. Le Vert was widely admired for her beauty, her literary talent, and her good works, which included saving George Washington's estate, Mount Vernon; unlike Sallie's, her life was free from scandal. As earlier noted, both appeared in Turkish costume at Newport's Ocean House, and we might add that to each a toast was drunk in her slipper.[2]

Two other women in one way or another related to Sallie invite comparison. One is her sister-in-law Anna Key Ward, who was accused of playing both sides when the Civil War swirled around her late husband's plantation, charming both Union and Confederate officers, and twice arrested for smuggling goods to the South. Then to save the estate from creditors, like Sallie (and Scarlett O'Hara) she married a rich man; as indicated earlier, his name was Major William Hemphill Govan and the wedding took place November 1, 1866. A son, Andrew Chevelett Govan, was born in 1869 in Arkansas, but died in Crab Orchard, Kentucky, on July 23, 1870. The funeral was held at the Louisville home of Mrs. Robert J. Ward, the mother of Anna's first husband, Matt F. Ward, and burial took place in the same lot of Cave Hill Cemetery where Matt, and the rest of the Ward family reside. Before early 1878, the Govans must have divorced, for he was at that time married to his second wife. By 1874 Anna had left him and Helena, Arkansas, to mix in East Coast society, at least for a few weeks: "Mrs. Govan, formerly Mrs. Matt Ward, of Kentucky, and her daughter, Miss Emily Ward, will pass the gay season in Washington," a newspaper in that city reported. Major Govan must have been the source for the funds needed to do so, whether directly or through a divorce settlement. When Anna Key Ward was interviewed in her Louisville home in 1886, she had dropped the name of Govan, and played the role of devoted widow to the hilt, as if she had always and only been married to Matt Ward.[3]

The other woman is Ellen Godwin, who, it will be recalled, was desperately in love with John Throckmorton, who was desperately in love with Sallie. Godwin found a spectacular way to fight male dominance, pretending to be the ultimate submissive woman, dogging the steps of her pretended beloved for twenty-three years in order to destroy his life, or at least his peace of mind. With indomitable will she stood on the sidewalk in the rain, the snow, and the blazing sun, like a suffragette chained to a railing to advance the cause.

Unlike the other women honored at the University of Kentucky in 1941, if Sallie ever accomplished anything in her life, it was without intending to. As we saw Margaret Erwin say, "Sooner or later women will be on a level with men in all matters but we are far from that today. My cousin, Sallie

Ward, seems to have made more progress in that sort of emancipation than any female I know. But her efforts are through flightiness and folly." She also observed that Sallie "showed that a woman in pants is sometimes more effectual than a man with or without." Any woman who manages to win a divorce at a time when few can contributes to the struggle for women's equality.[4]

She wore the pants in her marriage to Bigelow, literally when she dressed in Turkish silk trousers and figuratively when she refused to obey him with regard to cosmetic adornment. In the latter fight, however, she was egged on by her mother, who saw it as part of the war of the sexes. From what her mother wrote on April 15, 1849, we can see that Sallie had temporarily yielded to her husband's insistence but was saddened by its effect on her appearance:

> I am going to write you a real war letter. You say you are acting by Mr. Lawrence's command and you are unhappy by so doing. Then let me advise you in this case: seem to obey, but do as you please. If you use proper caution he can never know it. You say I can't imagine your appearance now. Yes, Sallie, I can, and nothing to object to either. You are better looking without complexion than with too much. This I have always said. But if you think differently, then do what would make you happy. You could not be less so, I should judge, under any circumstances. Then never fear Mr. Lawrence's anger; it could not be more enduring. Now, dear Sallie, if you would take the right means, he could never discover it. you must begin with caution, and keep it up. The most delicate tinge possible is all you want. If you have no more [on than that], defy the opinion of the universe, the commands of Mr. Lawrence, and every one else. Stick to it with some of your mother's spunk. . . . My dear child, determine one of two things: to give it up at once, or stick to it in defiance of all and everything that may oppose. You cannot live long as you are. Then, Sallie, be a woman, and act as one in future.[5]

This is the opposite of the advice most parents gave their daughters at that place and time, as Anne Firor Scott explains: "From earliest childhood girls were trained to the ideals of perfection and submission." Sallie Ward was an exception in many ways, and this was one. Another was the family wealth that enabled her to heed her mother's counsel to simply "do what would make you happy."[6]

Those were indeed words to live by for Sallie, and she learned them at her mother's knee. Nothing survives today of whatever advice her father may have given, but this letter from her mother offers a rare glimpse into family dynamics in the Ward household. The testimony of those who knew them was that Sallie's father had a "courtly grace of manner" whereas her mother

"had a decided hauteur of manner that she displayed not infrequently." The
latter observation reinforces the impression made by testimony at her son's
trial that her outrage at William's punishment ("she demanded what I meant
by treating *a Ward* in that manner," Sturgus recalled) encouraged her son
to wreak his vengeance on the teacher who inflicted it. We recall the *New
Albany Daily Ledger*'s observation that "It is generally understood that Matt
Ward was instigated by his mother to the attack on Butler." She in addition
probably helped Matt create the red mark on his cheek as evidence he was
acting in self-defense.[7]

The form that Sallie's self-pleasing behavior took was that of a quintes-
sential belle. For all the submissiveness that was normally drilled into the
souls of southern planters' daughters, Anya Jabour writes, "By becoming
southern belles" through the ritual of "coming-out" as a debutante, "young
women in the Old South took on an identity that permitted—and even en-
couraged—them to please themselves rather than pleasing others." It was "a
truly once-in-a-lifetime opportunity to live like a pampered princess." Yet
that opportunity was short-lived, for as debutantes they were entering the
marriage market, and a wife could rarely please herself. Sallie Ward, however,
never went through that process: "In those days it was customary to give
coming-out balls to launch a daughter into society, but instead, even when
a school girl, [Sallie] was permitted to take part in the home entertainments
of her mother, and gradually became a social factor of the household." She
was never suddenly a debutante, suddenly free from constraint, suddenly a
belle. She acquired her belle status gradually and once she had it never let
it go. All her life she did as she pleased and as one can tell from the history
of her marriages, she never submitted to a husband. And all her life she
worked to keep herself beautiful, in middle age and beyond consistently
appearing younger than her years. It came at the cost of the face enameling
that when it finally wrinkled may have kept her from venturing from her
Galt House apartment in the last months of her life.[8]

After listing the accomplishments of some other prominent Kentucky
women, Helen Deiss Irvin writes: "At the opposite of these dedicated, pro-
ductive lives was the life of the antebellum southern belle. Sallie Ward was
an archetype of this species. . . . The belle flourished in an elite world of
sentimental adulation of female purity and male code of honor—concepts
romantic enough in the abstract, but in practice, effective means of con-
trolling women. Her uselessness and ornamentality served as proof of her
family affluence and position." While the Southern code of honor goes far
to explain Matt Ward's crime, as Bertram Wyatt-Brown argues, to speak of
female purity with reference to Sallie is to confuse her with a bevy of more

traditional belles. Purity was not her style, certainly not after she became a divorcee, and it was not the source of her adulation, which continued long afterward. She was indeed useless and ornamental and could not have been so without her family's affluence and position, but it was not for the sake of proving her family was rich that she lived the life she did. Nor was she among the victims of men engaged in the task of "controlling women."[9]

As a belle, she was not exactly a southern one. Kentucky embraced the Confederacy only after the war was lost, and only then did it become southern. The first state admitted to the Union west of the Appalachians, before the war Kentucky was considered part of the West, and Sallie was typically called the "Belle of the West." It was not until after the Civil War that she began to be called a "southern belle" in American newspapers, for by then the old West had been swallowed up by the South, and a new one had emerged far beyond the Mississippi. When the *New York Daily Herald* commented in 1850 on Sallie's divorce from Bigelow Lawrence, it contrasted her roots and his not in terms of South vs. North but of West vs. East: "Louisville and the West are free, unrestrained, go-aheadative. Boston and Down East are shackled, conventional, and slow-coachy."[10]

April E. Holm writes: "Kentuckians had expected a return to 'the Union as it was' when the war was over, and the abolition of slavery made this impossible. Conservative Democrats' swift ascent to power" in Kentucky state government "reflected white Kentuckians' rejection of the war's outcome. Kentucky, in the famous words of . . . E. Merton Coulter, 'waited until after the war was over to secede from the Union.'" As Brad Asher notes, "Whether Kentucky was southern from the start or whether it 'became' southern after the Civil War has recently become something of a scholarly debate." On the one hand, Anne Marshall has maintained that "Kentucky was, before, during, and after the Civil War, a southern state" and that it was not the case that Kentucky only became southern after the Civil War but rather that its postwar politics "played a major role in cementing and embellishing Kentucky's already-existing southern identity, in effect making it more southern." On the other hand, Christopher Phillips has insisted on "the transitory nature of American regions," pointing out that for historian Frederick Jackson Turner the American frontier kept moving west. "At the turn of the twentieth century, the former western borderland had been replaced, or soon would be, by binate organizing principles known as North and South." When Turner moved to California, he "[l]eft far behind . . . a border, no longer between East and West, but rather between North and South." West vs. East (and not South vs. North) was precisely how the *New York Daily Herald* in 1850 saw the contrast between Sallie's Louisville

and Bigelow's Boston. Phillips further asserts that "the national confluence once represented as the West [including Kentucky] was remade as South and North by the internal political conflicts of the Civil War." According to Aaron Astor, "Kentuckians were westerners, as they often reminded themselves." They "valued a conservative order based less on the ancient traditions of the Virginia Tidewater than on social equality among the white masses on the settled frontier." Maryjean Wall argues that in the 1890s, with the help of such "plantation writers" as James Lane Allen and John Fox Jr., "Bluegrass Kentucky began to swap the remnants of its Western identity stereotypes identifying it with the South," and that it was consciously done to improve economic prospects for the horse industry.[11]

Not only was Sallie less a Southern belle than a Western one, but she was also not a planter's daughter, for though her father was an absentee landlord to plantations in Arkansas and Mississippi they were not the main source of his wealth, which came from his extensive mercantile enterprises. In one of Sallie's obituaries, it was said of him, "His income from a magnificent business in New Orleans was spent with an unparalleled lavishness" in Louisville. The notice said nothing of any plantation income, which did exist but paled in comparison. Of course, his business income came from the cotton trade—he advertised himself and his partners as "cotton factors"—and thus from the unrequited toil of the enslaved, but neither he nor Sallie ever lived on a plantation. Her brothers Matt and Bob later did, and after Matt's death Anna had to run the one in Arkansas by herself, saving the cotton and recovering some of the enslaved workers who had escaped, as had done the Confederate soldiers' wives in Drew Gilpin Faust's *Mothers of Invention*.[12]

In February 1879, humorist and platform lecturer Melville Landon, under the pseudonym Eli Perkins, wrote an account of Sallie's life up until that point. It was widely published in newspapers across the country, and she may not have been pleased at being the butt of his humor. But there were some home truths in what he said, despite his exaggerating for comic effect. T. Bigelow Lawrence, according to Landon, "fell in love with Sallie Ward. Sallie didn't love Bigelow—she never loved anybody—but old Mrs. Ward, who was a great matchmaker, thought it would be a splendid match and actually coaxed Sallie and teased her till she married this Yankee." To say that she never loved anybody is to forget that she may well have loved Robert Hunt, at least for a while. Her mother didn't choose him; Sallie did. And they certainly seemed happy enough for the first several years. But it was apparent their love had turned sour when she refused to visit him in

his imprisonment, when he refused at first to return to her when the war was over, and when he died alone in Chicago, a likely suicide. She certainly loved her son, although we unfortunately have little information on which to draw, and she loved her sister Malvina. But her first, third, and fourth marriages were not love matches. Vene Armstrong in particular was, for this Scarlett O'Hara *avant la lettre*, her Frank Kennedy, the physically repulsive though sweet-tempered merchant who saved her from ruin. Landon/ Perkins was also probably right when he said that she only married Bigelow because her mother talked her into it. The marital merger of the Ward and Lawrence fortunes was as transactional as the others, but unlike her union with Armstrong there was no need for it other than her mother's greed.[13]

Another retrospective look at Sallie's career comes from a not-disinterested party, John Harding (1843–1915), husband of Susie Downs, the daughter of George F. Downs from a previous marriage. He complains with some bitterness that his father-in-law was "decoyed to her parlors" and "parted from his dollars," as Sallie's previous husband had also been. On that occasion Vene Armstrong's son was so angry at being denied his inheritance that he tried to kill his father. For Harding, revenge took the form of the following unpublished poem:

"The Story of a Noted Belle"

Her bonnie eyes were brown and her chestnut tresses long,
Her form was a model for sculpture and for song,
Her poised head was classic and filled with love of gold,
Her divinely swelling bosom had neither heart nor soul.
She was the fairest beauty the New World had ever seen,
And living in ancient Sodom had reigned as its Queen.

When she rode through the market 'twas the talk of the town,
When she crossed the dusty street she raised her dainty gown,
And from her tidy ankles the laddies plainly see
Her leg deserved the diamond garter clasped above her knee.

She wedded a rich Boston youth of purely Puritan stock,
But her giddy manners gave his parents such a shock
They packed her, bag and baggage, back to her home,
Going a faster gait than gaily she had come.

But for all that she cared not a blether,
For off with the old love she soon married another;
She danged him, and banged him, and robbed him of his plunder,
And he fled from fury through a fourth story window[14]

The civil war coming on she grew patriotic,
Consoled Buell's army of officers erotic,[15]
And many a deluded gallant was caught in her trap,
Believing he alone had a highly private snap.

The fragrant rose sparkling with the dew at morn,
Sheds about the parent stem its withered leaves at noon;
The rare and radiant Beauty makes us mad with love today,
Tomorrow fades, and fades, and slowly fades away.

So with our famous fair one Time has played the devil,
Her face is gross and flabby from many a night's revel.
Rouge supplies the roses which from her cheeks have flown,
And a scratch conceals the spot on the naked scone.

Next she married old Booze drunk, and never let him sober,
Robbed his children of their fortune, and lived in clover,
Silks and diamonds, coach and horses, she cuts a great swell,
While poor old Booze is squealing in hell.[16]

Then the gallant Major is decoyed to her parlors,
He is married in a jiffy and parted from his dollars;
So the mighty Samson is shorn of his locks,
And'll be damned to save a pair of socks.[17]

But however absorbed and busy with many plans
We must drop all to go whenever Death commands,
Leaving our work undone in great confusion,
Our pleasures all a bubble, and our hopes all a delusion.

Thus Death snatched her away from this mortal shore;
St. Peter saw her coming and quickly slammed the door.
Old Hornie swore a mighty oath; "He'd be damned if he'd abide her,"
Death, greatly puzzled, knew not where to hide her;
So she incessantly wanders with ghosts and warlocks fell,
Rejected by heaven and refused by hell.[18]

Despite Harding's anger at Sallie for how she treated his father-in-law, and by extension his wife and himself, relations between George F. Downs and Sallie's son and heir John Wesley Hunt appear to have been cordial, to judge from the letter Hunt wrote Downs at a time when the uncertainty in her will had not yet been resolved. He asked his stepfather for financial advice (whether to keep or to sell the gas stock his mother's father had given her) and to say he just wanted the will settled, whether in his favor or not.

In contrast to Harding's Hudibrastic rebuke, Elvira Sydnor Miller, who adored her, paid tribute to her most essential quality, her beauty. If for Emerson the rhodora's beauty is its own excuse for being, for Miller Sallie's is its own best praise, and can almost defy death.

AT SUNSET

To Mrs. Sallie Ward Downs.

I saw thee at the sunset hour,
Ere young stars trembled into sight,
And, oh! methought thy beauty's power
Could charm and stay the fading light.

Though but one glance, one fleeting smile
To my rapt vision then was given,
I turned away, and dreamt erewhile,
'Tis thus an angel looks in heaven.

The dusty road seemed strangely fair,
The trees a softer shadow cast,
And tranced was sunset's golden air
As if a strain of music passed.

Thou didst recall all beauteous things,
That light, that joy we crave in vain,
The glory of eternal springs,
The chord that crowns some perfect strain.

But vain the minstrel's power to thrill
In praise of thee his votive lute,
The inspiration greater still
Than song or fancy makes him mute.

Enough that I have looked on thee,
And owned thee for my spirit's queen;
Aye! felt that paradise must be
Where'er thy radiant face was seen.

This is enough, be thou always
A sunset memory fair and bright,
Thy beauty is its own sweet praise,
And when thou goest—falls the night.[19]

To this same poet she once confided a secret: "I remember the late Sallie Ward Downs who said to me, 'When the war swept away our fortune, my dear, I found how shallow are the protestations of friendship; I was left alone

and poor; people I had entertained, those who owed their social positions perhaps to me, those whom I had aided, passed on by, because I had no more money and was of no further use to them. I said nothing, but I felt it. When fortune again smiled on me, they came rushing back, all smiles, kisses and flattery. I welcomed them affably, but I knew them all and in my heart I despised them.'" Forever beautiful did not mean forever happy.

Notes

INTRODUCTION

1. Elizabeth F. Ellet, *The Queens of American Society* (Philadelphia, 1867), 229.

2. Margaret Mitchell, *Gone with the Wind* (New York: Scribner, 1936), 3; "The Great Wedding," *Louisville Courier,* December 29, 1848; "Mrs. Sally Ward Downs," *Louisville Courier-Journal,* July 12, 1896.

3. Douglass Sherley, prologue to *Songs of the Heart,* by Elvira Sydnor Miller, (Louisville, 1885), xxi.

4. Ella Hutchison Ellwanger, "Sallie Ward: The Celebrated Kentucky Beauty," *Register of the Kentucky Historical Society* 16, no. 46 (January 1918): 7, 9–14. Ellwanger picked up several mistakes from Virginia Tatnall Peacock's *Famous American Belles of the Nineteenth Century* (Philadelphia: Lippincott, 1901), 148–60, and plagiarized Peacock in other ways, for many of their sentences are embarrassingly similar. Ellwanger errs in saying that Sallie was the eldest child of the Ward family; that honor belongs to her brother Matt. Bigelow Lawrence's father was not the ambassador to Great Britain at the time of his marriage to Sallie, but was named to that post the following year. Nor could Sallie have taken her daughter Emily with her to Louisville in 1861, for she died in 1854.

5. Clark, however, placed Sallie's first marriage in 1849 instead of 1848, the invention of bloomers in 1849 instead of 1851, and the death of her second husband during the Civil War instead of in Chicago after the conflict. Nor did she outlive her last husband, but he her; her third spouse died just ten months into their marriage, not "a few years"; she is not buried next to husbands three and four but two and three, for whom she built a monument. Thomas D. Clark, *The Kentucky* (New York: Farrar and Rinehart, 1942), 238–55.

6. *Chicago Tribune,* July 31, 1871, p. 2.

1. THE MOST PERFECT BEAUTY I EVER SAW

1. Among the accounts of the event published after Sallie's death are: "Death Claims a Southern Queen," *New Orleans Times-Picayune,* July 12, 1896; "Sea Tragedy Recalls Story of Remarkable Life," *Louisville Courier-Journal,* February 11, 1912; John W. Petrie, "Noted Characters Memorable to Louisville," *Louisville Courier-Journal,* February 20, 1916.

2. Clark, *The Kentucky,* 243; "Jacob Smyser, 93 and Still Active, Recalls Louisville of Years Ago," *Louisville Courier-Journal,* February 28, 1927; "The Lawrence Divorce Case," *New York Herald,* June 15, 1850.

3. Eli Perkins, "Power of Beauty: Successful Career of a Kentucky Belle," *Chicago Tribune,* February 10, 1879; "Miss Lorraine," *Lexington Daily Leader,* June 16, 1889.

4. Eugene Field, the *Chicago Record*, quoted in "Stories About Mrs. Sallie Ward Downs," *Owensboro (KY) Messenger*, August 31, 1894; "Mrs. Sallie Ward Downs," *New York World*, quoted in the *San Francisco Examiner*, April 23, 1885.

5. Peacock, 151; Thomas D. Clark, "Ward, Sallie," in *The Encyclopedia of Louisville*, ed. John Kleber (Lexington: University Press of Kentucky, 2001), 921; Ann Bolton Bevins, *The Ward and Johnson Families of Central Kentucky and the Lower Mississippi Valley* (Georgetown, KY: Ward Hall Press, 1984), 17; Martha B. Bullitt to John C. Bullitt, 27 October 1845, Filson Society Manuscripts.

6. Ellet, *Queens*, 229–30; William Henry Perrin, *History of Bourbon, Scott, Harrison and Nicholas Counties* (Chicago, 1882), 237. A gray (*Louisville Daily* Courier, April 21, 1847) filly named Sally [not Sallie] Ward, born in 1842, raced in New Orleans and Louisville, coming in as the favorite at 3:58 at the Louisville Jockey Club at Oakland in 1847 (*Louisville Courier*, June 3, 1847). She was owned by Col. Adam L. Bingaman, who raised horses at his Fatherland plantation near Natchez, Mississippi (New Orleans *Times-Picayune*, March 16, 1847).

7. "Sallie Ward Downs," *Chattanooga Daily Times*, August 23, 1896; H. C. Pindell to John C. Bullitt, 28 December 1845, Filson Library.

8. "Three Works of Art," *Louisville Courier-Journal*, June 14, 1896; "Death Relieves the Suffering of Sallie Ward Downs," July 8, 1896; Thomas D. Clark, *The Kentucky*, 239–43.

9. Clark, *The Kentucky*, 240; Anita J. Sanford, "Bryan's (Bryant's) Station," *Kentucky Encyclopedia*, ed. John E. Kleber (Lexington: University Press of Kentucky, 1992), 133–34. According to Sanford, it was "a popular story long believed true but now relegated to legend."

10. Christina Snyder, *Great Crossings: Indians, Settlers and Slaves in the Age of Jackson* (New York: Oxford University Press, 2017),44-46, 55-60.

11. Snyder, 14, 49–51, 226–27.

12. Deborah Boykin. "Choctaw Indians in the 21st Century." *Mississippi History Now,* December 2002 *https://mshistorynow.mdah.ms.gov/issue/choctaw-indians-in-the -21st-century* [an online publication of the Mississippi Historical Society]; James Taylor Carson, "Greenwood LeFlore: Southern Creole, Choctaw Chief," in Greg O'Brien, ed., *Pre-removal Choctaw History: Exploring New Paths* (Norman: University of Oklahoma Press, 2008), 231; Bevins, *The Ward and Johnson Families*, 4; *Frankfort Argus*, April 25, 1832.

13. Lindsey Apple, Frederick A. Johnston, and Ann Bolton Bevins, eds., *Scott County, Kentucky: A History* (Georgetown, KY: Scott County Historical Society, 1993), 41–42.

14. *Louisville Journal*, June 13, p. 2; July 30, p. 2, July 16, p. 2, 1836.

15. Bevins, *The Ward and Johnson Families*, 16.

16. Advertisements, *Frankfort Argus*, February 24, 1834; January 7, March 4, April 1, 1835; Leland R. Johnson and Charles E. Parrish, *Engineering the Kentucky River: The Commonwealth's Waterway* (Louisville: US Army Corps of Engineers, Louisville District, 1999), 29.

17. "Mr. Hardin," *Kentucky Gazette*, April 12, 1834; "Public Meeting," December 20, 1834; "State Bank of Kentucky," January 24, 1835; advertisements, *Louisville Journal*, April 9, 1835; May 9, August 2, 11, 19, 1836; June 2, 1837.

18. "Colonization Meeting," *Louisville Journal*, August 15, 1836; notice of meeting, March 20, 1839, p. 2.

19. "Around 1832 the [Ward] family moved to Louisville where in 1838 Robert J. Ward built a fabulous family residence at Second and Walnut Streets," according to Bevins, *The Ward and Johnson Families*, 15–16.

20. "For Hire," *Louisville Journal*, January 14, p. 3; advertisements, June 20, December 16, December 21, 1839; "Dissolution of Co-Partnership," March 6, 1840; "Firemen's Insurance Company of Louisville" [notice], January 30, 1841.

21. Joshua F. Bullitt to John C. Bullitt, 2 February 1845, Filson Society.

22. Colin S. Throckmorton was born March 2, 1818; Mildred to John C. Bullitt, 14 April 1846, Filson Society; Cary H. Fry to John Bullitt, 15 April 1846, Filson Society.

23. Fry to Bullitt, 15 April 1846; Fred F. Fairthorne to John C. Bullitt, 25 April 1846, Filson Society.

24. Mildred Bullitt to John C. Bullitt, 28 April 1846; *New York Daily Herald*, May 7, 1846, p. 4

25. *New York Daily Herald*, May 10, p. 4, 1846.

26. *New York Daily Herald*, May 7, 1846.

27. *New York Daily Herald*, May 10, 1846.

28. "Movements of Travellers," *New York Daily Herald*, May 11; "The Couple That Eloped," May 15; Logan McKnight to John C. Bullitt, 28 May 1846, Filson Society.

29. "Just as We Expected," *Milwaukee Daily Courier*, May 18; "An Elopement Case," *New Orleans Daily Delta*, May 15; *Vicksburg Daily Whig*, May 28, p. 2; "A Bold Stroke for a Wife," *Rutland (VT) Weekly Herald*, May 14; "Things in Philadelphia," *Hartford (CT) Courant*, May 8, 1846; Mildred Bullitt to John C. Bullitt, 5 December 1846, Filson Society; R. A. Hughes to John C. Bullitt, 4 January 1847, Filson Society.

30. The infant's grave marker in Louisville's Cave Hill Cemetery indicates that it died "aged 5 months"; Mildred Bullitt to John C. Bullitt, 18 February 1847, Filson Society.

31. *Louisville Courier*, May 25, p. 2; "Another Flag," May 26, 1846; Ellet, 330–31; Clark, *The Kentucky*, 244; Helen Deiss Irvin, *Women in Kentucky* (Lexington: University Press of Kentucky, 1979), 47.

32. "Our Texan Correspondence," *Louisville Courier*, June 29; "Our Army Correspondence," July 27, 1846; "Our Army Correspondence," March 24, 1847; John B. Castleman, *Louisville Times*, November 7, 1917, quoted in an editor's note to Ellwanger, "Sallie Ward," 13; *Louisville Courier*, "The Old Louisville Legion," February 2; "The Old Louisville Legion," May 10, 1867.

33. *New York Evening Express*, n.d., quoted in the *Louisville Courier*, "Fashion at the East," August 27, 1846 and the *Louisville Courier-Journal*, Advertisement for Stewart's Goods Co., August 21, 1921.

34. "The Lawrence Card—Romance of Life," *Weekly Wisconsin* (Milwaukee), April 3, 1850; Clark, *The Kentucky*, 241.

35. "Dodo—A Prim, Conventional Damsel," *Chicago Tribune*, July 22, 1894

36. "The Story of a Noted Belle," by John Harding (a relative by marriage), Filson Society.

37. Petrie, "Noted Characters," *Louisville Courier-Journal*, February 20, 1916. According to Kathy Peiss, "For some women, cosmetics use was less a deception, a false face,

than a dramatic performance of the self in a culture increasingly oriented to display, spectatorship, and consumption." That cultural change may not have come yet, but this does sound like Sallie, for much of what she did was performance art, making a spectacle of herself, whether it be riding a horse through the Market House or presenting a flag to the Louisville Legion. Kathy Peiss, *Hope in a Jar: The Making of America's Beauty Culture* (New York: Henry Holt, 1998), 39.

38. Mary E. Robertson to John C. Bullitt, 29 August 1844, Filson Society; Alfred Pirtle, "Society in Louisville Seventy-Five Years Ago," *Louisville Courier-Journal*, October 23, 1921.

39. *Biographical and Historical Memoirs of Louisiana* (Chicago, 1892), 1:191; "Melancholy Affair," *Louisville Daily Courier*, January 29, 1846; "Fatal Duel," *New York Daily Herald*, February 1, 1846.

40. *Biographical and Historical Memoirs of Louisiana*, 1:101; "Melancholy Affair"; Mrs. J. M. de Cottes, "Woman and Society," *Montgomery Advertiser*, February 10, 1898; de Cottes was born circa 1858, according to "Mrs. de Cottes Dead at 78," *Montgomery Advertiser*, July 11, 1936.

41. "Mrs. Sallie Ward Downs," *Louisville Courier-Journal*, July 12, 1896.

42. Cary H. Fry to John C. Bullitt, 15 April 1846, Filson Society; Martha B. Bullitt to John C. Bullitt, 2 February 1846.

43. George W. Cullum, *Biographical Register of the Officers and Graduates of the U. S. Military Academy at West Point, N.Y.* (Boston, 1891), 1:577-78.

44. "Bland Ballard . . . told Sue at Joshua's wedding, that John William Shreve and Sallie Ward are to do likewise [i.e., marry] this month, or next" (Mildred Bullitt to John C. Bullitt, 5 December 1846, Filson Society; Thomas Clark, *The Kentucky*, 245); R. A. Hughes to John C. Bullitt, 4 January 1847, Filson Society; Mildred Bullitt to John C. Bullitt, 1 April 1847, Filson Society.

45. Abbott Lawrence Jr., ed., *T. Bigelow Lawrence* (Boston, 1869), 19-20.

46. Reinhard H. Luthin, "Abraham Lincoln and the Massachusetts Whigs in 1848." *The New England Quarterly* 14, No. 4 (December 1941), 619-32; advertisement the *New Orleans Commercial Bulletin*, October 21, 1843.

2. A CLASH OF CULTURES

1. "From Our Western Correspondent," *Boston Post*, December 21, 1848.

2. "From Our Western Correspondent"; M. P. Wooley to Susan P. Shelby, 12 November 1848, Filson Society.

3. "Mrs. Sallie Ward Downs," *Louisville Courier-Journal*, July 12, 1896; Thomas D. Clark, *The Kentucky*, 249.

4. Mrs. J. M. de Cottes, "Woman and Society," *Montgomery Advertiser*, February 10, 1898; Clark, *The Kentucky*, 248; according to Bigelow Lawrence, he and his wife left Louisville March 13 and arrived in Boston April 1 (*An Exposition of the Difficulties Between T. B. Lawrence, and His Wife Sallie Ward Lawrence, Which Led to Their Divorce. Prepared by T. B. Lawrence and His Counsel* [Boston, ca. 1850], 8).

5. "The Lawrence Card—Romance of Life," *Weekly Wisconsin* (Milwaukee), April 3,

1850. Napoleon's sister Pauline Bonaparte (1780–1825) was a noted beauty and had many lovers; the Paris salon of Juliette Récamier (1777–1849) was frequented by artists and intellectuals.

6. "Romance in High Life," *Weekly Wisconsin* (Milwaukee), March 13, 1850; "Louisville Letter," *Cincinnati Commercial*, July 10, 1881.

7. "Mrs. Sallie Ward Downs: The Story of Her Life as Told by an Intimate Friend," *Louisville Courier-Journal*, July 12, 1896; I suspect the author was the poet and columnist Elvira Sydnor Miller.

8. Lawrence, *An Exposition*, 10; Charles Dickens, *American Notes for General Circulation* (London: Chapman and Hall, 1913), 21.

9. "Defence of Sallie Ward Lawrence," *New Orleans Weekly Delta*, August 5, 1850; the *Boston Times*, quoted in the Newport, RI, *Herald of the Times*, April 12, 1849, p. 2.

10. Lawrence, *An Exposition*, 8.

11. Lawrence, *An Exposition*, 9.

12. Lawrence, *An Exposition*, 9.

13. Lawrence, *An Exposition*, 10.

14. Clark, *The Kentucky*, 251.

15. Ellwanger, "Sallie Ward," 12; Peacock, *Famous American Belles*, 156; *The Atlanta Sunny South*, April 6, 1901; "Noted Characters," *Louisville Courier-Journal*, February 20, 1916. Clark, however, cites neither Peacock nor Ellwanger in his bibliography.

16. Dexter C. Bloomer, *The Life and Writings of Amelia Bloomer* (Boston, 1895), 65–66.

17. "Nearly eighty": Lawrence, *An Exposition*, 11; "Turkish pantalets": "Fashion at the East," *Louisville Courier*, August 27, 1846; "Turkish pantaloons": Bloomer, 66.

18. "Sea Tragedy Recalls Story of Remarkable Life," *Louisville Courier-Journal*, February 11, 1912. Born in 1861, Pickering could not have known these things personally, and must have learned them from other Bostonians such as her parents.

19. John Seymour Erwin, *Like Some Green Laurel: Letters of Margaret Johnson Erwin, 1821–1863* (Baton Rouge: Louisiana State University Press, 1981), 117.

20. Isabel McLennan McMeekin, *Louisville: The Gateway City* (New York: Julian Messner, 1946), 108.

21. Mary Jacob Tyler to James B. Clay, 17 December 1849, Filson Society; "So the World Goes," *Buffalo Courier*, October 31, 1849. David W. Yandell, the son of prominent Louisville physician Lunsford Pitts Yandell, became a noted one himself. Nancy Disher Baird, *David Wendel Yandell: Physician of Old Louisville* (Lexington: University Press of Kentucky, 1978).

22. Lawrence, *An Exposition*, 11.

23. Lawrence, *An Exposition*, 11–12.

24. "Grand Fancy Ball at Newport," *Boston Evening Transcript*, September 1, 1849; Lawrence, *An Exposition*, 13.

25. Sallie wrote to a Lawrence relative on October 7: Lawrence, *An Exposition*, 12; likening Sallie's escapades to Malvina's: Mary Jacob Tyler to James B. Clay, 17 December 1849, Filson Society; Allen P. Elston (1807–54) married Maria Pope (1813–43) in 1829.

26. Rose Anna Hughes to John C. Bullitt, 8 November 1849, Filson Society; Rose Anna Hughes to John C. Bullitt, 9 February 1850, Filson Society.

27. Ellen Gwathmey to John C. Bullitt, 25 December 1849, Filson Society; obituary for "Mrs. Ellen Gwathmey Fry," *Louisville Courier-Journal*, February 14, 1895.

28. Susan Forbes Silliman to Henrietta Silliman Dana, 18 January 1850, Filson Society; "Among the many prominent belles who came to the springs to enjoy the gracious hospitalities of Master Graham were Sally Ward. . ." (Clark, *The Kentucky*, 229).

29. Susan Forbes Silliman to her sisters-in-law, March 1850, Filson Society.

30. "Frankfort, Thursday, March 7," *Louisville Journal*, March 8, 1850; "Sallie, the Pride of Kentucky," *Cincinnati Enquirer*, July 19, 1896.

31. Joshua F. Bullitt to John C. Bullitt, 26 May 1850, Filson Society.

32. "Opinion of Judge Bullock on the Application of Mrs. Sallie W. Lawrence for a Divorce," *Louisville Courier*, June 15, 1850.

33. Mrs. J. M. de Cottes, "Woman and Society," *Montgomery Advertiser*, February 10, 1898.

34. "The Lawrence Divorce Case," *New York Daily Herald*, July 12, 1850.

35. *Burlington Hawkeye*, June 6, 1850; "The Lawrence Divorce Case," *New York Daily Herald*, June 15, 1850. This is the earliest allusion in print to her ride through the Market House that I have been able to find.

36. *Richmond* (VA) *Whig* quoted in "The Lawrence Affair," *Louisville Daily Courier*, June 20, 1850; "The Lawrence Divorce Case," *Brooklyn Daily Eagle*, July 13, 1850; *Mobile Advertiser* quoted in the *Weekly Mississippian* (Jackson), July 5, 1850, p. 1.

37. *Louisville Courier*, August 7, 1850; *New York Daily Herald*, July 30, 1850. It also appeared in the following papers: *Richmond (VA) Enquirer*, August 8, 1850; *Illinois Daily Journal* (Springfield), August 21, 1850. The poem is dated from "Norfolk, Va., July 23, 1850" and the author's name given as "Quilp."

38. *The Toilette of Health, Beauty, and Fashion* (Boston, 1834), 89; *The Mirror of the Graces* (Boston, 1831), 41–42. Neither book lists an author.

39. Nancy Rexford, "Clothing and Personal Adornment," in Mary Kupiec Cayton, Elliott J. Gorn, and Peter W. Williams, eds. *Encyclopedia of American Social History* (New York: Charles Scribner's Sons, 1993), 1360, 1363.

40. Eliza Leslie, "Eunice Rookley," *Godey's Lady's Book*, October 1843, 182; Mrs. S. C. Hall, "Gossip Stings," *Godey's Magazine and Lady's Book*, July 1846, 22; S. D. Powers, *The Ugly-Girl Papers; or, Hints for the Toilet* (New York, 1874), 63. Incidentally, the author observes that "The women of the South are more given to the use of cosmetics than their Northern sisters" (62).

41. "The Fancy Ball," *Louisville Courier*, September 30, 1850. On Cunningham: *Louisville Courier-Journal*, February 12, 1997, p. 37; and J. Blaine Hudson, "'Upon This Rock'—The Free African American Community of Antebellum Louisville, Kentucky," *Register of the Kentucky Historical Society* 109, No. 3/4 (Summer/Autumn 2011): 295–326.

42. Malvina and Colin had recently suffered a tragic loss, their newly constructed home nine miles west of Louisville having been consumed by fire on June 3, 1850. The couple, with two-year-old Emily, barely escaped with their lives, after having just gone to bed. All their clothing and furniture were destroyed. Improvident Colin had not taken out an insurance policy on the house, valued at $9,000 ("Fire," *Louisville Courier*, June 4; Madison, IN, *Weekly Courier*, June 12, 1850).

43. "The Fancy Ball," *Louisville Courier*, September 30, 1850.
44. "Fancy Ball at Louisville," *Richmond (VA) Enquirer*, October 11; other papers: *Buffalo Commercial*, October 10; *Buffalo Courier*, October 10; *Brooklyn Daily Eagle*, October 26; *Keowee Courier* of Pickens, SC, October 19; *Charleston (SC) Mercury*, October 12; *Baltimore Sun*, October 9; *Pittsburgh Daily Post*, October 5; *Boston Evening Transcript*, October 11; *Burlington (VT) Weekly Sentinel*, October 18, 1850.

3. A WHIRLWIND COURTSHIP

1. "Her Majesty's Costume Ball," *The Observer*, London, England, June 16, 1851; the *Detroit Free Press*, June 28, 1851.
2. "Vive la Humbug!," *New Orleans Crescent*, January 10, 1851; *Bowling Green (MO) Democratic Banner*, December 23, 1850, p.2; "Sallie Ward Tobacco," *Louisville Journal*, December 2, 1850; on Sallie and cigars: Martha B. Bullitt to John C. Bullitt, 27 October 1845, Filson Society.
3. James A. Ramage, *John Wesley Hunt: Pioneer Merchant, Manufacturer and Financier* (Lexington; University Press of Kentucky, 1974), 89.
4. "Mrs. Sallie Ward Downs," *Louisville Courier-Journal,* July 12, 1896.
5. Glenda Riley, *Divorce: An American Tradition* (New York: Oxford University Press, 1991), 52.
6. Ramage, *John Wesley Hunt*, 74.
7. For a colorful account of American medical students in Paris, see David McCullough, *The Greater Journey: Americans in Paris* (New York: Simon and Schuster, 2011), 103–36.
8. "Appointments," *Louisville Courier*, July 21; "From Monterey," November 28, 1846; October 18, 1847.
9. "Death of Doctor Robert P. Hunt," *Louisville Journal*, July 10, 1867; physical description: "United States Passport Applications, 1795–1925," database with images, *FamilySearch* (https://familysearch.org/ark:/61903/3:1:3QS7-L9D4-RHZ8?cc =2185145&wc=3XC5-RMQ%3A1056306401%2C1056323101, 8 February 2017), (M1372) Passport Applications, 1795–1905 > Roll 39, vol 84–85, 1852 May–Jul > image 256 of 1360; citing NARA microfilm publications M1490 and M1372 (Washington, DC: National Archives and Records Administration, n.d.); house and farm: *Louisville Journal*, November 8, 1852, p. 2, and *Louisville Courier*, February 25, 1853, p. 2.
10. Quoted in "Drennon Springs," *Louisville Journal*, June 2, 1851.
11. "Drennon Springs," *Louisville Courier*, August 5, and "The Masked Ball at Drennon," August 12, 1851.
12. "Drennon Springs," *Louisville Courier*, July 8, 1851 (the Clay who fell at Buena Vista was the statesman's son Henry Clay Jr.); "The First Annual Commencement of the Western Military Institute of Kentucky," *Louisville Courier*, July 1, 1851.
13. "Our Army Correspondence," *Louisville Courier*, July 27, 1846.
14. "Mrs. Sallie Ward Downs," *Louisville Courier-Journal*, July 12, 1896.

4. TRAVELS

1. "The Rush to Europe," *New York Daily Herald*, May 20, 1852.
2. Matt F. Ward, *Letters from Three Continents*, 2nd ed. (New York, 1851); "Letters from Three Continents," *New Orleans Daily Delta*, January 29; *Boston Post*, quoted in "Letters from Three Continents" [advertisement], New York *Evening Post*, February 15; "American Travellers in Europe," *New York Daily Herald*, April 22, 1851.
3. The lace: "Mrs. Downs' Rare Laces," *Louisville Courier-Journal*, January 23, 1898. The Hunts' return: "Returned," *Louisville Courier*, August 21, 1852, and "New York Passenger Lists, 1820–1891," database with images, *FamilySearch* (https://www.familysearch.org/ark:/61903/1:2:99QR-WKDN : 20 February 2021), Entry for R P Hunt, 1852; citing Immigration, New York City, New York, United States, NARA microfilm publication M237 (Washington, DC: National Archives and Records Administration, n.d.), FHL microfilm 175,474. For Matt: "New York Passenger Lists, 1820–1891," database with images, *FamilySearch* (https://www.familysearch.org/ark:/61903/1:2:99QR-4PHW : 20 February 2021), Matt's return: Entry for M F Ward, 1852; citing Immigration, New York City, New York, United States, NARA microfilm publication M237 (Washington, DC: National Archives and Records Administration, n.d.), FHL microfilm 175,475.
4. *Catalogue of the Officers and Members of the Institute of 1770, Harvard University* (Cambridge, 1868), 36–37; *Louisville Journal*, December 3, 1846, p. 2.
5. The letter was dated "Willowby Plantation, Ark., November 14, 1846," and published in the *Louisville Journal* of December 3, 1846, p. 2.
6. *Louisville Journal*, December 3, 1846, p.2.
7. "As tedious as a twice-told tale": William Shakespeare, *King John*, 3.4.109; *Louisville Journal*, December 3, 1846, p. 2.
8. *Louisville Journal*, March 31, 1847, p. 2
9. *Louisville Journal*, April 15, 1847, p. 2.
10. Ibid.
11. *Louisville Journal*, March 22, 1848, p. 2
12. Ibid.; "Proceedings of the Democratic State Convention," *Arkansas Banner* (Little Rock), January 10, 1848.
13. Matt F. Ward, *English Items or, Microscopic Views of England and Englishmen* (New York, 1853).
14. *Louisville Journal*, November 8, 1852, p. 2; *Louisville Courier*, February 25, 1853, p. 2 (and subsequent dates throughout the year) Unable to find a buyer, Hunt had it auctioned off on October 24 (*Louisville Journal*, October 24, 1853, p. 3). It came into the possession of Aaron Ray, a local real estate speculator who in 1859 was looking for someone to rent it out to on a yearly basis (*Louisville Courier*, February 14, 1859, p. 2).
15. "Steamer Robert J. Ward," *Louisville Courier*, October 5, 1852; "Steamer Robert J. Ward," *New Orleans Times-Picayune*, January 6, 1853; "New Steamer Robert J. Ward," *Louisville Journal*, February 2, 1853.
16. "Back in '53," *Louisville Courier-Journal*, March 6, 1898.

17. "Gamblers Made to Disgorge," *New Orleans Times-Picayune*, March 18, 1857.
18. *Louisville Courier*, May 31, 1853, p. 3; "The Belle Key," *Louisville Courier*, December 11, 1848; "River Intelligence," *Memphis Daily Appeal*, March 26, 1873.
19. James Buchanan to J. J. Crittenden, 2 February 1853, Filson Society.
20. Helen Hartman Gemmill, *The Bread Box Papers: A Biography of Elizabeth Chapman Lawrence* (Doylestown, PA: Tower Hill Press, 1983), 27.
21. "A Celebrity in the Southwest," *Louisville Journal*, October 29, 1867.

5. MURDER IN THE SCHOOLROOM

1. George Cole. *Trial of Matt F. Ward for the Murder of Prof. W. H. G. Butler* (Louisville, 1854), 169–70.
2. Cole, *Trial of Matt F. Ward*, 169–70. Bertram Wyatt-Brown points out that violence against teachers was a recurrent problem in the South. Schoolmasters were considered low caste and wealthy parents encouraged their sons to defy a teacher's authority. He cites an instance in North Carolina in 1831 of a boy's parents urging their son "to stand up to the teacher as a point of family pride. . . . Schoolmasters elsewhere in the South faced the same issue: parental and child defense of honor against outside authority. . . . Disobedience to the teacher helped to distinguish rich from poor and prepared the young planter's son to assume command over lesser folk in the social hierarchy, white and black" (Bertram Wyatt-Brown, *Southern Honor: Ethics and Behavior in the Old South* [New York: Oxford University Press, 1982; 2007], 162).
3. Josiah Bliss's sworn statement, May 8, 1854, in Cole, *Trial of Matt F. Ward*, 174.
4. "The Ward Trial," *Louisville Courier*, July 10, 1854.
5. "Not whipped at all": A. D. Richardson, *A Full and Authentic Report of the Testimony on the Trial of Matt. F. Ward* (New York, 1854), 43; Fisher and Johnston: Cole, *Trial of Matt F. Ward*, 170–73.
6. Cole, *Trial of Matt F. Ward*, 170, 172.
7. No additional ammunition: Cole, *Trial of Matt F. Ward*, 99; witness: Cole, *Trial of Matt F. Ward*, 26–27.
8. Richardson, *Full and Authentic Report*, 42.
9. Ibid., 50.
10. Location of the school: "A Killing Long Ago," *Louisville Courier-Journal*, March 4, 1886; description of the school's interior: Cole, *Trial of Matt F. Ward*, 8.
11. Cole, *Trial of Matt F. Ward*, 13–14.
12. Ibid., 14.
13. Ibid.
14. Robert M. Ireland, "Acquitted Yet Scorned: The Ward Trial and the Traditions of Antebellum Kentucky Criminal Justice." *The Register of the Kentucky Historical Society* 84, no. 2 (Spring 1986): 113–15.
15. Richardson, *Full and Authentic Report*, 43; Cole, *Trial of Matt F. Ward*, 43.
16. Ireland, "Acquitted Yet Scorned," 115.
17. Rev. John H. Heywood, *A Tribute to the Memory of William H. G. Butler* (Louisville, 1853), 6, 4; Butler was born October 3, 1825; Matt Ward on May 19, 1826.

18. "Police Court," *Louisville Courier*, November 4, 1853; *Louisville Democrat*, reprinted in "Police Court," *Weekly Arkansas Gazette*, November 18, 1853.
19. Prentice wrote, for example, in an editorial while the trial was taking place, "it was not our dury to take, during the pendency of a trial, a course which all the newspapers in a community could not take without rendering the obtaining of an honest jury in such community a thing highly improbable" (*Louisville Journal*, April 22, 1854).
20. "Burial of Mr. Butler," *Louisville Courier*, November 5, 1853.
21. "The Wards—Change of Venue," *Louisville Courier*, December 20, 1853; Ireland, "Acquitted Yet Scorned," 117n.
22. "Our Louisville Correspondence," *New York Daily Herald*, January 27, 1854.
23. "The Wards in Prison," *Boston Evening Transcript*, February 20, 1854; "Fashion and Murder," *St. Louis Globe-Democrat*, March 7 and 8, 1854.
24. Quoted in "Ward, the Murderer," *Richmond (VA) Enquirer*, December 2, 1853.
25. "The Wards in Prison," *Boston Evening Transcript*, February 20, 1854.
26. "Hotel Arrivals Yesterday," *New Orleans Times-Picayune*, March 5, 1854. It was the St. Charles Hotel.
27. "The Ward Trial," *Louisville Courier*, April 19, 1854.
28. "The indictment in the first count charges M. F. Ward and R. J. Ward, Jr., with shooting, with malice aforethought, W. H. G. Butler. . . . The second count charges Matt F. Ward with the shooting and R. J. Ward, Jr., with being accessory" (Cole, *Trial of Matt F. Ward*, 9)
29. Crawford: Cole, *Trial of Matt F. Ward*, 22, and James M. Lawson, "Notes on the Trial of Matt F. Ward," Filson Society Manuscript, 82. Lawson mistakenly attributes this part of the testimony to the immediately preceding witness, John A. Campbell.
30. "The Ward Trial," *New Orleans Daily Delta*, April 29, 1854.
31. Cole, *Trial of Matt F. Ward*, 33; Lawson, "Notes on the Trial," 96; Cole, *Trial of Matt F. Ward*, 34.
32. Barlow's conversation with Robert J. Ward: Cole, *Trial of Matt F. Ward*, 35–36; George Sullivan's testimony: Cole, *Trial of Matt F. Ward*, 54–55. When questioned at the trial, Barlow denied hearing he would be amply repaid (Cole, *Trial of Matt F. Ward*, 36; Richardson, *Full and Authentic Report*, 36, 52–53), and Ward denied making such an offer (Richardson, *Full and Authentic Report*, 55).
33. Cole, *Trial of Matt F. Ward*, 45, 32, 31; "The Ward Trial," *New Orleans Daily Delta*, April 29, 1854.
34. "Butler sprang": Cole, *Trial of Matt F. Ward*, 50–51; "confusion": Cole, *Trial of Matt F. Ward*, 141.
35. Cole, *Trial of Matt F. Ward*, 87, 84
36. North Carolina cowhiding: James C. Klotter, *Kentucky Justice, Southern Honor, and American Manhood: Understanding the Life and Death of Richard Reid* (Baton Rouge: Louisiana State University Press, 2003), 50; Richard Collins and Luther Dobyns: letter from W. B. Houston, *Louisville Journal*, January 5, 1854.
37. Cole, *Trial of Matt F. Ward*, 91, 116; Ireland, "Acquitted Yet Scorned," 138.
38. "The Ward Trial," *New Orleans Daily Delta*, April 29, 1854.

39. "The Ward Trial," *New Orleans Daily Delta*, May 5 and 7, 1854; "The Ward Trial: Interesting Letter," *Louisville Courier*, April 25, 1854.

40. "The Ward Trial: The Last Scene," *New Orleans Daily Delta*, May 7, 1854.

41. Ibid.; Cole, *Trial of Matt F. Ward*, 163.

42. "The Ward Trial: The Last Scene," *New Orleans Daily Delta*, May 7, 1854.

43. James Crutcher, "The Trial of Matt. F. Ward," *Louisville Courier*, June 22, 1854. Bertram Wyatt-Brown (*Southern Honor*, 162) cites Matt Ward's acquittal as a demonstration "of planter power on behalf of juvenile assertions of honor." But this is triply wrong: Ward was acquitted on the grounds of self-defense, not because he was defending family honor; he was not a juvenile (nor an adolescent, as Wyatt-Brown elsewhere says) but twenty-seven years old; and Robert J. Ward Sr.'s wealth came principally from his mercantile activity, not his plantations. He did not live on a plantation, nor did he manage one. He was an urban dweller (in both Louisville and New Orleans). It wasn't planter power that won the day but Ward's immense wealth, which afforded him better lawyers and a suborned witness.

44. *Louisville Democrat*, reprinted in the *Louisville Courier*, May 1, 1854, p. 3; "From Capt. Downing," *Louisville Courier*, May 10; "Fate of the Hardin County Jurors," *Louisville Courier*, July 18; "Trial of One of the Ward Jurors for Perjury," December 2, 1854; "Acquittal of Yates," *Weekly Wisconsin* (Milwaukee), December 20, 1854.

45. Albert D. Kirwan, *John J. Crittenden: The Struggle for the Union* (Lexington: University Press of Kentucky, 1962), 475, 285–89.

46. David S. Heidler and Jeanne T. Heidler, *Henry Clay: The Essential American* (New York: Random House, 2010), 398; *New York Sunday Mercury* (date uncertain but probably February 5, 1854) quoted in "Ward the Murderer," *St. Louis Globe-Democrat*, February 8, 1854.

6. TOGETHER IN NEW ORLEANS

1. *Indiana State Journal* (Indianapolis), quoted in "The Ward Case," *Indiana Herald* (Huntington), May 10, 1854.

2. "Acquittal of Matt. F. Ward," *Louisville Journal*, April 28, 1854; "One of the Results," *Louisville Courier*, April 29, 1854.

3. "Verdict of the People," *Louisville Courier*, May 1, 1854.

4. A. J. Webster, "Louisville in the Eighteen Fifties." *Filson Club History Quarterly* 4 (1930): 138; Charles G. Shanks, "George D. Prentice. Reminiscences of Editorial Life in the West." *Lippincott's Magazine of Literature, Science and Education* 4 (November 1869): 552–59; "Movements of Matt Ward," *Indiana Herald*, Huntington, IN, May 17, 1854; Alexander Bate to William Marshall Bullitt, 3 March 1948, Filson Society.

5. George Quimby, "Matt Ward and wife. . .," *New Albany Daily Ledger*, June 20, 1854.

6. "Mr. Ward's House," *Louisville Courier*, May 2, 1854.

7. "Died," *New Orleans Daily Delta*, May 21, 1854; "Deaths," *New Orleans Times-Picayune*, May 22, 1854; the cause of death was indicated in "Louisiana, New Orleans, Interment Registers, 1836–1972", database, *FamilySearch* (https://familysearch.org

/ark:/61903/1:1:4LPG-V5ZM : 13 December 2019), Emily Ward Hunt, 1854. Thomas
D. Clark erroneously states that Emily Hunt died at the age of nine (Kleber, *Encyclo-
pedia of Louisville*, 921).

8. The *Robert J. Ward* had arrived from Louisville on May 31 ("The Port of New Or-
leans," *New Orleans Daily Delta*, June 1, 1854). An additional indication that Matt
Ward had not yet arrived in New Orleans as of May 27 is that there was a letter wait-
ing for him at the city post office ("List of Letters," *New Orleans Times-Picayune*,
May 28, 1854).

9. "The Ward Family," *Cahaba (AL) Gazette*, June 9, 1854. Of course, it was not quite
"the whole Ward family," as Dr. Hunt and his father-in-law were not among them.

10. "The Ward Family," *New Albany Daily Ledger*, May 16, 1854.

11. *Paris Flag*, August 9, 1854, quoted in "Murderous Assault," *Weekly Arkansas Ga-
zette*, September 15, 1854.

12. Mass meeting: *Plymouth [IN] Weekly Banner*, October 19, 1854, and *The Raleigh
[NC] Register*, October 4, 1854; back in Arkansas: "Cotton Picking," *Daily Delta*,
December 11, 1854; "lion of the streets": "Matt Ward," *Daily Milwaukee News*,
February 19, 1855; "refused his hand: "The Mark of Cain," *St. Paul [MN] Weekly
Minnesotian*, July 31, 1855.

13. Sarah Jacobs to her sister, 29 August 1853, Filson Society.

14. Erwin, *Like Some Green Laurel*, 74; Ellet, *Queens of American Society*, 235.

15. "Theatre d'Orleans," *New Orleans Times-Picayune*, December 2, 1854; "The Young
Bachelors," February 2, 1855; "A Famous Belle of Ye Olden Time," October 7, 1894.

16. "A Talk with Mrs. Dion Boucicault," *New Orleans Times-Picayune*, November 2,
1887; the play was "Bob Nettles," performed in Louisville on October 8, 1855, ac-
cording to the *Louisville Journal*, October 8, 1855.

17. "Louisville, Ky., June 4, 1857," *The Potter Journal and News Item* (Coudersport,
PA), June 18, 1857; "Life at the White Sulphur," *Charleston [SC] Daily Courier*, Au-
gust 6, 1857; "Beauty and Intellect," *Louisville Courier-Journal*, September 6, 1888.

18. John Wesley Hunt's date of birth is given on his 1899 passport application; Ellet,
Queens of American Society, 237.

19. "Correspondence of the Courier," *Charleston [SC] Daily Courier*, December 15,
1858; "Reception of Senator Douglas," *New Orleans Crescent*, December 3, 1858.

20. "Docket Cases," *Louisville Journal*, March 5, 1856; "An Affray on the Victoria,"
Louisville Courier, February 17, 1859; "Death of Victor F. Ward," *Louisville Cou-
rier*, June 29, 1859; "From Arkansas," *Daily Milwaukee News*, February 11, 1863.

21. "Letter from Mississippi," *Louisville Courier*, June 8, 1859; *Louisville Daily
Democrat*, July 4, 1860, p. 4; "Died," *Louisville Daily Courier*, July 4, 1860.

22. "Steamer Robert J. Ward for Sale" [advertisement], *Louisville Journal*, August 5,
1859; *Weekly Arkansas Gazette* (Little Rock), February 18, 1860, p. 3; "Extensive
Sale of All the Furniture and Effects. . ." [advertisement], *New Orleans Crescent*,
May 24, 1860; "Cotton Plantations and Negroes for Sale," *New Orleans Times-
Picayune*, September 28, 1859.

23. The Speed Museum of Louisville has these seven portraits and kindly allowed me to
reproduce them here. Malvina Ward Throckmorton, William Ward, and Robert J.

Ward Jr. are not among those depicted, probably because they remained in Kentucky; Victor, as we know, had died the previous year. Healy, who was living in Chicago, often traveled to New Orleans, where he kept a studio at 166 Customhouse Street, according to the New Orleans *Times-Picayune*, April 6, 1860. We know from the *Chicago Tribune* of January 4, 1860, that he was then en route for New Orleans, and from the same newspaper on June 5, 1860, and that he had just returned from his winter sojourn there. A photograph of his price list dated May 1860 appears in *G. P. A. Healy: Famous Figures and Louisiana Patrons* (New Orleans: Lousiana State Museum, 1976), 26. It ranges from $200 for a 22 x 27 inch portrait to $1000 for a 47 x 62 inch image (Sallie's was slightly smaller and cost $800). Given the dimensions provided by the Speed Museum for each portrait, it appears that the total was $2800. "But it seems to simper": Erwin, *Like Some Green Laurel*, 104; Vaughn L. Glasgow: *G. P. A. Healy: Famous Figures and Louisiana Patrons*, 38, 40. Thomas D. Clark errs in stating that Healy did Sallie's portrait in Paris, France (Kleber, *Encyclopedia of Louisville*, 921).

24. These passages are from two different letters. John Erwin dates the first from 1860 or later, and the second from June 6 of that year (Erwin, *Like Some Green Laurel*, 104–5).

25. Erwin, *Like Some Green Laurel*, 76; "Mademoiselle Adelina Patti," *New Orleans Crescent*, December 17, 1860.

26. "Copartnership," *New Orleans Times-Picayune*, May 7, 1861.

7. ALONE IN LOUISVILLE

1. Mildred Bullitt to Thomas Bullitt, 18 June 1861, Filson Society.

2. "Public Meeting," *Louisville Courier*, April 16, 1861.

3. James A. Ramage, *Rebel Raider: The Life of General John Hunt Morgan* (Lexington: University Press of Kentucky, 1986), 193–94; "Col. Clarence Prentice," *Louisville Courier-Journal*, November 17, 1873; death of William Courtney Prentice: Amy Murrell Taylor, *The Divided Family in Civil War America* (Chapel Hill: University of North Carolina Press, 2005), 30-31.

4. Robert Emmett McDowell, *City of Conflict: Louisville in the Civil War 1861– 1865* (Louisville: Louisville Civil War Roundtable, 1962), 17; "The Death of Mrs. Adams," *Louisville Courier-Journal*, May 2, 1905.

5. Erwin, *Like Some Green Laurel*, 124.

6. "The Cause of the South," *Louisville Courier*, April 16, 1861.

7. *Louisville Courier-Journal*, September 9, 2009, p. G12; US War Department, *The War of the Rebellion*, 8 vols., Serial 115 (US Government Printing Office, 1897), 885–87.

8. Ibid., 892–94.

9. "The War in Kentucky," *Cincinnati Daily Gazette*, October 31, 1861.

10. "Auction Sales . . .Julian Neville," *New Orleans Times-Picayune*, April 15, 1862.

11. "United States Confederate Officers Card Index, 1861–1865", database with images, *FamilySearch*(https://familysearch.org/ark:/61903/1:2:7MKJ-4CZM : 6 September 2019), Entry for Robert P Hunt, 1861–65.

12. Henry Villard, *Memoirs* (Boston: Houghton, Mifflin, 1904), 1:203; McDowell, *City of Conflict*, 50.

13. Bryan S. Bush, *Louisville and the Civil War* (Charleston, SC: History Press, 2008), 56.

14. "Matt. Ward—Fearful Retribution," *The Daily Milwaukee News*, February 11, 1863; "Matt. Ward," *Detroit Free Press*, August 30, 1862.

15. *The Daily Milwaukee News*, February 11, 1863; "From Arkansas," *Chicago Tribune*, September 5, 1862.

16. *Louisville Times*, March 5, 1886; quoted in "Matt. Ward's Defense," Memphis *Weekly Public Ledger*, March 16, 1886.

17. "Matt Ward Shot by Guerillas," *Daily Missouri Republican*, St. Louis, October 8, 1862; Matt and Anna's daughter Sallie was evidently born in early 1858, for at the time of her death August 17, 1866, she was eight years and six months old, according to the *Louisville Journal* of August 20, 1866; *Memphis Weekly Public Ledger*, March 16, 1886.

18. *Memphis Weekly Public Ledger*, March 16, 1886.

19. *The Daily Milwaukee News*, February 11, 1863.

20. "Military Court of Inquiry," *Daily Missouri Republican*, St. Louis, April 28, 1863.

21. *St. Louis Republican* quoted in the *Detroit Free Press*, August 30, 1862; "General Items," *Weekly Standard* (Raleigh, NC), October 29, 1862.

22. Letter from Emily Johnson Bartley, 1862, to her stepdaughter, Nora Bartley Kent, Filson Society; *Louisville Journal*, December 4, 1862, p. 3. Matt's remains "passed up the river yesterday on the Lady Pike en route to Louisville," the Evansville, Indiana, *Daily Journal* reported on February 25, 1863. Sallie's cousin Emily Johnson Bartley is not to be confused with Sallie's sister Emily Johnston, who married a William Johnston in 1857.

23. Emily Johnson Bartley to Nora Bartley Kent, 1862.

24. "Mrs. Matt Ward," *Sacramento Bee*, May 4, 1863; "From Cairo," *Chicago Tribune*, February 14, 1863; "Miss Bell Key," *National Republican*, Washington, DC, March 28, 1863; "From Below," *Louisville Journal*, January 18, 1864. The incident in which she was enlisted to search her associates occurred at Island No. 10, since disappeared, near Tiptonville, Tennessee. As Drew Gilpin Faust explains, "Confident that the Yankees would not violate the innermost realms of feminine privacy," a woman hid her jewelry in pockets beneath her hoops. "Like . . . countless other besieged southern women she assumed 'they will hardly search our persons.'" (*Mothers of Invention: Women of the Slaveholding South in the American Civil War* [New York: Random House, 1996], 199).

25. *Louisville Journal*, June 23, 1864, p. 2.

26. "Wanted—A Partner," *Louisville Journal*, October 19, 1865. Concerning the painting, Paul C. Nagel, in *George Caleb Bingham: Missouri's Famed Painter and Forgotten Politician* (Columbia, MO: University of Missouri Press), writes: "A viewer in New Orleans was so captivated by the canvas that he wished to buy it outright, offering George twelve hundred dollars for it. The sum was too much for the artist to resist, and when the purchaser agreed that George could continue the tour with the canvas, George sold it on the spot" (Nagel, 73). The impulsive buyer was Sal-

lie's father, according to the *Louisville Journal*, May 16, and the *Louisville Courier*, May 18 and 19, 1853. The May 19 article makes it clear that Bingham had entrusted the original to a Philadelphia engraver in October 1852 and was touring with the copy Ward bought. A 1923 article made the false claim that Ward had commissioned the painting and owned the original ("Original of Famous Painting," *Louisville Courier-Journal*, May 11, 1923).

27. "Arkansas, County Marriages, 1837–1957," database with images, *FamilySearch* (https://familysearch.org/ark:/61903/1:1:N9SK-3MN : 9 March 2021), William H Govan, 1 Nov 1866; citing Marriage, Phillips, Arkansas, United States, county offices, Arkansas. On Matt Ward's conversion: "Mat. Ward, who murdered Butler, the school teacher, in Louisville, because he chastised a brother of his, has recently been received into the Catholic Church" (*The Highland Weekly News* [Hillsboro, OH], July 21, 1859, p. 2).

28. "Louisville in the Eighteen Fifties," *Louisville Courier-Journal*, August 17, 1930; "Famous Old Homes of Louisville," *Louisville Courier-Journal*, November 7, 1917. Webster's article appeared as well in the July 1930 *Filson Club History Quarterly* 4, no. 4: 132–41. *Harper's Weekly*, January 11, 1862, 28–29, however, gives a different location: "General Buell's Head-Quarters are situated in one of the most aristocratic streets in Louisville—Fourth, between Green and Walnut," and provides an illustration of a house that is not the Wards'.

29. H. E. Whipple, "Notes from a Visit to the Army of the Cumberland," *The Hillsdale (MI) Standard*, July 14, 1863; *History of the Second Presbyterian Church, Louisville, Kentucky* (Louisville, 1933), 11; Stuart Robinson, *Slavery as Recognized in the Mosaic Law* (Toronto, 1865).

30. "Arrest of a Traitor," *The Hillsdale (MI) Standard*, July 14, 1863.

31. Mrs. Sallie Ward Hunt to Mrs. Mary Todd Lincoln, 31 March 1864, *The Lincoln mss., ca. 1798–1959*, LMC 1664, Lilly Library, Indiana University Bloomington.

32. William Townsend, *Lincoln and the Bluegrass: Slavery and Civil War in Kentucky* (Lexington: University Press of Kentucky, 1955), 324–25.

33. Abraham Lincoln, *Collected Works*, ed. Roy P. Blaser (New Brunswick, NJ: Rutgers University Press, 1953), 7:296n.

34. "A Celebrity in the Southwest," *Louisville Journal*, October 29, 1867.

35. Patrick A. Lewis, *For Slavery and Union: Benjamin Buckner and Kentucky Loyalties in the Civil War* (Lexington: University Press of Kentucky, 2015), 54.

36. Olive Pendleton, "Some Southern Reminiscences," *St. Joseph (MO) Herald*, February 9, 1890.

37. William's death: "Died," *Louisville Journal*, August 6, 1865; Olive Pendleton, "Some Southern Reminiscences."

38. "Marshal's Sale," *Louisville Journal*, September 27, 1865; "General Council," *Louisville Courier*, October 6, 1866. The lots came into Johnston's possession, and on October 4, 1866, he deeded to the city portions of what became Ward Street and Ward Alley, both connecting Fifth Street with Sixth. Ward Street was later renamed Garland, but the name Ward Alley remains, the only such reminder of what had once been one of the first families of the city. The auctioned properties are now a parking lot.

39. *Memphis Daily Appeal,* November 8, 1865, p. 1; *New Orleans Times-Picayune,* December 21, 1865, p. 3.
40. "Bedford Springs, Trimble County, Ky.," *Louisville Courier,* May 10, 1866.
41. Ibid.
42. "Mrs. Sallie Ward Downs," *Louisville Courier-Journal,* July 12, 1896.
43. Elizabeth Fries Ellet to Jane Charlotte Ross, 26 May 1867, Filson Society.
44. A jury found that it was an accident ("Fatal Accident," *Chicago Evening Post,* July 9, 1867), but the *Chicago Tribune* in an obituary of Bigelow Lawrence on March 25, 1869, said it was suicide. *Louisville Journal,* August 17, 1867, p. 2.
45. "Meeting of the Physicians of Louisville on the Death of Dr. R. P. Hunt," *Louisville Journal,* July 18, 1867.

8. A CHANGE OF FORTUNE

1. "Death of T. Bigelow Lawrence," *Macon (GA) Weekly Telegraph,* April 2, 1869.
2. *Memphis Post,* quoted in the *Cincinnati Commercial,* March 29, 1869, p. 3; "T. Bigelow Lawrence," *Chicago Tribune,* March 25, 1869; "Death of Mr. T. B. Lawrence," *Daily Milwaukee News,* March 26, 1869.
3. *Macon (GA) Weekly Telegraph,* April 2, 1869; *Memphis Post,* quoted in the *Cincinnati Commercial,* March 29, 1869.
4. Thomas: "General Thomas's Headquarters," *Louisville Journal,* October 20, 1866; Freedmen's Bureau: "Fifty Years Ago Today," *Louisville Courier-Journal,* November 5, 1918, p. 6; Cook Benevolent Association: "Noble Charities," *Louisville Courier-Journal,* December 10, 1882. In 1901 the house was reborn as the Bryant and Stratton Business College. The coup de grâce came in 1918 when the association tore down the mansion and replaced it with a garage that it leased to the Louisville Carriage and Taxicab Company. In 1960 the association sold the property to the Independence Life Insurance Company, which built its home office there.
5. "Literary Notes," *New-York Tribune,* September 2, 1871; *Santa Fe New Mexican,* September 7, 1871, p. 1.
6. "In a Mad-House," *Louisville Courier-Journal,* June 18, 1891.
7. *Charlotte (NC) Democrat,* September 12, 1871, p. 4; Erwin, *Like Some Green Laurel,* 105.
8. *Cincinnati Commercial,* July 25, 1871, p. 8; August 7, 1871, p. 4.
9. "Famous Robbery," *Hagerstown (IN) Exponent,* July 22, 1891; "Great Bank Robbery!" [advertisement], *Louisville Courier-Journal,* March 16, 1873.
10. "Throckmorton's Ghost," *Stanford (KY) Interior Journal,* May 1, 1874.
11. Lawrence, *An Exposition,* 13. John Throckmorton was a guest at Sallie's wedding to Vene Armstrong in 1876 ("Sensation in Society," *Louisville Courier-Journal,* June 24, 1876).
12. Octavia at Newport: "The Fancy Ball at Newport," *Charleston (SC) Mercury,* September 6, 1848, and Ellet, *Queens of American Society,* 412; Sallie at Newport: "Fashion at the East," *Louisville Courier,* August 27, 1846; as Nourmahal: Ellet, *Queens of American Society,* 232.

13. "About Women," *Atlanta Sunny South*, July 24, 1875; *St. Louis Post-Dispatch*, June 19, 1875, p. 4; "Current Notes," *New Orleans Times-Picayune*, September 16, 1875; *Chicago Tribune*, "Hotel Arrivals," May 28; "Announcements," June 1, 1876; "Madame Le Vert," June 2, 1876. Singing lessons: "Death Relieves the Suffering of Sallie Ward Downs," *Louisville Courier-Journal*, July 8, 1896; *St. Louis Republic*, quoted in "Mrs. Sallie Ward Downs," *Louisville Courier-Journal*, August 26, 1890.

14. "Mrs. Sallie Ward Hunt, with M'me Le Vert, will give readings in Northern cities during the coming season" ("Current Notes," *New Orleans Times-Picayune*, September 16, 1875).

15. "Louisville Gossip," *Cincinnati Enquirer*, June 30, 1876; "A Louisville Wedding," *Pittsburgh Weekly Gazette*, June 28, 1876.

16. Richard Collins, *History of Kentucky* (Covington, KY: Collins, 1882), 1:145; *Louisville Courier-Journal*, April 20, 1877; "Kentucky Correspondence," *Buffalo Courier*, April 10, 1861.

17. "How Two Kentucky Belles Startled Society," *New Orleans Daily Democrat*, May 5, 1877; house: George H. Yater, *Two Hundred Years at the Falls of the Ohio: A History of Louisville and Jefferson County* (Louisville: The Heritage Corporation, 1979), 110; horses: *Washington, DC, Evening Star*, July 24, 1876, p. 4.

18. "Vene P. Armstrong," *Louisville Courier-Journal*, April 21, 1877.

19. "Lassoed by Lawyers," *Kansas City (MO) Times*, May 4, 1877. Vene's first wife had died in 1875.

20. *Chicago Tribune*, June 30, 1877, p. 5; "Compromise with the Heirs of Vene P. Armstrong," *Cincinnati Commercial*, May 29, 1877; *Boonville (IN) Enquirer*, July 7, 1877, p. 1.

21. "A 'Pinafore' Boom," *Chicago Tribune*, September 27, 1879; "Kentucky's Contribution to the Drama," *Danville (KY) Advocate-Messenger*, August 20, 1941.

22. "At that time there were still traces of her beauty although she was very stout" ("Stories of By-Gone Days," *Louisville Courier-Journal*, September 1, 1924); "Grant Gossip," *Cincinnati Commercial*, December 12, 1879.

23. "Louisville's Pageant," *Savannah Morning News*, August 7, 1883.

9. FINAL YEARS

1. "A Fascinating Woman," *Nashville Tennessean*, November 19, 1878; "pleased to show her silks and satins": Olive Pendleton, *St. Joseph (MO) Herald*, February 9, 1890; "The Fancy Ball," *Louisville Courier*, September 30, 1850; "Wedding at the Galt House," *Louisville Courier-Journal*, April 8, 1885; "A Blue-Grass Belle," *St. Louis Globe-Democrat*, April 8, 1885.

2. *Louisville Dispatch*, quoted in "A Southern Belle," *Wheeling Daily Intelligencer*, April 13, 1885; Bertha Cooper: handwritten notes on the wedding in the Filson Society Manuscript Collection. Probably no relation to Sallie, Miss Cooper was born December 24, 1877 and lived until February 20, 1960. "Find A Grave Index," database, *FamilySearch*(https://www.familysearch.org/ark:/61903/1:1:6NL8-WXSQ:

12 September 2022), Bertha Morton Cooper Hewett, ; Burial, Louisville, Jefferson, Kentucky, United States of America, Cave Hill Cemetery; citing record ID 243104585, *Find a Grave*, http://www.findagrave.com.

3. Downs's account book, Filson Society Manuscript Collection.

4. "Once the City's First Merchant," *Louisville Courier-Journal*, August 21, 1908; "A Famous Beauty Married," *New Orleans Times-Picayune*, April 13, 1885.

5. "Pretty Feet in Tune," *Louisville Courier-Journal*, February 16, 1889; "A Hoosier Listening Post," *Indianapolis Star*, August 18, 1930; "Derby Day Way Back Then," *Miami Herald*, May 4, 1957.

6. *St. Louis Republic*, quoted in "Mrs. Sallie Ward Downs," *Louisville Courier-Journal*, August 26, 1890; "St. Louis' Visitor," *Philadelphia Times*, September 5, 1890.

7. "Both Dead," *Owensboro (KY) Messenger*, August 21, 1890; "Gossip," *St. Louis Post-Dispatch*, October 2, 1890; "Deaths," *Louisville Courier-Journal*, September 20, 1883.

8. "Community History," *Owensboro (KY) Messenger-Inquirer*, February 14, 1995; "In Society," *Owensboro (KY) Messenger*, January 7, 1906; "Particulars of the Death of Aris Throckmorton," *Memphis Public Ledger*, December 7, 1870; "Famous Murder Trial Took Place Fifty Years Ago," *Owensboro (KY) Messenger*, June 24, 1923.

9. "Mob at Birmingham," *Owensboro (KY) Messenger and Examiner*, December 13, 1888.

10. "A Beautiful Evening," *Louisville Courier-Journal*, June 28, 1891; "Ovation to Beauty," *Louisville Courier-Journal*, September 26, 1891; "Choosing Maids of Honor," *Louisville Courier-Journal*, November 2, 1892; "Mrs. Sallie Ward Downs Sets a New Style in Carriage Painting," *Kentucky Leader* (Lexington), December 14, 1892.

11. "Don't Look Now," *Louisville Courier-Journal*, December 22, 1939.

12. "A Famous Belle of Ye Olden Time," *New Orleans Times-Picayune*, October 7, 1894.

13. "Wayside Gossip," *Owensboro (KY) Twice-A-Week Messenger*, October 18, 1894.

14. "Death Relieves the Suffering of Sallie Ward Downs," *Louisville Courier-Journal*, July 8, 1896; "Ex-Maid of Sally Ward Downs," *Louisville Courier*-Journal, May 16, 1921.

15. "Old Lady Dying," *Louisville Courier-Journal*, August 13, 1939; Thomas D. Clark, *The Kentucky*, 238–39.

16. "Death Claims a Southern Queen," *New Orleans Times-Picayune*, July 12, 1896.

10. DIANA BOURBON

1. "Mrs. Downs' Will," *Owensboro (KY) Messenger*, July 18, 1896; "New York, New York City Marriage Records, 1829–1940," database, *FamilySearch* (https://family search.org/ark:/61903/1:1:24HT-4KT : 10 February 2018), John Hunt and Mary Darcy, 07 Nov 1892; citing Marriage, Manhattan, New York, New York, United

States, New York City Municipal Archives, New York; FHL microfilm 1,452,333.
Malvina was buried in Hollywood Cemetery in McComb, Mississippi. Her gravestone
reads: "Vine Ward Throckmorton. Born May 12, 1831. Died Jan. 20, 1897." She had
apparently shortened *Malvina* to *Vine*.

2. John W. Hunt to George F. Downs, 30 August 1897, Filson Society. Judge Humphrey's
father was Rev. Edward Porter Humphrey, pastor of Louisville's Second Presbyterian
Church, who married John Wesley Hunt's mother and Bigelow Lawrence back in 1848
(*"A Leader Gone," Danville (KY) Advocate*, December 16, 1887).

3. House for rent: *Louisville Courier-Journal*, February 26, 1896, p. 3. A handwritten
line in the application by Mrs. Hunt for a new US passport on April 23, 1923, gives
the date of their marriage as November 7, 1897, even though the New York City
Marriage Records erroneously gives it as November 7, 1892. "United States Passport
Applications, 1795–1925," database with images, FamilySearch (https://familysearch
.org/ark:/61903/3:1:3QS7-89D3-Y4KW?cc=2185145&wc=3XCP-BZ7%3A1056306501
%2C1056369001 : 22 December 2014), (M1490) Passport Applications, January 2,
1906–March 31, 1925 > Roll 2233, 1923 Apr, certificate no 273850-274349 > image
218 of 871; citing NARA microfilm publications M1490 and M1372 (Washington,
DC: National Archives and Records Administration, n.d.).

4. "Sea Tragedy Recalls Story of Remarkable Life," *Louisville Courier-Journal*, Febru-
ary 11, 1912; "Hotel Arrivals," New Orleans *Times-Democrat*, February 2, 1879;
"Journalists Present," *New York World*, December 11, 1890; "Personals," *Louisville
Courier-Journal*, September 2, 1894; "United States Passport Applications, 1795–1925,"
database with images, *FamilySearch* (https://familysearch.org/ark:/61903/3:1:3QSQ
-G9X7-HLTD?cc=2185145&wc=3XZ8-4WL%3A1056306401%2C1056422501 : 4
October 2016), (M1372) Passport Applications, 1795–1905 > Roll 518, vol 879, 1899
Jan > image 146 of 807; citing NARA microfilm publications M1490 and M1372
(Washington, DC: National Archives and Records Administration, n.d.).

5. The birth of Ruth Hunt: "New York, New York City Births, 1846–1909," data-
base, *FamilySearch* (https://familysearch.org/ark:/61903/1:1:2WWJ-8JG : 11 Febru-
ary 2018), Ruth Hunt, 28 Aug 1900; citing Manhattan, New York, New York, United
States, reference cn 34020 New York Municipal Archives, New York; FHL microfilm
1,953,786. For her 1915 passport application: "United States Passport Applica-
tions, 1795–1925," database with images, *FamilySearch* (https://familysearch.org
/ark:/61903/1:1:QVJP-CL8B : 16 March 2018), Mary E Hunt, 1915; citing Passport
Application, source certificate #6368, Passport Applications, January 2, 1906–March
31, 1925, 264, NARA microfilm publications M1490 and M1372 (Washington DC:
National Archives and Records Administration, n.d.). For her 1920 passport applica-
tion: "United States Passport Applications, 1795–1925," database with images, *Family-
Search* (https://familysearch.org/ark:/61903/1:1:QV5B-4DTP : 16 March 2018),
Mary E Hunt, 1920; citing Passport Application, London, England, source certificate
#75275, Passport Applications, January 2, 1906–March 31, 1925, 1317, NARA
microfilm publications M1490 and M1372 (Washington DC: National Archives and
Records Administration, n.d.). It was on this 1920 application that Mary Ellen Hunt

stated that they left for England in June 1901. For Robert Hunt's 1902 letter: "Letter
from John W. Hunt Is Rejected as Will," *Louisville Courier-Journal*, May 9, 1912.
For their 1911 address: "England and Wales Census, 1911," database, *FamilySearch*
(https://familysearch.org/ark:/61903/1:1:XWLV-635 : 16 May 2019), John Wesley
Hunt, Marylebone, London, England, United Kingdom; from "1911 England and
Wales census," database and images, *findmypast* (http://www.findmypast.com : n.d.);
citing PRO RG 14, The National Archives of the UK, Kew, Surrey.

6. That he frequently crossed the Atlantic: Mary Ellen Hunt's 1920 passport application;
"Man Jumped Off Liner," *New York Evening World*, "Hunt Lost from Ship after
Poring Over Wife's Photo," January 2, 1912; *Buffalo Courier*, January 3, 1912.

7. Pavlova and Coward: "Dynamic Diana Bourbon Keeps Radio's Soap and Soup Serial
Dramas Always Humming," *Fort Worth Star-Telegram*, June 22, 1941; volunteer
nurse's assistant: "Miss Ruth Hunt," *San Francisco Chronicle*, September 28, 1919;
ambulance: "Drama," *Des Moines Tribune*, January 24, 1941; "killed without
exception": "Why England Hoots Talkie," *Los Angeles Times*, October 19, 1930.

8. "Miss Ruth Hunt," *San Francisco Chronicle*, September 28, 1919; Diana Bourbon,
"The Fun of Being a Fool," *Cosmopolitan*, June 1931, 58–59, 186–87.

9. "The Theaters," *New York Tribune*, September 28, 1922.

10. "Odd Remarks on Brains and Acting," *New York Times*, November 19, 1922.

11. "On That Necessary Evil, the Audience," *New York Times*, December 17, 1922; "A
Talk with Mrs. Dion Boucicault," *New Orleans Times-Picayune*, November 2, 1887.

12. "An Innocent at Home Again," *New York Times*, January 7, 1923.

13. "The Homeless Christmas," *New York Times*, December 24, 1922.

14. H. G. Wells: *New York Times*, June 6, 1926; Clemenceau: *New York Times*, January 10, 1926; Goldman: *New York Times*, December 7, 1924; Lady Astor: *New
York Times*, July 13, 1924; gigolos: *New York Times*, August 15, 1926; *Comédie
française*: *New York Times*, June 29, 1924; eastern France: *New York Times*,
January 24, 1926; Deauville: *New York Times*, September 6, 1925; Biarritz, *New
York Times*, October 19, 1925; dance craze: *New York Times*, July 27, 1924; miners: *New York Times*, September 12, 1926; "weekend terror": *London Evening
Standard*, August 14, 1924; Cockneys: *New York Times*, November 16, 1924;
Shakespeare: *New York Times*, July 6, 1924; riding to hounds: *New York Times*,
April 10, 1927.

15. Ruth Hunt to William Marshall Bullitt, 20 April 1925, Filson Society.

16. Bourbon, "The Fun of Being a Fool," 186.

17. Yearly bonus: "Woman Produces Radio Shows," *San Francisco Examiner*, February
10, 1937; *Sphere, Brittannia and Eve*: Harrisburg (PA) Telegraph, "Woman Director Was Actress," February 1, 1941; Bourbon, "The Fun of Being a Fool," 58, 186.

18. "How Many Wives Are Worth Their Keep?," *Cosmopolitan*, December 1928,
quoted in the *Lake County (IL) Register*, November 21, 1928; Bourbon, "The
Fun of Being a Fool," 187. She would have been greatly embarrassed had she stayed
married, for in 1937 he published a defense of Hitler, *I Speak of Germany: A Plea
for Anglo-American Friendship*. As one reviewer put it, it was in essence nothing

more than "one of Herr Ribbentrop's speeches." K. Norman Hillson, *I Speak of Germany: A Plea for Anglo-German Friendship* (London: Routledge, 1937); E. M. Higgins, review of *I Speak of Germany*, *The Australian Quarterly*, 10, no. 1 (March 1938), 102–4.

19. Leonard Maltin, *The Great American Broadcast: A Celebration of Radio's Golden Age* (New York: Penguin, 1997): 233–35.
20. "Programs on the Air for Tonight and Tomorrow," *Los Angeles Daily News*, April 22, 1936.
21. "Woman Radio Producer," *Pasadena Independent*, April 11, 1950.
22. "The Radio Spotlight," *Napa Journal*, May 24, 1938; "Woman Produces Radio Shows," *San Francisco Examiner*, February 10. 1937.
23. Frank Brady, *Citizen Welles* (New York: Charles Scribner's Sons, 1989), 221.
24. Brady, *Citizen Welles*, 225; "Woman Radio Producer," *Pasadena Independent*, April 11, 1950.
25. "L. Barrymore Again Stars As 'Scrooge,'" *Harrisburg (PA) Telegraph*, December 14, 1940; "Pair to Co-Star on 'Campbell Playhouse,'" *Minneapolis Star*, December 27, 1940; "Dynamic Diana Bourbon," *Fort Worth Star-Telegram*, June 22, 1941.
26. "Brennan Cast for 'State Fair' Revival," *Salt Lake Tribune*, July 29, 1943; "Woman Radio Producer," *Pasadena Independent*, April 11, 1950.
27. "Woman Radio Producer," *Pasadena Independent*, April 11, 1950.
28. "California Death Index, 1940–1997," database, *FamilySearch* (https://familysearch .org/ark:/61903/1:1:VPC9-L52 : 26 November 2014), Diana Bourbon Hillson, 19 Mar 1978; Department of Public Health Services, Sacramento.

11. SALLIE REMEMBERED

1. "Historical Pageant Saturday By Eastern School," *Louisville Courier-Journal*, June 6; "Flag Day Celebration and Historical Pageant," *Louisville Courier-Journal*, June 13, 1915; "400 Expected to Attend U. K. Women's Banquet," *Lexington Herald*, March 29, 1941; "Kentucky's Greatest," *Louisville Courier-Journal*, December 31, 1999. A more recent grouping of noteworthy women from the state appears in *Kentucky Women: Their Lives and Times*, ed. Melissa A. McEuen and Thomas H. Appleton Jr. (Athens: University of Georgia Press, 2015). Madeline McDowell Breckinridge and Linda Neville appear both here and in the 1941 list. Helen Deiss Irvin's *Women in Kentucky* (Lexington: University Press of Kentucky, 1979) is a superb collection of vignettes of women of all races and walks of life.
2. "Sallie Ward Downs," *Chattanooga Daily Times*, August 23, 1896; "A Notable American Woman," *Boston Globe*, March 30, 1877.
3. Death of Andrew Govan: *Louisville Courier-Journal*, July 17, 1870; Govan remarried: *Daily Arkansas Gazette*, February 3, 1878; Anna in Washington: Washington, DC, *Evening Star*, December 4, 1874. The article goes on to say: "Mrs. Govan is the sister of the handsome Madame Zabrouski, who created a great sensation in Washington three years ago. Madame Zabrouski was noted for her beauty, elegant Parisian

toilettes and her diamonds. This accomplished lady died in Paris two years ago from the effects of a violent cold." This was Isabelle Key, after whom her father named the steamboat Belle Key. In 1852 she had married James W. Hewitt of Louisville, who became a lieutenant colonel in the Confederate Army and died at the Battle of Chickamauga. Zabrouski was "a Polish nobleman . . . who had taken refuge in France," according to the *Evansville Journal* of December 11, 1889.

4. Erwin, *Like Some Green Laurel*, 105, 117.

5. Lawrence, *An Exposition*, 8.

6. Anne Firor Scott, *The Southern Lady: From Pedestal to Politics 1830–1930* (Chicago: University of Chicago Press, 1970), 7.

7. "Courtly grace": "Beauty and Intellect," *Louisville Courier-Journal*, September 6, 1888; "hauteur": Alfred Pirtle, "Society in Louisville Seventy-Five Years Ago," *Louisville Courier-Journal*, October 23, 1921; "instigated by his mother": "The Ward Family," *New Albany Daily Ledger*, May 16, 1854; "red mark": Cole, *Trial of Matt F. Ward*, 169. There is a certain irony in the parallel between artificially creating a red mark for her son and recommending to her daughter a slight blush of rouge, both meant to deceive the observer. Evidence that Emily Flournoy Ward may have held more power in the family than her husband may be found in the fact that their firstborn was named Matthews Flournoy after her father and grandfather, and that it was the second son, Robert Johnson Ward Jr., who took his father's name.

8. Anya Jabour, *Scarlett's Sisters: Young Women in the Old South* (Chapel Hill: University of North Carolina Press, 2007), 120; "In those days": "Death Relieves the Suffering of Sallie Ward Downs," *Louisville Courier-Journal*, July 8, 1896. The *Boston Post* correspondent who covered Sallie's wedding to Bigelow Lawrence assumed that upon tying the knot she would cease to be a belle: "The great deed has been consummated, and the 'belle of the west' is numbered amongst the 'things that were.' Her race has been run, her career is finished, her horoscope is completed." Normally, that would have been the case. But Sallie proved the exception. ("From Our Western Correspondent," *Boston Post*, December 21, 1848).

9. Irvin, *Women of Kentucky*, 46–47.

10. "The Lawrence Divorce Case," *New York Daily Herald*, June 25, 1850. Instances of Sallie Ward being called a (often *the*) "Belle of the West" or a "Western Belle": "From Our Western Correspondent," *Boston Post*, December 21, 1848; "So the World Goes," *Buffalo Courier*, October 31, 1849; "Posting a Wife," *Buffalo Courier*, April 22, 1850; "Romance in High High Life," *Weekly Wisconsin* (Milwaukee), March 13, 1850; Ellet, *Queens of American Society* "Belle of the Southwest" or "Southwestern Belle": "Bell's Tavern; A Reminiscence of Ante-Bellum Days in Kentucky," *Appleton's Journal*, October 3, 1874. "Belle of Louisville" or "Louisville Belle: "The Lawrence Divorce Case," *New York Daily Herald*, June 15, 1850; "What's in a Name?," *Buffalo Morning Express*, December 20, 1850. "Belle of Kentucky" or "Kentucky Belle": "New-York Correspondence," *Charleston (SC) Daily Courier*, November 12, 1853; "Death of Mr. T. B. Lawrence," *Daily Milwaukee News*, March 26, 1869; "T. Bigelow Lawrence and the Belle of Kentucky," *Memphis Evening Post*, March

26, 1869; "A Famous Kentucky Belle," *St. Louis Republican*, July 2, 1876; "Grant Gossip," *Cincinnati Commercial*, December 12, 1879; "Woman Gossip," *Cincinnati Enquirer*, September 1, 1890. "Belle of the South" or "Southern Belle": *Boonville (IN) Enquirer*, July 7, 1877, p. 1; "Death Relieves the Suffering of Sallie Ward Downs," *Louisville Courier-Journal*, July 8, 1896; "Death of Notable Woman," *Boston Post*, July 9, 1896. "Belle of the country" or "American Belle": "New-York Correspondence," *Charleston (SC) Daily Courier*, November 12, 1853; "A Fascinating Woman," *Memphis Daily Appeal*, November 24, 1878: *"Women Folk," Weekly Raleigh (NC) Register*, October 15, 1884. Not South vs. North but West vs. East: "The Lawrence Divorce Case," *New York Daily Herald*, June 15, 1850.

11. April E. Holm, *A Kingdom Divided: Evangelicals, Loyalty, and Sectionalism in the Civil War Era* (Baton Rouge: Louisiana State University Press, 2017), 156; Brad Asher, *The Most Hated Man in Kentucky: The Lost Cause and the Legacy of Union General Stephen Burbridge* (Lexington: University Press of Kentucky, 2021), 15; Anne E. Marshall, *Creating a Confederate Kentucky: The Lost Cause and Civil War Memory in a Border State* (Chapel Hill: University of North Carolina Press, 2010), 4; Christopher Phillips, *The Rivers Ran Backward: The Civil War and the Remaking of the American Middle Border* (Oxford: Oxford University Press, 2016), 336–38; Aaron Astor, *Rebels on the Border: Civil War, Emancipation, and the Reconstruction of Kentucky and Missouri* (Baton Rouge: Louisiana State University Press, 2012), 40; Maryjean Wall, *How Kentucky Became Southern: A Tale of Outlaws, Horse Thieves, Gamblers, and Breeders* (Lexington: University Press of Kentucky, 2010), 203–4.

12. On the source of Ward's wealth: "Death Relieves the Suffering of Sallie Ward Downs," *Louisville Courier-Journal*, July 8, 1896. His plantations were in Arkansas and Mississippi, not Kentucky.

13. Eli Perkins, "Power of Beauty: Successful Career of a Kentucky Belle," *Chicago Tribune*, February 10, 1879.

14. Harding wrote "fourth" but it was from the second story that Robert Hunt fell.

15. An apparent allusion to Buell and his officers having their offices in the Ward mansion during the Civil War.

16. "Old Booze" is Vene Armstrong, Sallie's third husband.

17. The "gallant Major" is Major Downs, the poet's father-in-law.

18. "Old Hornie" is the Devil; John Harding, "The Story of a Noted Belle," Filson Society.

19. *Jeffersontown (KY) Jeffersonian*, July 2, 1908, p. 8; Elvira Sydnor Miller, *Songs of the Heart* (Louisville, 1885), 116–17.

Bibliography

Apple, Lindsey, Frederick A. Johnston, and Ann Bolton Bevins, eds. *Scott County, Kentucky: A History*. Georgetown, KY: Scott County Historical Society, 1993.

"Arkansas, County Marriages, 1837–1957." Database with images, *FamilySearch* (https://familysearch.org/ark:/61903/1:1:N9SK-3MN : 9 March 2021). William H Govan, 1 Nov 1866; citing Marriage, Phillips, Arkansas, United States, county offices, Arkansas; FHL microfilm 1,002,899.

Asher, Brad. *The Most Hated Man in Kentucky: The Lost Cause and the Legacy of Union General Stephen Burbridge*. Lexington: University Press of Kentucky, 2021.

Astor, Aaron. *Rebels on the Border: Civil War, Emancipation, and the Reconstruction of Kentucky and Missouri*. Baton Rouge: Louisiana State University Press, 2012.

Baird, Nancy Disher. *David Wendel Yandell: Physician of Old Louisville*. Lexington: University Press of Kentucky, 1978.

Bevins, Ann Bolton. *The Ward and Johnson Families of Central Kentucky and the Lower Mississippi Valley*. Georgetown, KY: Ward Hall Press, 1984.

Biographical and Historical Memoirs of Louisiana. Vol. 1. Chicago, 1892.

Bloomer, Dexter C. *The Life and Writings of Amelia Bloomer*. Boston, 1895.

Bourbon, Diana. "The Fun of Being a Fool," *Cosmopolitan*, vol. 90, no. 6, June 1931: 58–59, 186–87.

Boykin, Deborah. "Choctaw Indians in the 21st Century." *Mississippi History Now, December 2002 https://mshistorynow.mdah.ms.gov/issue/choctaw-indians-in-the-21st-century* [an online publication of the Mississippi Historical Society].

Brady, Frank. *Citizen Welles*. New York: Charles Scribner's Sons, 1989.

Bush, Bryan S. *Louisville and the Civil War*. Charleston, SC: History Press, 2008.

"California Death Index, 1940–1997," database, *FamilySearch*(https://familysearch.org/ark:/61903/1:1:VPC9-L52 : 26 November 2014), Diana Bourbon Hillson, 19 Mar 1978; Department of Public Health Services, Sacramento.

Carson, James Taylor. "Greenwood LeFlore: Southern Creole, Choctaw Chief." *Pre-removal Choctaw History: Exploring New Paths*, ed. Greg O'Brien, 221–36. Norman: University of Oklahoma Press, 2008.

Catalogue of the Officers and Members of the Institute of 1770, Harvard University. Cambridge, 1868.

Clark, Thomas D. *The Kentucky*. New York: Farrar and Rinehart, 1942.

———. "Ward, Sallie." In *The Encyclopedia of Louisville*, edited by John Kleber, 921. Lexington: University Press of Kentucky , 2001.

Cole, George. *Trial of Matt F. Ward for the Murder of Prof. W. H. G. Butler*. Louisville, 1854.

Collins, Richard. *History of Kentucky, Vol. One*, 1882.

Cullum, George W. *Biographical Register of the Officers and Graduates of the U. S. Military Academy at West Point, N.Y.* Vol. 1. Boston, 1891.

BIBLIOGRAPHY

Dickens, Charles. *American Notes for General Circulation*. London: Chapman and Hall, 1913.

Ellet, Elizabeth F. *The Queens of American Society*. Philadelphia, 1867.

Ellwanger, Ella Hutchison. "Sallie Ward: The Celebrated Kentucky Beauty." *Register of the Kentucky Historical Society* 6, no. 46 (January 1918): 7, 9–14.

"England and Wales Census, 1911." Database, *FamilySearch* (https://familysearch. org/ark:/61903/1:1:XWLV-635 : 16 May 2019). John Wesley Hunt, Marylebone, London, England, United Kingdom; from "1911 England and Wales census," database and images, *findmypast* (http://www.findmypast.com : n.d.); citing PRO RG 14, The National Archives of the UK, Kew, Surrey.

Erwin, John Seymour. *Like Some Green Laurel: Letters of Margaret Johnson Erwin, 1821–1863*. Baton Rouge: Louisiana State University Press, 1981.

Faust, Drew Gilpin. *Mothers of Invention: Women of the Slaveholding South in the American Civil War*. New York: Random House, 1996.

Filson Society Manuscript Collection. Filson Historical Society, Louisvlle.

G. P. A. Healy: Famous Figures and Louisiana Patrons. New Orleans: Lousiana State Museum, 1976.

Gemmill, Helen Hartman. *The Bread Box Papers: A Biography of Elizabeth Chapman Lawrence*. Doylestown, PA: Tower Hill Press, 1983.

Hall, S. C. "Gossip Stings." *Godey's Magazine and Lady's Book* July 1846.

Heidler, David S., and Jeanne T. Heidler. *Henry Clay: The Essential American*. New York: Random House, 2010.

Heywood, Rev. John H. *A Tribute to the Memory of William H. G. Butler*. Louisville, 1853.

Higgins, E. M. Review of *I Speak of Germany: A Plea for Anglo-German Friendship*, by K. Norman Hillson. *The Australian Quarterly* 10, no. 1 (March 1938): 102–4.

Hillson, K. Norman. *I Speak of Germany: A Plea for Anglo-German Friendship*. London: Routledge, 1937.

History of the Ohio Falls Cities and Their Counties. Cleveland, 1882.

History of the Second Presbyterian Church of Louisville, Kentucky. Louisville, 1930.

Holm, April E. *A Kingdom Divided: Evangelicals, Loyalty, and Sectionalism in the Civil War Era*. Baton Rouge: Louisiana State University Press, 2017.

Hudson, J. Blaine. "'Upon This Rock'—The Free African American Community of Antebellum Louisville, Kentucky," *Register of the Kentucky Historical Society* 109, no. 3/4 (Summer/Autumn 2011): 295–326.

Ireland, Robert M. "Acquitted Yet Scorned: The Ward Trial and the Traditions of Antebellum Kentucky Criminal Justice." *The Register of the Kentucky Historical Society* 84, no. 2 (Spring 1986) 107–45.

Irvin, Helen Deiss. *Women in Kentucky*. Lexington: University Press of Kentucky, 1979.

Jabour, Anya. *Scarlett's Sisters: Young Women in the Old South*. Chapel Hill: University of North Carolina Press, 2007.

Johnson, Leland R., and Charles E. Parrish. *Engineering the Kentucky River: The Commonwealth's Waterway*. Louisville: US Army Corps of Engineers, Louisville District, 1999.

Kirwan, Albert D. *John J. Crittenden: The Struggle for the Union*. Lexington: University Press of Kentucky, 1962.

Klotter, James C. *Kentucky Justice, Southern Honor, and American Manhood: Understanding the Life and Death of Richard Reid.* Baton Rouge: Louisiana State University Press, 2003.

Lawrence, Abbott, Jr., ed. *T. Bigelow Lawrence.* Boston, 1869.

Lawrence, Timothy Bigelow. *An Exposition of the Difficulties Between T. B. Lawrence, and His Wife Sallie Ward Lawrence, Which Led to Their Divorce. Prepared by T. B. Lawrence and His Counsel.* Boston, 1850.

Leslie, Eliza. "Eunice Rookley," *Godey's Lady's Book*, October 1843.

Lewis, Patrick A. *For Slavery and Union: Benjamin Buckner and Kentucky Loyalties in the Civil War.* Lexington: University Press of Kentucky, 2015.

Lincoln, Abraham. *Collected Works.* Vol. 7, edited by Roy P. Blaser. New Brunswick, NJ: Rutgers University Press, 1953.

Lincoln mss., ca. 1798–1959. Lilly Library, Indiana University Bloomington.

"Louisiana, New Orleans, Interment Registers, 1836–1972." Database, *FamilySearch* (https://familysearch.org/ark:/61903/1:1:4LPG-V5ZM : 13 December 2019). Emily Ward Hunt, 1854.

Luthin, Reinhard H. "Abraham Lincoln and the Massachusetts Whigs in 1848." *The New England Quarterly* 14, no. 4 (December, 1941): 619–32.

Maltin, Leonard. *The Great American Broadcast: A Celebration of Radio's Golden Age.* New York: Penguin, 1997.

Marshall, Ann E. *Creating a Confederate Kentucky: The Lost Cause and Civil War Memory in a Border State.* Chapel Hill: University of North Carolina Press, 2010.

McCullough, David. *The Greater Journey: Americans in Paris.* New York: Simon and Schuster, 2011.

McDowell, Robert Emmett. *City of Conflict: Louisville in the Civil War 1861–1865.* Louisville: Louisville Civil War Roundtable, 1962.

McEuen, Melissa A., and Thomas H. Appleton Jr. *Kentucky Women: Their Lives and Times.* Athens: University of Georgia Press, 2015.

McMeekin, Isabel McLennan. *Louisville: The Gateway City.* New York: Julian Messner, 1946.

Miller, Elvira Sydnor, *Songs of the Heart.* Louisville, 1885.

Mirror of the Graces. Boston, 1831.

Mitchell, Margaret. *Gone with the Wind.* New York: Scribner, 1936.

Nagel, Paul C. *George Caleb Bingham: Missouri's Famed Painter and Forgotten Politician.* Columbia, MO: University of Missouri Press.

"New York, New York City Births, 1846–1909." Database, *FamilySearch* (https://familysearch.org/ark:/61903/1:1:2WWJ-8JG : 11 February 2018). Ruth Hunt, 28 Aug 1900; citing Manhattan, New York, New York, United States, reference cn 34020 New York Municipal Archives, New York; FHL microfilm 1,953,786.

"New York, New York City Marriage Records, 1829–1940." Database, *FamilySearch* (https://familysearch.org/ark:/61903/1:1:24HT-4KT : 10 February 2018). John Hunt and Mary Darcy, 07 Nov 1892; citing Marriage, Manhattan, New York, New York, United States, New York City Municipal Archives, New York; FHL microfilm 1,452,333.

"New York Passenger Lists, 1820–1891." Database with images, *FamilySearch* (https://familysearch.org/ark:/61903/1:1:275H-47T : 20 February 2021). R P Hunt, 1852, Sallie W. Hunt, 1852; citing Immigration, New York City, New York, United States, NARA microfilm publication M237. FHL microfilm 175,474. Washington, DC: National Archives and Records Administration, n.d.

"New York, New York Passenger and Crew Lists, 1909, 1925–1957." Database with images, *FamilySearch* (https://familysearch.org/ark:/61903/3:1:33S7-95WP-9HC7?cc =1923888&wc=MFV1-M68%3A1029937201 : 2 October 2015). 4801 - vol 10413–10414, Aug 17, 1930 > image 385 of 898; citing NARA microfilm publication T715. Washington, DC: National Archives and Records Administration, n.d.

Passenger Lists of Vessels arriving at New York, 1820–1897, Passenger Lists 1 September 1852–25 September 1852 (NARA Series M237, Roll 119).

Peacock, Virginia Tatnall. *Famous American Belles of the Nineteenth Century.* Philadelphia: Lippincott, 1901.

Peiss, Kathy. *Hope in a Jar: The Making of America's Beauty Culture.* New York: Henry Holt, 1998.

Perrin, William Henry. *History of Bourbon, Scott, Harrison and Nicholas Counties.* Chicago, 1882.

Phillips, Christopher. *The Rivers Ran Backward: The Civil War and the Remaking of the American Middle Border.* Oxford: Oxford University Press, 2016.

Powers, S. D. *The Ugly-Girl Papers; or, Hints for the Toilet.* New York, 1874.

Ramage, James A. *John Wesley Hunt: Pioneer Merchant, Manufacturer and Financier.* Lexington; University Press of Kentucky, 1974.

———. *Rebel Raider: The Life of General John Hunt Morgan.* Lexington: University Press of Kentucky, 1986.

Rexford, Nancy. "Clothing and Personal Adornment." In *Encyclopedia of American Social History*, edited by Mary Kupiec Cayton, Elliott J. Gorn, and Peter W. Williams, [AU: inclusive page numbers of contribution should appear here]. New York: Charles Scribner's Sons, 1993.

Richardson, A. D. *A Full and Authentic Report of the Testimony on the Trial of Matt. F. Ward.* New York, 1854.

Riley, Glenda. *Divorce: An American Tradition.* New York: Oxford University Press, 1991.

Robinson, Stuart. *Slavery as Recognized in the Mosaic Law.* Toronto, 1865.

Sanford, Anita J. "Bryan's (Bryant's) Station." In *The Kentucky Encyclopedia*, edited by John E. Kleber, 133–34. Lexington: University Press of Kentucky, 1992.

Scott, Anne Firor. *The Southern Lady: From Pedestal to Politics 1830–1930.* Chicago: University of Chicago Press, 1970.

Shanks, Charles G. "George D. Prentice. Reminiscences of Editorial Life in the West." *Lippincott's Magazine of Literature, Science and Education* November 1869.

Sherley, Douglass. Prologue to *Songs of the Heart*, by Elvira Syndor Miller, ix–xxi. Louisville, 1885.

Snyder, Christina. *Great Crossings: Indians, Settlers, and Slaves in the Age of Jackson.* New York: Oxford University Press, 2017.

Taylor, Amy Murrell. *The Divided Family in Civil War America*. Chapel Hill: University of North Carolina Press, 2005.

Toilette of Health, Beauty, and Fashion. Boston, 1834.

Townsend, William. *Lincoln and the Bluegrass: Slavery and Civil War in Kentucky*. Lexington: University Press of Kentucky, 1955.

"United States Census, 1870." Database with images. *FamilySearch* (https://www.family search.org/ark:/61903/1:1:MNCZ-5K6 : 28 May 2021). William Govan, 1870.

"United States Confederate Officers Card Index, 1861–1865." Database with images, *FamilySearch* (https://familysearch.org/ark:/61903/1:2:7MKJ-4CZM : 6 September 2019). Robert P Hunt, 1861–1865.

"United States Passport Applications, 1795–1925." Database with images, *FamilySearch* (https://familysearch.org/ark:/61903/1:1:Q24F-K3PX : 16 March 2018). John W. Hunt, 1899; citing Passport Application, New York, United States, source certificate #, Passport Applications, 1795–1905., 518, NARA microfilm publications M1490 and M1372. Washington, DC: National Archives and Records Administration, n.d.

"United States Passport Applications, 1795–1925." Database with images, *FamilySearch* (https://familysearch.org/ark:/61903/3:1:3QS7-89D3-Y4KW?cc=2185145&wc=3XCP -BZ7%3A1056306501%2C1056369001 : 22 December 2014), (M1490) Passport Applications, January 2, 1906–March 31, 1925 > Roll 2233, 1923 Apr, certificate no 273850-274349 > image 218 of 871; citing NARA microfilm publications M1490 and M1372. Washington, DC: National Archives and Records Administration, n.d.

"United States Passport Applications, 1795–1925." Database with images, *FamilySearch* (https://familysearch.org/ark:/61903/3:1:3QSQ-G9X7-HLTD?cc=2185145&wc=3XZ8 -4WL%3A1056306401%2C1056422501 : 4 October 2016), (M1372) Passport Applications, 1795–1905 > Roll 518, vol 879, 1899 Jan > image 146 of 807; citing NARA microfilm publications M1490 and M1372. Washington, DC: National Archives and Records Administration, n.d.

"United States Passport Applications, 1795–1925." Database with images, *FamilySearch* (https://familysearch.org/ark:/61903/1:1:QVJP-CL8B : 16 March 2018). Mary E Hunt, 1915; citing Passport Application, source certificate #6368, Passport Applications, January 2, 1906–March 31, 1925, 264, NARA microfilm publications M1490 and M1372. Washington DC: National Archives and Records Administration, n.d.

US War Department. *War of the Rebellion*. 8 vols [serial no. 114–121]. Washington, DC: US Government Printing Office, 1897.

Villard, Henry. *Memoirs*. Boston: Houghton Mifflin, 1904.

Wall, Maryjean. *How Kentucky Became Southern: A Tale of Outlaws, Horse Thieves, Gamblers, and Breeders*. Lexington: University Press of Kentucky, 2010.

Ward, Matt. F. *English Items: or, Microscopic Views of England and Englishmen*. New York, 1853.

———. *Letters from Three Continents*, 2nd Edition. New York, 1851.

Ward, Robert J., Sr. Letter to Hon. R. W. Johnson, April 22, 1852. US Passport Applications Roll 038 (1 October 1851–April 30, 1852).

Webster, A. J. "Louisville in the Eighteen Fifties." *Filson Club History Quarterly* 4 (1930), 132–41.

Wyatt-Brown, Bertram. *Southern Honor: Ethics and Behavior in the Old South.* 25th anniversary ed. New York: Oxford University Press, 2007.

Yater, George H. *Two Hundred Years at the Falls of the Ohio: A History of Louisville and Jefferson County.* Louisville: Heritage Corporation, 1979.

LETTERS AND DOCUMENTS FROM THE
FILSON SOCIETY MANUSCRIPT COLLECTION

Bartley, Emily Johnson, to unidentified recipient, 1862.

Bate, Alexander, to William Marshall Bullitt, 3 March 1948.

Buchanan, James, to J. J. Crittenden, 2 February 1853.

Bullitt, Joshua Fry, to John C. Bullitt, 2 February 1845.

Bullitt, Joshua Fry, to John C. Bullitt, 26 May 1850.

Bullitt, Martha B., to John C. Bullitt, 27 October 1845.

Bullitt, Martha B., to John C. Bullitt, 2 February 1846.

Bullitt, Mildred, to Thomas Bullitt, 18 June 1861.

Bullitt, Mildred, to John C. Bullitt, 14 April 1846.

Bullitt, Mildred, to John C. Bullitt, 28 April 1846.

Bullitt, Mildred,=, to John C. Bullitt, 5 December 1846.

Bullitt, Mildred, to John C. Bullitt, 1 April 1847.

Bullitt, Mildred, to John C. Bullitt, 18 February 1847.

Ellet, Elizabeth Fries, to Jane Charlotte Ross, 26 May 1867.

Fairthorne, Fred F., to John C. Bullitt, 25 April 1846.

Fry, Cary H., to John Bullitt, 15 April 1846.

Gwathmey, Ellen, to John C. Bullitt, 25 December 1849.

Harding, John. "The Story of a Noted Belle" (poem).

Hughes, Rose Anna, to John C. Bullitt, 4 January 1847.

Hughes, Rose Anna, to John C. Bullitt, 10 May 1849.

Hughes, Rose Anna, to John C. Bullitt, 8 November 1849.

Hughes, Rose Anna, to John C. Bullitt, 9 February 1850.

Hunt, John W., to George F. Downs, 30 August 1897.

Hunt, Ruth, to William Marshall Bullitt, 20 April 1925.

Jacobs, Sarah, to her sister, 29 August 1853.

Lawson, James M. "Notes on the Trial of Matt F. Ward"

McKnight, Logan, to John C. Bullitt, 28 May 1846.

Pindell, H. C., to John C. Bullitt, 28 December 1845.

Robertson, Mary E., to John C. Bullitt, 29 August 1844.

Silliman, Susan Forbes, to Henrietta Silliman Dana, 8 January 1850.

Silliman, Susan Forbes, to her sisters-in-law, March 1850.

Tyler, Mary Jacob, to James B. Clay, 17 December 1849.

Woolley, M. P., to Susan P. Shelby, 12 November 1848.

Index

Armstrong, Venerando Politza, xiv. *See also* Ward, Sallie: marriages
Arthur, Chester, 109
Asher, Brad, 131
Astor, Aaron, 132

"belle" (concept), 130–31, 158. *See also under* Ward, Sallie
Bingham, George Caleb, 93, 150–51
Bloomer, Amelia, 21–23, 31
Bourbon, Diana (Ruth Hunt, Sallie's granddaughter): actress, 120–21, 125; becomes Diana Bourbon, 121; birth, 119; directs Orson Welles, 124–125; education, 120, 122–23; and Healy portrait of Sallie, 122; journalism, 121–23; marries and divorces, 123; radio career, 123–25; raised in England, 120–21; wears a dress made from one of Sallie's, 120
Buchanan, James, 45
Buell, General Don Carlos Buell, 89, 94, 102, 134, 151
Buford, Napoleon, 93
Butler, William H., 47–60

Chinn, Julia, 4
Choctaw Indians, xiv, 4–5

Clark, Thomas D., xv, 1, 12, 18, 21, 137, 141, 148, 149
Coulter, E. Merton, 131
Crittenden, John J., 18, 45, 54, 56, 57, 58, 59–60

Dickens, Charles, 19
Douglas, Stephen A., 66
Downs, George F., 112, 118, 133, 134. *See also* Ward, Sallie: marriages

Ellwanger, Ella Hutchison, xv, 21–22, 137
Erwin, Margaret Johnson (Sallie's cousin), 23, 64–65, 68, 103, 128–29

Faust, Drew Gilpin, 132, 150
Flournoy, Jean-Jacques, 5
Flournoy, Matthews, 5
Flournoy, Matthews, Jr., 5–6
Fry, Cary H., 9, 14, 25

Godwin, Ellen, 104–5, 128
Govan, William H. (Anna Key Ward's second husband), 93, 128
Grant, Ulysses, 109

Harding, John (George F. Downs's son-in-law), 133–34

168

INDEX

Hawes, Emily Throckmorton (Malvina's
daughter), 113

Healy, George Peter Alexander, xi, 68,
122, 149, 190

Holm, April E., 131

Hunt, Emily Ward (Sallie's daughter),
44, 62, 137, 148

Hunt, John Wesley (Robert Pearson
Hunt's father), 34, 35, 66

Hunt, John Wesley (Sallie's son), xiv,
66, 85, 92, 93, 114, 117–20; suicide,
119–20; 134

Hunt, Mary Ellen Darcy (John Wesley
Hunt's wife), 118, 119

Hunt, Robert Pearson, xiv; death, 99,
120; education, 35; family back-
ground, 34–35; and John Hunt
Morgan, 95–96; Mexican-American
War service, 35. *See also* Ward,
Sallie: marriages

Hunt, Ruth. *See* Bourbon, Diana

Irvin, Helen Deiss, 11, 130

Jabour, Anya, 130

Jackson, Andrew, 5

Johnson, Jemima Suggett (Sallie's great-
grandmother), 4

Johnson, Richard Mentor, 4

Johnston, Emily Ward (Sallie's sister), 6,
31, 66, 68, 92, 93, 113, 150

Key, Isabelle (Anna Key Ward's sister),
157–58

Lawrence, Abbott (T. Bigelow Lawrence's
father), 15–16, 18, 19, 33, 137

Lawrence, Elizabeth Chapman (T. Big-
elow Lawrence's second wife), 45–46

Lawrence, Katherine Bigelow (T. Bigelow
Lawrence's mother), 19, 20, 21, 24

Lawrence, T. Bigelow, 33, 40, 45, 46,
101, 129. *See also* Ward, Sallie:
marriages

Le Vert, Octavia, 106, 127–28. *See also
under* Ward, Sallie

Lewis, Patrick, A., 96

Lincoln, Abraham, xv, 52, 86, 92, 94,
95–96, 98

Marshall, Anne, 131

Miller, Elvira Sydnor, 135–36, 141

Morgan, John Hunt (Robert Pearson
Hunt's nephew), 34, 86, 88, 95–96

O'Hara, Scarlett, xiv–xv, 128, 133

Pendleton, Olive, 96–97

Perkins, Eli (Melville Landon), 2, 132,
133

Phillips, Christopher, 131–32

Prentice, George D., 12, 26, 33–34, 43,
52, 55, 56, 62, 85, 86, 94, 146

Robert J. Ward (steamboat), xiv, 44–45,
63, 67

Sallie Ward Candy, 33

Sallie Ward Chewing Tobacco, 33–34

Sand, George, 2

Schroeder, Emily Sidell (Lillie Ward
Schroeder's daughter), 117, 118

Schroeder, Lillie Ward (Sallie's sister), 6,
31, 68, 117

Scott, Anne Firor, 129

Speed, James, 52

Speed, Joshua, 52, 95

Sturgus, Minard, 47–48, 50–53, 55, 67,
130

Throckmorton, Aris, 8, 10–11, 36

Throckmorton, Aris (Malvina Throck-
morton's son), 113

Throckmorton, Colin (Malvina's hus-
band), 8–11, 14, 19, 25, 31, 85, 93,
104, 113, 139, 142

Throckmorton, Emily (Malvina's
daughter), 142